The Writing of Where

Writing, Culture, and Community Practices
Steve Parks and Eileen Schell, *Series Editors*

Syracuse University Press's Writing, Culture, and Community Practices series is distinguished by works that move between disciplinary identity and community practices to address how literacies and writing projects empower a population and promote social change.

Other Titles in Writing, Culture, and Community Practices

The Arkansas Delta Oral History Project: Culture, Place, and Authenticity
 David A. Jolliffe, Christian Z. Goering,
 Krista Jones Oldham, and James A. Anderson Jr.

Latina Leadership: Language and Literacy Education across Communities
 Laura Gonzales and Michelle Hall Kells, eds.

Writing Suburban Citizenship: Place-Conscious Education
and the Conundrum of Suburbia
 Robert E. Brooke, ed.

The Writing of Where

Graffiti and the Production of Writing Spaces

Charles N. Lesh

Syracuse University Press

First Edition 2022

22 23 24 25 26 27 6 5 4 3 2 1

∞ The paper used in this publication meets the minimum requirements
of the American National Standard for Information Sciences—Permanence
of Paper for Printed Library Materials, ANSI Z39.48-1992.

For a listing of books published and distributed by Syracuse University Press,
visit https://press.syr.edu/.

ISBN: 978-0-8156-3767-7 (hardcover)
 978-0-8156-3762-2 (paperback)
 978-0-8156-5559-6 (e-book)

Library of Congress Cataloging-in-Publication Data

Names: Lesh, Charles N. author.
Title: The writing of where : graffiti and the production of writing spaces /
 Charles N. Lesh.
Description: First edition. | Syracuse : Syracuse University Press, 2022. |
 Series: Writing, culture, and community practices | Includes bibliographical
 references and index.
Identifiers: LCCN 2022008173 (print) | LCCN 2022008174 (ebook) |
 ISBN 9780815637677 (hardback) | ISBN 9780815637622 (paperback) |
 ISBN 9780815655596 (ebook)
Subjects: LCSH: Graffiti—Social aspects—Massachusetts—Boston. | Graffiti artists—
 Massachusetts—Boston—Social conditions. | Street art—Social aspects—
 Massachusetts—Boston.
Classification: LCC GT3913.M42 B675 2022 (print) | LCC GT3913.M42 (ebook) |
 DDC 306/.1—dc23/eng/20220429
LC record available at https://lccn.loc.gov/2022008173
LC ebook record available at https://lccn.loc.gov/2022008174

Manufactured in the United States of America

Publication supported by a grant from

The Community Foundation *for* Greater New Haven

as part of the Urban Haven Project.

Contents

List of Illustrations *ix*

Acknowledgments *xi*

Introduction: *Mission* *1*

1. Boston(s) *33*

Community Interlude 1: *Piecing* *68*

2. Spot *81*

Community Interlude 2: *Bombing* *121*

3. Bible *128*

Community Interlude 3: *Blackbooking* *164*

4. Train *173*

Community Interlude 4: *Benching* *208*

5. Warehouse *214*

Works Cited *243*

Index *263*

Illustrations

I.1 Kulturez 2

I.2 SENSE Truck 19

1.1 "The Curse of Graffiti," *Boston Globe*, 1973 39

1.2 Wild Style at the Coolidge Theatre 50

1.3 The Critique of Graffiti 61

1.4 VISE at Northeastern University 78

2.1 BEAN Warehouse 86

2.2 NIRO Roller 90

2.3 MBRK Stickers 99

2.4 BOWZ Stickers 103

2.5 MYND × SPIN 105

2.6 SPIN × 4CAST 107

2.7 Peters Park in Process 111

2.8 SENSE × GOFIVE 115

2.9 "The Lab" by GOFIVE 122

2.10 SOEM, ODESY, TENSE, PROBLAK 123

2.11 PATS × KEMS 123

2.12 SPIN, Eight Years Later 125

3.1 LIFE Bible 130

3.2 Practice Page in Bible 138

3.3 SPIN in Author's Bible 141

3.4 WERD in Author's Bible 148

3.5 BEAN in Author's Bible 149

3.6 GOFIVE in Author's Bible 150

3.7 SWAT in Author's Bible 159

3.8 TAKE in Author's Bible 167

3.9 HATE in Author's Bible 169

3.10 PROBLAK in Author's Bible 170

3.11 REACT in Author's Bible 171

3.12 ACOMA in Author's Bible 172

4.1 BEAN, Train Bible 193

4.2 MYND Bible 194

4.3 LIFE Model Train 195

4.4 MYND Model Train 196

4.5 SWIL Model Train 196

4.6 SYNAPSE Faces 204

4.7 TEMP Model Train 211

4.8 BEAN Freight 212

Acknowledgments

If anyone had told me twenty years ago that I would be writing acknowledgments for a book, I, and surely most who knew me, would have laughed. On the path from then to now, I have been fortunate to encounter remarkable people with whom I've found solidarity, warmth, and insight. I'd like to acknowledge a few of them here.

I found my first academic home in graduate school at Northeastern University, which was inhabited by scholars who continue to shape the way I approach this work. While I will never be able to repay the support that place has given me, I try to pay it forward every day. Chris Gallagher believed in this project before it was even a project and has supported it, and me, in too many ways to list here. I consider myself lucky to call him my mentor and friend. Conversations with Beth Britt on methodology, and its limits, continue to inspire me, all these years later. Working with Mya Poe taught me the value of collaborative research and that academic work is better when done together. Neal Lerner and Ellen Cushman continually met me, and continue to meet me, with open doors and willing ears.

The core ideas of this book were formed as much around tables at Punter's Pub as they were in seminar rooms. I could hardly have been luckier to share those tables with colleagues like Frank Capogna, Emily Cummins, Kristi Girdharry, Rachel Lewis, Jess Pauszek, and Michael Turner.

Kevin Smith was also a regular fixture at those tables. In Kevin, I found a collaborator and writing partner whose voice plays in my head whenever my writing begins to sound a bit "too Charlie." Kevin has read every word of this book, multiple times, and the good parts bear his fingerprints. He's also easily my favorite academic to run a pick-and-roll with.

At Auburn University, I encountered a group of supportive colleagues and students who guided me through the twists and turns of the tenure track. I thank all of them here. Whether it was with the institutional support I needed to complete this project, in talking through ideas, or in random hallway conversations, this work simply would not exist without the community I've found at Auburn. I want to give a special acknowledgment to Leigh Gruwell, my colleague, collaborator, and friend just down the hall.

A huge thank you to the entire team at Syracuse University Press: editors Steve Parks and Eileen Schell, acquisitions editor Deborah Manion, and everyone else who helped with this project. Writing a first book can be a scary, scary process, and I hope all first-time authors find as much support and patience as I did. I'd like to thank The Community Foundation for Greater New Haven for its generous support in helping with the publication of this project. I am likewise grateful to the journal editors who aided my publication of earlier portions of this research.[1]

Thank you to Jim Holstun. I met Jim when I was a struggling and aimless undergraduate at SUNY Buffalo, and with one bit of encouraging feedback (I still have the paper), he launched me onto this academic path. Jim convinced me before anyone else did that I had something to say and that something might be worth saying. I am grateful for that.

I couldn't imagine writing this book without the earliest lessons I learned from my family. My mom taught me that education is only worth something if it is used to support others. My dad taught me how to talk to anyone, anywhere, about anything. My brothers and sisters—Cara, Vinnie, Matthew, Nina, and Joey—taught me to be tough, how to get in trouble, but more importantly, how to be kind and to love unconditionally. I love you all.

In 2010, I called my wife Allie on my way home from Burlington, Vermont, to tell her that I had decided not to go to graduate school. A

1. Portions of this research were originally published in *Reflections: A Journal of Community-Engaged Writing and Rhetoric* 18, no. 2 (Fall/Winter 2018–19): 116–50, and in *Community Literacy Journal* 12, no. 1 (Autumn 2017): 62–86. I am grateful to the journals for permission to reprint.

year later, Allie convinced me to overcome my fears, move to Boston, and give it a shot. I will spend the rest of my life thanking her. Allie is my best friend, and her love and patience are present in every single word of this book. From Buffalo to Boston to Auburn, I absolutely could not have done this without her, and I am thankful each day that I didn't have to try. Thanks, bug.

The joy my kids bring sustained me during the writing of this book. Watching Jack and Graham grow up is without question the happiest experience of my life, and I wake up each day excited for what comes next. Jackie Boy and Graham Man, I am so proud of both of you.

Finally, my gratitude goes to all of the graffiti writers in Boston, both the ones who have allowed me to share their thoughts and images in this book and all those getting up in the city. In the process of conducting this research, I've made some lifelong friends, met many of my heroes, and chopped it up with some of the smartest, most inspirational people I'll ever meet. I hope in some very small way this book repays the patience they've had with me all these years. These writers are the energy for this research, and I cannot begin to thank them sufficiently for the trust and time they've spent on me.

SENSE lives.

—Charlie

The Writing of Where

Introduction

Mission

I think that I am a writer, you know? It's graffiti. It's not art. So, I
am a fucking writer and I've earned it. For various sorts of political,
sociopolitical, class, race, and other reasons, we're writers. It's the
thing that we do. And it's our thing. It's a thing for us, not for you,
general public, civilian man out in the street. I think that's the heart
of it. Writing your name is a powerful thing for a kid with nothing.
 BAST (personal interview with author)

Perhaps in the end, it is finding out where to begin that is left out in
most of our talk of public writing.
 Diana George (2002, 16)

The Garage is a red-brick commercial building in the thick of the Harvard
Square section of Cambridge, Massachusetts. Walking toward the build-
ing, you might notice the iconic gates of Harvard University, the open-
air chess tables, and the newsstand, among other established sites. You
might also notice the graffiti: tags and stickers, mostly, a sort-of graffiti
bread trail. Inside, you will likely notice the smell: a corporate-olfactory
swirl of Starbucks, Ben & Jerry's, and Subway, with just a hint of incense
coming from the upstairs head shop. Riding the escalator to the second
floor, the smells from below fade, replaced by the unmistakable scent of
aerosol paint and ink markers. Turn right, past the record and tattoo shops,
and you arrive at Kulturez (fig. I.1). Its presence is announced boldly. Big,
white dead letters against a matte black background.[1] KULTUREZ.

1. *Dead letter* is a term Boston writers use to describe legible graffiti letters. It is not
a negative term, as "dead" might suggest. When I asked LIFE about it, he defined *dead*

1

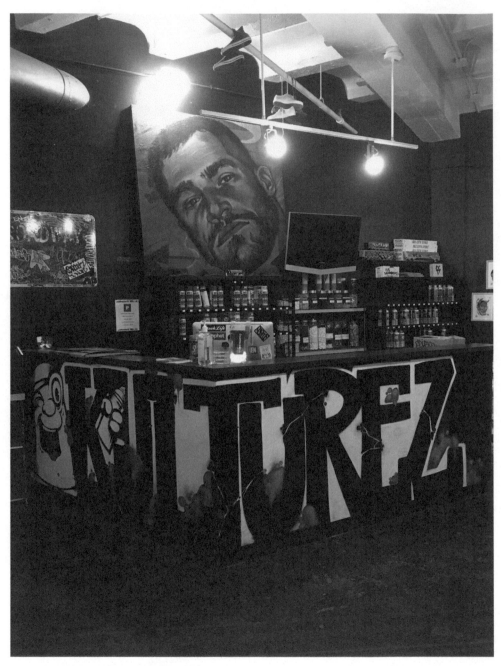

I.1 Kulturez. Photo by BONES.

Kulturez was a hip-hop and culture shop from 2010 to 2016. During that time, it served important roles for graffiti writers from Boston, Cambridge, Lynn, and other areas within the Greater Boston metropolitan area.[2] At Kulturez, you could buy materials for writing. It was always stocked with markers (paint and ink), spray paint (mostly Ironlak and Montana), and a variety of paint-burst modifying caps with names like banana cap, pink dot, orange dot, New York fat, and Boston fat. Adapters, too, that turn any cheaper brand of spray paint (like Rustoleum, or "Rusto") into a more precise and predictable writing tool.

The shop was also a space to write and to discuss writing. There was a wall that regularly featured work from some of the most well-known writers in the city and a bathroom on the ground floor of the building where the walls were almost entirely saturated with tags, including many of my own. Writers would huddle around the counter in the shop, exchange blackbooks, pour over flicks of recent work, critique and encourage, talk trash, workshop. When writers would come through the shop, they'd often leave stickers bearing their names affixed to a small panel on the side of the counter. That counter became an ever-evolving palimpsest, a history of the space and the larger city, written and rewritten. Kulturez was a space for memorials, to remember. When SENSE, a writer I came to know during this project, passed away in 2014, writers descended on the shop to pay respects and to reflect on his work and legacy.

When I received a text from BONES, one of the owners, that the shop was closing—priced out of the increasingly expensive and exclusive neighborhood, like so many other community spaces—I was devastated. Kulturez was home base for the research presented in this book. No matter where my interests in rhetoric, writing, and literacy took me, I always

letter as a "basic bold sans serif letter. Just bouncy or with a little bit of attitude. A dead letter is basically legible and a nice thick letter."

2. Throughout this book, I use "Boston" as shorthand for the Greater Boston metropolitan area. This is not to collapse differences between areas, many of which have their own unique graffiti styles and histories. But for the purposes of this book, because it does not purport to tell the history of any of these regions, this more inclusive term allows me to explore the spatiality of writing from a broader perspective.

returned to Kulturez. It was where I met writers, discussed writing, and practiced my own writing—academic or otherwise. From the first day I awkwardly walked in to its last day, Kulturez was much more than a shop that sold graffiti materials. When inside, the surrounding cities seemed to melt away. When inside, *writing* was what remained in focus.

During the hours and hours I spent in the shop—as a researcher, as a friend, as an occasional "shop watcher" when folks would go outside to smoke—the spaces of graffiti were topics of unending debate. *You see that South End spot I hit? I gotta get you my bible. Man, look at this train.* Around the counter, I learned of the complex community spaces that writers have made for themselves and continue to make for themselves. Constellated together, these new spaces, I learned, structured a New Boston, or a *"New* New Boston," as BAST named it. Kulturez was something of a seminar for me, an immersive and experiential pedagogical space that introduced me to alternative cartographies of writing in Boston.

These spaces seemed different to me than the locations of writing I was encountering in my work in rhetoric and composition. At the shop, the relationship between writing and space was more direct, more deliberate, more urgent. My disciplinary training taught me to locate "the *where* of writing" (Reynolds 2004, 176). Graffiti writers taught me to locate *the writing of where*, the production of alternative community and public writing spaces in defiance of those who would eliminate them. And for years, I worked with writers as they made and sustained these spaces, all along the way gathering insights about space and writing.

The Writing of Where tells that story. Each chapter ethnographically explores writing spaces that graffiti writers in Boston make for themselves: "Spot," invented locations of (counter)public writing produced and sustained by the circulation of community genres of writing (chapter 2); "Bible," community notebooks where writers practice, circulate, and archive their work, also called blackbooks (chapter 3); and "Train," real and imagined locations of mobility that writers simultaneously take and make as writing spaces (chapter 4). Between each of these chapters, readers will find Community Interludes, responses to the preceding chapters from some of the graffiti writers I worked with on this project. Through this participatory work—both in conducting this research and composing

the book in this way (which I describe in chapter 5)—I ultimately argue that these writing spaces reinvent the city's literacy landscape, producing a series of *wheres* distinct from larger, more dominant identities of a city defined, in part, by entrenched segregation, neoliberal spatial restructuring and restriction, and an abiding commitment to preserving a cultural, educational, and historical legacy (chapter 1).

It is here, in writing's ability to make alternatives spaces, that the intervention of this book lies. It asks: *What do we do when the spaces of writing fail us? How can we act, as writers, when writing spaces don't facilitate the publics we crave or need? How are new writing spaces made?* Asking these questions and working through them in the field leads me to consider an alternative theory of writing for rhetoric and composition, one in which writing is elemental in the production of emergent spaces. For graffiti writers, writing not only exists in space, requires adequate space, or circulates through the materiality and politics of particular spaces, it also produces, directly, a diverse range of discernible *writing spaces* that differently promote, facilitate, and limit rhetorical engagements: from the bold and broadly visible spots along the highway to the bridge underpasses seldom seen by nonwriters; from the freight yard to the bible bouncing around a writer's backpack; from the model train to the abandoned factory. As writers cultivate these new writing spaces, the rhetorical landscape of the city is refigured, not as an already authored space, a product to be divvied up or reformed, but as a process, multiple and diverse productions of new spaces jostling to organize the material and metaphorical conditions of writing. Moving through these different spaces, *The Writing of Where* considers what this refigured relationship between writing and space might mean for rhetoric and composition.

In working with graffiti writers—writers who Kurt Iveson (2010a) calls "urban geographers *par excellence*"(26)—my hope is that this book also provides a more fundamental challenge beyond the theoretical interventions it makes. By developing participatory methods of community engagement and working ethnographically with writers on the fringes of public, legal, and disciplinary conceptions of writing, this book moves outside of the inward facing ways our field can sometimes *write about writing* and even beyond the landscapes of our own disciplinary "public turn" (Mathieu

2005). Instead, this book locates the public work of writing (studies) in spaces betwixt and between, in the interstices of discernible public and community spaces and in the gaps of what scholarship often feels, looks, and reads like. My hope is that this book implores those of us invested in writing's public potential to play a more active role in the production of participatory, diverse, and potentially more equitable landscapes of writing spaces and writing studies.

"Mission" is how graffiti writers describe the planning and execution of writing, oftentimes in precarious urban locations. *What's the mission tonight?* It is part of a larger militarized lexicon that writers use to describe their work, engaged in a larger conflict, or war, over the control of urban space, over who gets to write what, and where. All graffiti writing, MYND once told me, is about knowing "what the mission at hand is."

The Writing of Where asks rhetoric and composition: What's the mission at hand?

Space

In this book I argue that graffiti writing produces writing spaces. More specifically, I argue that graffiti writing in Boston produces a range of specific public and community spaces through the literacy work of reading and writing and, in doing so, can help us imagine and experience not just writing's role in improving or reforming rhetorical geographies but in the creation of alternative ones. By *writing spaces*, I don't mean just the locations of writing, however dynamic those settings might be. Rather, writing spaces here are material and metaphorical venues, participants, *and outcomes* of writing processes. They are meaningful social venues not just where writing happens but because writing happens. As graffiti writing cultivates alternative writing spaces, it troubles rhetoric and composition's emphasis on "making space" for rhetorical work, which often implies spatial expansion and reform, not multiplicity. My goal, then, is to trace a sampling of these emergent writing spaces and, through this engagement, structure a theory in which writing, in all its forms, plays an elemental role in the production of spaces.

In advocating for, and participating in, this more direct and multitudinous framework for writing's relationship to space, I'm building on a

growing body of literature in rhetoric and composition on the spatiality of writing: the material and metaphorical locations where writing takes place. Indeed, questions of space and place are well established in the research and teaching of writing.[3] Work within this spatial turn has unpacked the significance of space not as a static, absolute, apolitical container in which writing occurs but, rather, what Henri Lefebvre (1991) calls a "social morphology," an active participant in, and product of, social actions (like writing) (94). Drawing on spatial theorists like Lefebvre (1991), Tim Cresswell (1996), Edward Soja (1989, 1996), Doreen Massey (1994), bell hooks (1990), Michel Foucault (1986), Yi-Fu Tuan (1977), and others, writing scholars have punctured notions of transparent disciplinary space, drawing attention to the materiality, politics, and specificity of the spaces and places in which we work. We've had a lot to say about space, at least in part because, as Nedra Reynolds (1998) has written, "Writing itself is spatial, or we cannot very well conceive of writing in ways other than spatial" (14).[4]

3. I should note that distinctions between space and place have recurred in scholarship in rhetoric and composition and elsewhere. This work has convincingly posited differences between the two terms, mostly echoing Yi-Fu Tuan's (1977) description of place as space made socially meaningful. Still, most of this work recognizes the complex and codependent relationship between these terms—particularly in relation to Henri Lefebvre's "social space" (Cresswell 2004, 10)—leaving us with no neat distinction. I find this lack of distinction generative, and to that end, I won't offer one here. When I use space in this book, I'm attempting to capture its more social connotations while also preserving some of the openness that Tuan identifies. I see its relationship with place to be mutually constitutive but ultimately ineffable.

4. Though it is difficult, and perhaps undesirable, to identify boundaries of our larger spatial turn, some limited sense of its expansiveness is useful. There have been edited collections and special issues dedicated to the spaces of writing (Keller and Weisser 2007; Powell and Tassoni 2009; *College Composition and Communication* 2014; *Kairos* 2012). Scholars have examined "rhetorical space" (Mountford 2001; also Ackerman 2003; Marback 2004), writing studios (Grego and Thompson 2008), suburbs (Brooke 2015; Topinka 2012), cities (Bruch and Marback 1996; Fleming 2008; Kinloch 2010; McComiskey and Ryan 2003; Rai 2016; Rice 2012), rural locations (Ball 2009; Jolliffe et al. 2016), and ecologies (Cooper 1986; Dobrin and Weisser 2002; Edbauer 2005b; Rivers and Weber 2011; Weisser and Dobrin 2001). Work has explored the spatiality of protests (Endres and Senda-Cook 2011), of genres (Dryer 2008; Reiff 2011 and 2016), and of Writing Studies

While spatial work in rhetoric and composition is diffuse, the most central call has been to situate or contextualize writing, research, and teaching within this more dynamic rendering of space, in this "swirling combination of metaphor and materiality" (Reynolds 2004, 175). For example, Reynolds's own foundational work on the spatiality of writing traces how writers—mainly students from her fieldwork at the University of Leeds—write in, move through, and dwell within spaces in socially meaningful ways, and how sociospatial difference is manifest in that process. Reynolds calls on us to situate writing within material and metaphorical spaces, not as backdrops against which writers write, but as active, albeit often overlooked and dematerialized, participants in writing processes and pedagogies.

Sidney Dobrin, too, has worked to understand the situatedness of writing, perhaps best crystallized in the notion that "writing takes place." For Dobrin (2001), this phrase signals something fundamental about writing:

> Writing is an ecological pursuit. In order to be successful, it must situate itself in context; it must grow from location (contextual, historical, and ideological) . . . Writing does not begin in the self; rather, writers begin writing by situating themselves, by putting themselves in a place, by locating with in [sic] a space. (18)

In *Postcomposition*, Dobrin (2011) further elaborates this contextual and reciprocal relationship between writing and space. "Writing requires space," Dobrin argues; it "requires the material space onto/into which writing is inscribed, and it requires cultural, historical, political space to occupy" (56). Writing takes place. It requires it. It needs it. More recent work has continued this tradition of em-placed composition. Hannah Rule's (2018) work on the locations of writing processes, for example, shows how "writing activity is *never not emplaced*; composing processes *only* happen through things, spaces, time, action, and bodily movement"

itself (Dobrin 2007). We've emplaced writing instruction (Brooke 2003; Marback 2001) within larger changes to institutional spaces (Mauk 2003) and become more sensitive to the multiple locations of pedagogy that writers inhabit within and beyond classrooms (Carlo 2016; Drew 2001; Owens 2001; Reddy 2019).

(404). Writing takes place. "To claim that writing gives or can give shape to space, provides structure to the shapelessness of space," Dobrin (2011) dismisses, "is to suffuse writing with power over space" (56).

In many ways, my work in this book, and the work I see graffiti doing in Boston, does just that: it posits a direct link between writing and spatial production and, in doing so, offers not just new venues for writing research and teaching but new frameworks for understanding the possibilities and politics of writing spaces. In this book, you'll find writing that is situated and that situates. Graffiti writing in Boston, and elsewhere, is about just this: writers without adequate space for public engagement using writing, a precious resource, not to reform space, but to invent new locations for community work. Writing is spatial, as Reynolds argues, and writing does take place, per Dobrin. Space does inform, shape, and produce (the conditions for) writing. But in graffiti, we see how writing also informs, shapes, and produces (the conditions for) space. The spaces I look at in this book take writing. They require it. They need it.

Within this refigured understanding of space and writing resides a new mission for writing studies. In addition to the important work of locating, securing, or reforming venues for rhetorical work—or working within bureaucratic channels to reform space (Dryer 2008; Marback 2003)—we might also consider the ways our writing itself can tactically make alternative spaces for writing. These spaces might be constitutively different than our disciplinary venues of writing and the institutional or community locations of writing to which we're most often drawn. That's the point. The writing spaces in this book announce: *Our writing spaces are different than yours.* They mark boundaries that exist elsewhere in relation to attempts to create a singular, expandable writing landscape. As they do, these spaces implore us to theorize spatial multiplicity rather than extension or reform: Boston (or rhetoric and composition) not as a singular writing infrastructure that expands or shrinks, that includes or excludes, but as a fluid tapestry of emerging and receding writing spaces that coexist, cohere, or potentially conflict with one another.

This multitudinous rendering of space and writing adds nuance to psychologist Rebio Diaz Cardona's (2016) work on writing's spatializing role in urban environments in the digital age. In concluding this work,

Cardona offers thoughts on the spatializing role of writing, worth quoting at length here:

> Along these lines, I would like to propose a strong (literal) version of the claim that writing is one of the ways in which society "produces its (own) social space." I call this version direct spatialization. In contrast to a view in which the contribution of writing to social space is contingent on its specific meaning and its use in contexts of practice, I suggest that writing *directly* produces space, effectively extending social space, in a sense, prior to practice, or more precisely prior to any particular use, as it extends the material support available for social interaction . . . This direct spatialization thesis leads me to propose an incremental, or additive view of social space, in which every act of writing . . . creates "more" social space, just as conversely, less social space results when texts are deleted or destroyed. One implication of this idea is that the (hypothetical) size of social space is not constant, but variable, ever fluctuating. (649)

Cardona's claim that a society's spatial infrastructure expands or retracts with the introduction of deletion of text is compelling, particularly in relation to graffiti, writing that is constantly being produced and erased, or sprayed and buffed. Yet an incremental view of social space framed here implies a singularity: "Boston" as one social space that shrinks or grows with each inscription or removal of text. But the spaces of (graffiti) writing often rely on multiplicity and distinction rather than extension or reform. As writing circulates, it doesn't just bump into or push the boundaries of given social spaces, it also imagines new ones, filled with different possibilities, modes of address, and politics.

Graffiti writing seems exemplary of this spatial-production-via-writing. To say that it interacts with urban space in productive ways can be viewed as somewhat of a topoi, a commonplace that scholarship on graffiti frequently returns to. Andrzej Zieleniec, for example, notes that in scholarship on graffiti, there is often "an implicit if not explicit recognition that graffiti is not only an urban cultural product but that its practitioners seek to use and transform the space of the urban" (2016, 2; see also Bloch 2016a, 444). Indeed, writing graffiti is a patently spatial-rhetorical act, and existing scholarship across disciplines has documented this nested relationship

between the spaces of graffiti and the production of and, especially, the resistance to, neoliberal urban spaces.

What we can learn from these spaces has varied, depending on the study. For Jeff Ferrell (1996), graffiti constructs alternative contexts in which anarchist opposition and aesthetics can challenge the "aesthetics of authority" and models of discipline so entrenched in capitalist cities. For Tim Cresswell (1996), the literal placement of graffiti—what he calls its "crucial 'where'"—transgresses, and thus makes visible, the implicit normative geographies that structure our experiences of everyday life. Stefano Bloch, across a range of work, has brought a rich and explicitly spatial approach to scholarship on graffiti. For example, in his defense of graffiti via critique of existing defenses of graffiti, Bloch (2016a) notes "graffiti's most powerful attribute as a marker and producer of alternative urban spatialities" (445; see also 2012, 2016b, 2019). Alison Young (2014) has considered the ways that graffiti and street art's spatial productiveness alerts us to the "multiplicities within the singular city," to the possibilities of other types of cities, of spaces, and of forms of interaction and encounter (53). Jessica Nydia Pabón-Colón (2018) has shown through innovative digital methods how graffiti "grrlz" form transnational digital and nondigital spaces of community by "performing feminism." And closer to my own field, Caitlin Frances Bruce (2019) has argued that transnational legal graffiti scenes produce various types of publics within "spaces *for* encounter," contingent and not necessarily antagonistic occasions for rhetorical "contact, convergence, or conflict" (2). In this and other work, which I draw on throughout this book, the ability of graffiti to make space is emphasized, if interpreted in different ways.[5]

> CHARLIE: Discuss the politics of graffiti.
> RELM: Man, I don't like politics. But I'll give it a shot.

5. This is just a small sampling of work on the spaces of graffiti. See also, for example, Andron 2017; Brighenti 2010; Dickinson 2008; Dovey, Wollan, and Woodcock 2012; Ferrell and Weide 2010; Halsey and Young 2006; Iveson 2007; Mitman 2018; Megler, Banis, and Chang 2014; Pennycook 2010; Phillips 1999; Snyder 2009; Stewart 1991; Wimsatt 1994.

The Writing of Where takes a different approach, perhaps more lim- ited in intent, but also, I hope, more widely useful for rhetoric and com- position. At its core, this book is a story about writers writing. And what I think can be lost in our discussions of the rhetoricity of graffiti, and what I am most interested in here, is more subtle than a particular civic or social function. Beyond all of the different roles these spaces serve, at their core they are writing spaces: spaces where writers write, spaces because writers write. Let me put it this way. This book is less a study of the important "I was here!" function of graffiti that so dominates scholarship: the decla- ration of belonging, purpose, and exclusion. Rather, my focus is on the "Here!" part of that sentiment, the ways that communities of writers tacti- cally make alternative spaces *by writing.*

These writing spaces communicate something on their own: from the seldom seen to the broadly visible, they articulate and call forth visions of a different rhetorical relationship to the city distinct from those spaces reflective of longstanding segregation, the preservation of historical and educational legacy, and neoliberal spatial restructuring. This production of alternative writing experiences, of what Lefebvre (1991) might call a "differential" set of writing spaces, is itself, for the purposes of this book, the politics of graffiti, and what we in writing studies might learn from it. Paula Mathieu, Steve Parks, and Tiffany Rousculp (2012) have noted that a primary challenge in assessing the effectiveness of community writing is "how to assess its impact, which moment in its travel from individual to writing group to public audience speaks most directly to its intent" (6). I see no such challenge here. The impact of graffiti, the message it com- municates, is, among other things, the space it produces for itself and the possibility for others to do the same. The "Here!"

In situating the impact of graffiti in these terms, readers will note that I am careful not to assign a single, resistive, or cooperative politics to writing or the spaces it produces. Doing so would homogenize what is in fact an immensely heterogeneous community: every writer I worked with on this project had a different perspective on the "why" of graffiti. I agree with Iveson (2017) that the politics of graffiti are mercurial, situated, and difficult to generalize. I agree, too, that we are best served theorizing "the diverse practices of graffiti and street art not so much as *confrontations with*

authority, but as *assertions of* authority" (89–90). The form these assertions take, and thus the politics of graffiti I am most invested in here, is the production of writing spaces that reflect core community goals like style, (in)visibility, preservation, mobility, revision, and others. Despite any overt political intention, the very presence of these spaces is itself a political act, a declaration of spatial multiplicity, that writing can play a fundamental role in the production of new and potentially more equitable rhetorical landscapes. By their very existence, these spaces critique the ways that more strategic writing spaces in Boston are distributed: from classrooms to billboards, from signage to corporate logos.

Yet these writing spaces do not exist just to counter, are not always in direct response to dominant spatialities in Boston. Rather, they are sustained by their own internal logics, vocabularies, politics, histories, and rhetorical potential. They assert, and announce, their own autonomy, their own spatial identity and DNA, distant from but connected to broader spatial politics in Boston. And while, as I note several times throughout this book, these spaces are not utopian or free from harmful exclusions, they do offer an alternative vision of a city and its writing culture, a constellation of writing spaces organized by community members written out of our larger literacy landscapes. In this sense, they do offer something to strive for, however imperfectly and incompletely.

In this centering of graffiti's writing spaces, I want to highlight some resonances between my work here and work on decolonial rhetorics and spaces while not claiming decoloniality for this project. Scholars of decoloniality have emphasized the political urgency of delinking spaces from larger networks of power and erasure. Malea Powell's (2012) celebrated address to the Conference on College Composition and Communication offered a decolonial working of space, as "made recursively through specific, material practices rooted in specific land bases, through the cultural practices linked to that place, and through the accompanying theoretical practices that arise from that place—like imagining community 'away' from but related to that space" (388). More recently, Romeo García and Damián Baca's (2019) work on decoloniality similarly invokes spatial multiplicity and distinction through the *elsewhere* and *otherwise*, "*where the possibility of new stories exist*" (3). This *where* of the decolonial

project is a site at which "the anthropoi reinscribe their position as the 'knowing subjects,' subjects that emerge from a local history of language, memories, and political economy and not just from the colonial European center" (4). Without this delinking, without this locating "elsewhere and otherwise, the hope of a world built on principles of pluriversality is difficult to imagine" (4).[6]

I want to be clear that I do not consider my project to be decolonial. As Eve Tuck and K. Wayne Yang (2012) have taught me, decoloniality cannot be a metaphor but, rather, must involve "the repatriation of Indigenous land and life" (21). My work here does not do that, nor do I necessarily see the writing spaces of graffiti doing decolonial work. By invoking decoloniality, I mean to acknowledge the important work on space happening within decolonial studies in rhetoric and composition and to identify potential points of connection between that work and my own: overlapping questions of power, where knowledge and community practices emerge, and the rhetorical, political, and cultural viability of writing's work in the elsewhere and otherwise. In centering the writing spaces of graffiti and rejecting blanket understandings of them—writing or crime, art or vandalism, legal or illegal, productive or destructive—I present space not as a finite resource to be divvied up, not as property to be exchanged or refurbished, but as a dynamic, malleable production through which groups of people develop histories, cultures, and identities.

The spaces the reader will find in this book exist somewhere else, alongside the dominant spatial narratives in Boston. They bump up against. They reverberate through them and reverberate themselves. In a way, they are the type of mirror that Foucault (1986) describes in his work on heterotopias, real spaces that bounce you from here (I am in this place) to there (I am also over there, in the mirror). Graffiti spaces at once announce their connection and their break. They are here, in Boston. Of that you have no doubt. But they are also over there. They also imagine

6. Included in García and Baca's collection is a chapter by Fatima Zahrae Chrifi Alaoui (2019), a fascinating study of political graffiti arising in Tunisia throughout the Arab Spring.

an over there. They insist that the Boston you've heard about, the Boston you think you know, is not finished. They are here, and they imagine different wheres.

Publics

Publics—discursive complexes always already arriving at shared interests and investments through the circulation of texts—are consequences of spatial productions that activate possible engagements: some limited to other, likeminded community members; others meant to be more broadly accessible. Connecting the above discussion of *where* to questions of publicity in this way seems crucial in our contemporary disciplinary (and political) moment. Our field's interest in public writing continues apace (Weisser 2002), even as the spaces for public writing continue to grow increasingly limited, privatized, or attenuated (Welch 2008). In this collision, graffiti writing offers us a community-based framework for thinking through the specific ways that writers with public ambitions must go beyond finding, expanding, or reforming writing venues. They must also consider how their writing might form new public venues (see Iveson 2007).

My work in situating public writing as a deliberate spatial act builds on work in rhetoric and composition on the relationship between space, publics, and writing. Most of this work has been concentrated within what Paula Mathieu (2005) dubbed the "public turn." From the beginning of this turn, scholars have looked to a post-Habermasian rendering of publics, moving beyond idealized notions of an inclusive and singular public sphere generated through rational-critical discourse (e.g., Weisser 2002; Wells 1996). To understand writing's role in public, we've looked to Nancy Fraser's (1999) notion of subaltern counterpublics, Oskar Negt and Alexander Kluge's (1993) proletarian public sphere, and, perhaps especially, Michael Warner's (2002) definition of publics as

> intertextual, frameworks for understanding texts against an organized background of the circulation of other texts, all interwoven not just by citational references but by the incorporation of a reflexive circulatory field in the mode of address and consumption. (16)

This notion of multiple, interested, and textual public spheres has led to a diversity of scholarship.[7] Indeed, I don't think it would be an overstatement to say that the public turn has transformed our discipline, from our objects of inquiry to the methodologies we employ to, perhaps most profoundly, *where* our work takes us. As our research and teaching has taken us into more diverse writing venues, we've come to understand publics not as preexisting sites of discourse but rather as consequences of rhetorical—and I would add, spatial—work. From Susan Wells's (1996) call that "we need to build, or take part in building" the publics we desire (326) to Laurie Gries's (2019) new materialist emphasis on "assembling publics," rhetoric and composition has been committed not to simply finding and engaging publics but to building them.

Where to build them—perhaps the fundamental question this book asks—has been the source of some confusion. I tend to agree with William Burns (2009) when he writes that discussions of public writing often "answer the what, how, and why of the public, but the significant question of *where* is the public is not always highlighted" (31). Addressing that question has required some inventiveness. For example, Nathaniel Rivers (2016) has developed a pedagogy he calls "geocomposition," which employs locative-media technologies like geocaching in order to move students outside of the classroom, to "write on the move in order to compose the multiple layers of a public place" (579). "Writing moves (in) the world," Rivers notes, and as public writing moves through space, it "shapes and becomes a part of the environment" (576). These environments of public writing are diverse, and the public turn has directed our attention to

7. See, for example, work on: (counter)public writing and pedagogy (Eberly 1999; Holmes 2016; Weisser 2002); community engagement and service learning (Deans, Roswell, and Wurr 2010; Mathieu 2005; Restaino and Cella 2013); public and counterpublic rhetorical theory, activism, and research (Ackerman and Coogan 2010; Asen 2000; Cushman 1998; Fleming 2008; Hauser 1999); community publishing (Goldblatt 2007; Kuebrich 2015; Mathieu, Parks, and Rousculp 2012; Parks 2010); community writing groups (Gere 1994; Moss, Highberg, and Nicolas 2004); community literacy (Flower 2008; Kynard 2014; Moss 2003; Pritchard 2017; Royster 2000); and the technologies, ecologies, and networks of public work (Rice 2012; Rivers 2016; Rivers and Weber 2011; Ward 1997).

meaningful writing happening in spaces like street papers (Mathieu and George 2009), community writing centers (Rousculp 2014), zines (Farmer 2013), and prison workshops (Jacobi 2011).

Within this landscape of community and public writing spaces, *The Writing of Where* builds most directly on existing work on the convergence of spatial and public thinking, work that regularly invokes the concept of "making space" for increased publicity. In "making space," I find that scholars often mean something like the need for writers to (re)claim or reform spaces for alternative public work. We see this quite literally in a chapter on graffiti by Donnie Johnson Sackey, Jim Ridolfo, and Dànielle Nicole DeVoss (2018)—"Making Space in Lansing, Michigan: Communities and/in Circulation"—which tells the story of street artists, graffiti writers, and others reclaiming an abandoned hotel in the service of a public art installment. The clearest articulation of "making space" comes from Nancy Welch (2008). Through a range of historical examples and contemporary pedagogies, Welch explores a fundamental irony that writers face within neoliberal spatial privatization: a lack of space to engage in crucial public argumentation to contest that lack of space (9). In a chapter titled "Making Space," Welch explores the obstacles that writers face as they attempt to go public, and in turn, the ways that writers locate space for public comment, often in ways deemed uncivil or beyond the pale.[8]

> What these moments from that semester also tell me is that *rhetorical space*—that is, public space with the potential to operate as a persuasive public sphere—is created not through good-intentioned civic planning or through the application of a few sound and reasonable rhetorical rules of conduct. Ordinary people *make* rhetorical space through a concerted, often protracted struggle for visibility, voice, and impact against powerful interests that seek to render them invisible. People *take* and *make* space in acts that are simultaneously verbal and physical. (93)

Welch and others direct us to consider ways to make space within, and against, larger arrangements, to find locations in which to mount a resistance. In this way, "making space" primarily means securing space to

8. See also Alexander, Jarratt, and Welch 2018; Meckfessel 2015; Welch 2012.

contest, making room within existing public-spatial landscapes, partition-ing off a space of our own in which our voices can be heard, spaces that open up the possibilities of persuasion, of revision, of change.

This book takes on a slightly different orientation to the question of where. If Wells (1996) argues that we need to make the publics we wish to participate in, and wish our students to participate in, *The Writing of Where* argues that we also need to build the public, community, and disciplinary spaces we wish to inhabit, that we wish our students to participate in. In both the ethnographic content it provides and in the multivocal structure it adopts, this book reflects a more interrelated, consociate relationship between public writing and space. That is, despite the importance of the work described above, I can't help but think that making space only gets us so far, only gets us to reform, to expansion. We don't just need writing space, after all. We need different writing spaces. Working with graffiti writers, I began to see "making space" as too two-dimensional, too flat, too generalizable to encompass all of the diverse spatial relationships and arrangements that writers develop in public. Let me give you a scene that might illustrate why a new framework is necessary.

It's 2016, and I'm getting off the Green Line train at the Hynes Con-vention Center stop. It's March and it's freezing. As I ascend the stairs from the subterranean station, I brace myself for the cold Boston air. "Only twenty minutes to campus," I think as I turn left out the door, shoving headphones in my ears, fumbling with my music, and wrapping my collar over my mouth. The streetlights are still illuminated. It's before 7:00 a.m.

From across the intersection of Boylston and Massachusetts Avenue, I see a white box truck parked in front of a convenience store. On the left, street-facing side, I notice a splash of green paint. I swing left on the sidewalk to get a better view. SENSE. I've seen pictures of this truck, flicks circulating after the writer's death, but I had never seen it in person. I later learned that the truck was a tribute, painted by one of SENSE's friends. I sprint past the overpass (we'll return here later in the book) and cross the intersection, ignoring the blinking red hand telling me to stop. On the opposite side of the street, just before another truck pulls out and obstructs my view, I slide to a stop and snap a flick. SENSE, still getting up and around in the city (fig. I.2).

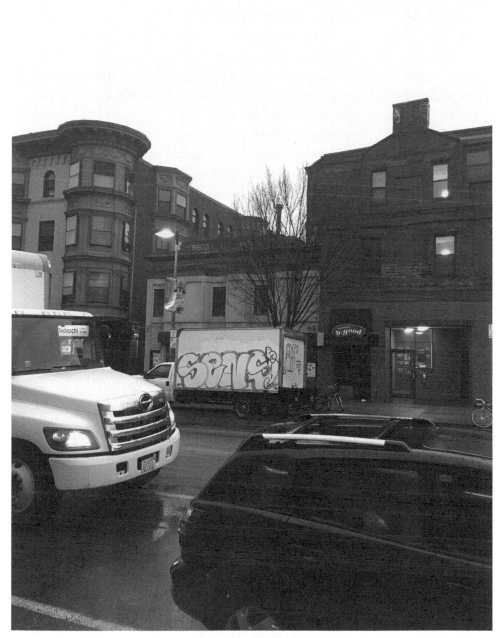

I.2 SENSE Truck. Photo by Charles Lesh.

A public writing space like the one this SENSE truck makes doesn't exist on the XY axis of the city and its rhetorical politics. It doesn't push the boundaries of appropriate public discourse, making space for itself within the large scene. It exists somewhere else, on the Z axis, in three dimensions, not just within, but on top of, around the way, bumping into, obscuring and revealing. It doesn't exist just to counter but to create something new entirely, somewhere over there.

In this way, these writing spaces find resonances with—though are importantly distinct from—the spaces that scholars of African American rhetoric have described. In her work on the Phenomenal Women, Incorporated, Beverly Moss (2010) draws on the work of Elaine Richardson and Jacqueline Jones Royster to note how "African-American women use their literacy skills and practices to create public and private rhetorical spaces for themselves and their communities" (5). Similarly, Vorris Nunley's (2011) work has traced Black spaces from hush harbors to barbershops, centering these locations not only as responses to white supremacy, but as locations directed by their own productive qualities and world making, built by and for Black rhetoric. This "not-so-public" quality is, according to Nunley, what makes these spaces so vital to the community (34). What I've learned from these scholars is a need to engage the specific models of community and public spaces that writers make for themselves, not always in response to hegemonic spatial formations, but on their own terms. The SENSE truck is geographically within, but rhetorically alongside, bumping-into-but-crucially-distinct-from more dominant writing spaces in the city. Graffiti writers make space, sure, in a general sense. But what's more, they make *spots*, they make *bibles*, they make *trains*. They make new publics and new *wheres* of public writing.

Reflecting on this scene, I'm reminded of a few of the questions Kathleen Blake Yancey (2014) once posed in *College Composition and Communication (CCC)*: "Where do we write? And what difference, if any, does the location of our writing make?" (5). Looking back at the SENSE truck, feeling the coldness of my breath through the picture, I want to ask different questions about public writing: "How do we write where? And what difference, if any, does our writing make on our locations?" This book provides one answer: that graffiti writing produces of a diverse range of

writing spaces that afford alternative forms of publicity in ways beyond expansion or revision. More ambitiously, I hope to open spaces for more answers, for more engagements and participation in the productions of other *wheres*. I hope we answer these questions not within our own framework of "making space," but rather in the vocabularies and theories of space found in actually existing communities and publics.

Writers

On January 3, 2007, the *Boston Globe* ran an article describing the work of a street artist called Pixnit. Through direct observation and interviewing, the article explains her philosophy on art and public space. The article contains interviews with area business owners, gallery curators, and Pixnit herself and offers a complex, and oftentimes contradictory, portrait of the ways that street art is either rejected ("Sometimes graffiti is graffiti.") or embraced ("On a formal level [Pixnit's work has] become more and more highly developed. It portrays a real sense of beauty."). Pixnit, the article argues, is not a typical graffiti writer: "She is a well-educated artist—not a rough-around-the-edges high-school drop-out—and her work is nuanced and dynamic. In person, she is articulate, often launching into long diatribes on the state of modern street art, and is astonishingly pretty, with a wide, off-kilter smile" (Shaer 2007).

Five days later, the *Globe* ran an article detailing the arrest of a graffiti writer in the Mission Hill neighborhood of Boston. Titled "Mission Hill Man Held in Weeks-Old Vandalism Case," the article has a celebratory tone around the arrest and, through interviews with urban officials and neighborhood residents (but not the writer), paints an entirely negative portrait of the role that graffiti plays in a community. The article ends with a quote from City Councilor Michael Ross: "It's a myth that there is some art component to it" (Ballou 2007).

The divergence between these two representations is not difficult to account for. Though graffiti and street art are classified the same legally, the receptions they receive can be notably different (Young 2012). Ferrell (2017), for example, has noted that while it is likely a "bit too cynical and simplistic," perhaps the distinction between graffiti and street art most pronounced today is that graffiti "is that which gets caught up in the panoptic

gaze of urban surveillance and street policing, and 'street art' that which is appropriated into new economies of urban consumerism" (29). On January 10, the *Globe* ran a letter from a Needham resident, who in part notes the slippage in terminology in the two aforementioned stories.

> In the first place, shouldn't the *Globe* have a consistent point of view concerning how it describes the same event? Can it really be that in less than a week an action has morphed from art to crime? (Daly 2007)

This episode reflects how meaningful distinctions between types of graffiti can be in Boston and elsewhere, that the ways we describe an act of wall marking has implications both for our own understanding of the rhetoricity of the event—what the writing does, the types of spaces it produces—and the reception it might receive.

In this book, the main focus is on graffiti *writing*, a specific rhetorical practice importantly distinct from other forms of wall marking, like street art, latrinalia, gang graffiti, and racist graffiti. Graffiti writing refers to name-based writing on urban surfaces that, while vacillating between legal and illegal spaces (both of which I examine in this book), maintains a particular and historically textured letter-based aesthetic foundation emanating from Philadelphia and New York City in the 1960s and 1970s.[9] The emphasis on the individual name belies the inherently collaborative nature of the enterprise, from the production of texts to their intended audiences. Writers write for other writers, primarily, with a secondary—and sometimes quite welcome—recognition that some texts will be encountered by unaffiliated readers. The graffiti writing encountered in this book participates in the production of alternative writing spaces and publics, as articulated above. In this sense, it runs counter to other forms of wall writing that might be encountered in cities, from corporate branding to racist graffiti, which, while still producing and sustaining (neoliberal,

9. Some scholars refer to graffiti writing specifically as "hip-hop graffiti," a nod to its perceived place as a central pillar within hip-hop culture. Others have taken issue with this designation, noting graffiti's evolution alongside, though not necessarily always a part of, hip-hop, as well as its more racially diverse earliest practitioners. For discussion, see Pabón-Colón (2018) and Snyder (2009).

racist) spaces, reproduce dominant spaces rather than offer alternatives. Distinctions between types of wall writing are not always neat, of course. For example, many of the writers in Boston I worked with on this project might move between street art and writing, and their work is alternately prized in situations of neighborhood change or vilified as urban decay. Still, the claims of this book are founded on readings of *writing*, even if street art does pop up from time to time.[10]

Scholarship on graffiti writing has been robust, as scholars in a range of disciplines have brought their own questions and methodologies to the study of writing.[11] Still, I find myself agreeing with Joe Austin's (2013) call for more work on the topic, or perhaps because of the topic.

> Compared with [graffiti] **writers'** collective output on any typical night, it's a very small stash of publications indeed. Compared with the barrels of ink spilled in consideration of the individual "fine" artists and art movements now occupying gallery and museum walls, I am at a loss to explain why my colleagues have not found **writing** more worthy of their research time. (para 2)

I share Austin's desire even more intensely within the context of rhetoric and composition. Despite the ubiquity of graffiti in both the streets and in academic literature, rhetoric and composition has produced notably little on the subject. In 1974, Frank J. D'Angelo wrote in *CCC* that scholars "seem to have barely touched upon [graffiti's] importance for the study of rhetoric" (173). Forty years later, Veronica Oliver (2014) notes the continued dearth of "detailed discussion placing graffiti as a rhetorical tradition spanning time and cultures, legitimizing it as a rhetorical tool against reductive notions of criminal acts and/or intentions" (66–67). In many

10. A recent issue of the *Boston Art Review* focused on public art has an interesting discussion of this distinction between street art and graffiti in Boston (Gray 2019).

11. Jeffrey Ian Ross et al. (2017) recently surveyed this burgeoning research across disciplines on street art and graffiti. Recent edited collections (Avramidis and Tsilimpounidi 2017; Förster and Youkhana 2015; Lovata and Olton 2015; Ross 2016) and special issues of journals (*City* 2010; *Rhizomes* 2013; *Visual Inquiry: Learning & Teaching Art* 2020) speak to the substantial scope of this research.

ways, graffiti writing has seemed almost entirely outside of our disciplinary purview, popping up in our literature from time to time but lacking the sort of sustained presence one might expect this ubiquitous rhetorical practice to have in a field invested in writing.

This is not to say that no work on graffiti has appeared in rhetoric and composition. In the 1970s, D'Angelo published multiple articles on the rhetoric of wall writing, the "crude drawings, inscriptions, and markings which appear on billboards, fences, and walls and various other kinds of writing surfaces" (1974, 173; also 1975, 1976a, 1976b). Since then, work on various forms of graffiti and street art has circulated in disciplinary venues, steadily if a bit scantly (e.g., Alaoui 2019; Cintron 1997; Cozza 2015; Edbauer 2005a; Haynes-Burton 1994; Lauzon and Cooke 2017; Lunsford 2018; Piano 2017; Rohen 2012). Taken together, this work has signaled an interest in graffiti, though sometimes in uneven ways. Still, as a field, we need more work, especially research that not only uses graffiti as an object of analysis but also talks to graffiti writers and works with them in the production of these writing spaces (Bruce 2019). This more collaborative, community-engaged approach to the study of graffiti might align more directly with our disciplinary emphasis on community literacy. In making the argument that writing directly produces a range of alternative writing spaces requires, to my mind, a more participatory, active approach than simply reading the writing on the wall. That is, to engage with the spatial productiveness of (community, public, academic) writing requires us to spend time in these spaces, to learn directly from those who produce them, and to engage in reciprocal partnerships even, or especially, in situations that might appear beyond scholarly landscapes.

The larger argument of this book involves us in ways not just theoretical but methodological. Understanding writing as spatially productive led me to seek out ways to partner with writers in the productions of these spaces, to leverage my own research to participate, in whatever ways I could, in the making and sustaining of these writing spaces. This will be evident throughout this book in my own presence and participation within these scenes of writing. Though, as I explain later, I don't consider myself a graffiti writer, my familiarity with the community and personal history with writing allowed me to play an active role in many scenes of

writing. This partnership is also present formally in the ways this book is composed. After each chapter was drafted, I circulated it to a set of writers I thought would be interested in its claims. Their responses—which range from interviews to photographs, essays to stories—are included in the Community Interlude sections directly following the chapters to which they respond. Each Community Interlude section is quite different, in length and content, and while I elaborate more on this process in "Warehouse," it is worth flagging here that my goal in composing the book in this collaborative way is to continue the work of writing's spatial production: that this book might create, in some way, its own space that calls forth a public and a consequent set of values in relation to the ethos of community partnerships in rhetoric and composition. That is, my hope is that this book might create a where, someplace other than current scholarship on writing.

Composing the book in this way caused me to reflect on the term "writer" itself. *Who gets to call themselves writers? Who do we in rhetoric and composition have in mind when we use that term?* While almost all scholarship on graffiti writing notes that, historically and contemporarily, producers of name-based graffiti refer to themselves as writers, this often does not go beyond a footnote or parenthetical explanation of word choice. Ella Chmielewska (2007), in her explicitly spatial "in situ" reading of graffiti in Montreal and Warsaw, makes this point quite clearly.

> Although signature graffitists insist on calling themselves *writers*, their practice is not commonly explored as writing. Even the term writers, when encountered in literature on graffiti, is often set in quotation marks (Stewart 1991). Yet the practice of graffiti is certainly that of writing. It involves language forms as much as it implicates graphic marks; ways of phrasing and those of forming letters; composing words and skillful use of tools to inscribe surfaces with markings; engagement with sound; and committed training of hand in penmanship, calligraphy, and typography. (149)

Taking the term "writer" seriously requires, to my mind, engaging with communities of writers not as case studies for our disciplinary theories of writing or rhetoric but as fellow theorists of writing. It requires us to engage

with their work as writing, and so while there might be, and indeed have been, immensely generative discussions of graffiti and street art based on notions of visual rhetoric—and surely some of my readings in this book are indebted to that work (see Gries 2015)—my work here it intended to explore graffiti, with graffiti writers, as *writing*.

On Writers and Writing

At the end of every interview I conducted for this book—between the years 2014 and 2019—I asked some version of the question: "Why do graffiti writers call themselves writers?" I was less interested in where the term came from; I knew that it originated in the earliest days of the culture. I was more interested in what it meant to writers in Boston, primarily, but also how their working of the term might challenge our own disciplinary understandings and enactments of it, which are still so tethered to the idea of the (student) writer emplaced in the classroom or other institutionally contiguous locations. The answers develop a nuanced, community-based theory of writing and writerly identity, one grounded not in the hallways of any academic discipline but in community spaces and histories, in the style that unites them into a public, and in the knowledge of a city and its writing traditions.

Before I discuss individual chapters, I want to make space for writers to share their thoughts on the significance of the terms writing and writer without interruption from me. These writers, and the others introduced in this book, have thoughts on writing, on the politics of writing, on what it means to be a writer, and what writing does and can do. My goal is to engage with these theories of writing and to take the term "writer" seriously.

> MYND: (Throws pen at Charlie) What do you do with it?
> CHARLIE: Write? . . .
> MYND: There you go. Now put your name up.

<p style="text-align:center">⸺⸺⸺⸺⸺</p>

> TAKE: I don't consider myself an artist. I'm a graffiti writer, and I
> like to draw. And I can draw. Writer is what we've always called
> ourselves, even when I was getting on. Even when you delve into
> graff, you have the different subclasses of the graffiti writer. You

have the taggers. You have the bombers. You have the style techni-
cians. But at the end of the day, we all write our name on the wall.
That's what it is.

MBRK: The term is important because writers, like you—write with
 words. And writers, like us—also write with words. That's where I
 think it derived from. And I think that's why it stuck. Even though
 there's people doing crazy pieces and dope murals with wild
 scenery and stuff like that—we all started just . . . writing. "Why
 did you write on that?" I think that's all it is. And it stuck. And as
 writers, we embraced it. "Yeah, you know what? I'm a WRITER."
 You can go deeper and say it's poetic but I don't think it's neces-
 sary. We just write on shit. It's writers because that's how it started.
 Wall writers.

RELM: Because that's what we do. We write . . . with style.

RENONE: I feel like it's because of your name. You're writing your
 name. You are learning to finesse a word that makes it artistic. So,
 that's why you call it writer. You don't say graffiti painter because,
 yes, you are, technically, painting but it's really the word that
 you're finessing. It's how you finesse that word, whatever you call
 yourself, whatever your tag is. You are freaking, finessing, making
 it into a piece of work, but it is just a word or two words. Whatever
 it is. I think that's why we tend to go with writer. It's because you
 are writing on the wall. You're in the act of writing, a stylized way
 of writing.

WERD OBS: I consider myself a writer because I love letters, you
 know? If I am just painting and shit, all I'm concentrating on is
 letters, and structure, and how this connects to that. I think it's a
 little bit more intellectual than just being a vandal. That's why I
 would consider myself a writer.

BOWZ: I think I am an artist with a tool, and my tool is writing.
You're not just practicing using a pen or whatever. You are using
that pen to write out a piece of calligraphy. What are the Muslim
calligraphists called? It's ornamental writing. Illuminators. Our
word for it is writing. We are writers. Yeah, I'm a writer.

LIFE: I guess that's why I'm proud. I'm rooted and stable in some-
thing. Something about me feels proud when I say I'm a writer.
Because I am writing mostly based in letters. It all came from
writing your name. This is who I am and I am going to say it. I
just think of a writer as fucking someone who really knows their
shit. They know their history. They know the writers before them.
They know their city's history. They know the ropes. They know
the etiquette. They know not to paint on mom and pop's shit.
They'll paint on something abandoned or city based, all the big
system and the big conglomerate.

SPIN: Writing the name. There's so many people, right? So, if you're
going to be that guy who puts up a quirky little character or
something, maybe if you repeated it enough times, people will
start to recognize it. . . . That shit gets forgotten in my mind unless
somebody makes a real impact writing . . . [Tagging] is the rawest
form of graff. The oldest form. That's what it was in New York and
Philly. You'd have a tag and you'd repeat it and you'd try to get it
up as many places as you can. That's the name of the game.

PROBLAK: Graffiti is letters. No questions asked. You can be a
graffiti artist. But are you a letter technician? Do you understand
the alphabet and the responsibility of it when it comes down to
being a graff writer? Writing is what charges and gets the respect.
It's the script. It's the scribe. DJs cutting up the words. You're
writing them. MCs rapping the words. You're writing them. The

B-boys are interpreting the beat. You're capturing it with a series of lines . . . But I think there is significance behind anybody that takes it very seriously, to be called a writer. It's just based off holding that tradition, through thick and thin.

———————

TENSE: The term *writer* is because graffiti was never our term. We never gave it. The government and politicians gave it that colloquial term. We never did. We're always called writers. Because we were writing. With whiteout pens. With a Magnum 44. With an Uni. With a friggin' Pentel. We were writing. We weren't graffitiing. We were writing. Literally, we were writing our name, but we were also writing a message. We were writing "Can't stop won't stop!" "The city won't sleep!" "From here to fame!"

I've probably written TENSE ONE a million times. Just writing, writing until my hand hurts. Sketching, doing throwups. We write. We are just writers. In the truest sense of it, we are writers.

No, we're not vandal graffiti artists. We're writers. We write. We're writing. We write our names all over the city. And you guys watch and you copy our handwriting and you put it on your business. Or you put it on your logo, or you put it on your van.

So that's why we're called writers. Because we are the epitome of the definition of a writer.

Overview

Like all ethnography, what follows is a "true fiction," as James Clifford (1986) calls it, not in the sense that it is made up, but rather that it is made and is "thus inherently *partial*—committed and incomplete" (6–7). *The Writing of Where* is not intended to be a history of graffiti writing in Boston. I am emphatic about that point. Like Austin (2001), I believe that any history of graffiti writing—or of any writing community, whenever possible—is a "history that is best left to the writers themselves to debate and record" (7).[12] Nor is it intended to be in any way comprehensive

12. For work on the history of Boston graffiti, see Gastman and Neelon (2010).

or representative of the entire writing community in the city. Like any other space created by writing, this book is not all encompassing. It represents one iteration of a community writing space, while recognizing that another network of writers, another researcher, would produce a different iteration of a community writing space. My goal here is to understand the spatial productiveness of graffiti writing in Boston, and to do so, I worked with, wrote with, and talked to a diverse group of writers knowledgeable about writing in the city.

To complete the mission presented here, *The Writing of Where* is organized around five chapters and four Community Interludes. It is organized spatially, moving the reader through, first, the larger rhetorical landscape of Boston and then through a variety of writing spaces produced by graffiti. Each chapter is named with a noun to indicate the primary writing space explored: Boston(s), Spot, Bible, Train, and Warehouse. The Community Interludes are named with verbs to reflect the collaborative and unfolding nature of their production: Piecing, Bombing, Blackbooking, and Benching. While each chapter is composed in multivocal ways—with interview data, fieldwork narratives, and examples of graffiti writing—these interludes offer direct, and sometimes differing, interpretations, reflections, and explanations of the spatialities of graffiti. In this way, this book is produced as a particular type of writing space not entirely dissimilar from the spaces I explore in it: a multivocal, sometimes messy, space where multiple voices and perspectives are shared, a space constantly being produced, debated, revised, and sustained.

Chapter 1, "Boston(s)," offers an archival sketch of dominant writing spaces in Boston, particularly as they relate to, and are positioned against, graffiti writing. I argue that antigraffiti rhetoric must be understood within the larger rhetorical production of space, how a city seeks to situate all writing within or outside dominant narratives of place. To model this, "Boston(s)" is organized around four narratives (Melting Pot, Athens of America, Cradle of Liberty, and New Boston) to show how these place-based identities—and their relationships with the city's persistent racial segregation, cultural and educational legacy, and neoliberal restructuring—are mobilized in newspapers, laws, antigraffiti campaigns, and elsewhere in the production of a cityscape hostile to graffiti writing.

Chapter 2, "Spot," explores the public writing spaces, or "spots," that different genres of graffiti writing produce in Boston, spaces that exist elsewhere from the dominant urban politics explored in chapter 1. Walking through a range of different spots, I show how a disciplinary reorientation away from "making space" toward "making spots" signals a more direct link between writing and alternative spatial productions. I focus on two primary genres of graffiti, bombing and piecing, and consider the different social spaces and writing experiences produced by these orientations to urban life.

Chapter 3, "Bible," focuses on a different sort of writing space: graffiti blackbooks, referred to in Boston as "bibles." A graffiti bible is a notebook that, while individually owned, is produced as a community writing space through its circulation and use within groups of writers. Organized around three coterminous writing spaces housed within the bible—the practice page, the traveling gallery, and the talismanic archive—this chapter considers the bible as a crucial countergeography of writing, one produced by writers as a space to practice, circulate, and archive writing.

Chapter 4, "Train," considers how writers in Boston produce and sustain trains as writing spaces reflective of larger community attitudes toward circulation and mobility. Writing on or near trains in a city like Boston is inevitably tied up in the mobility and immobility of bodies, perhaps most evident in the busing and school desegregation events of the 1970s. Against that backdrop and invoking theories of circulation and mobility, this chapter examines the various mobilities that trains afford writers: the literal, physical movement of texts on rails; the representational value; and the embodied experience of movement. This chapter examines the varied and oftentimes obscured ways that writers continually make and remake trains as real and imagined community writing spaces within situations of significant opposition.

Chapter 5, "Warehouse," tells the story of writing this book and also of what I hope it will mean to readers. This chapter details the methodology of this study and its stakes for community-based research, teaching, and partnerships in rhetoric and composition. I recognize that some readers might want to engage with this chapter before reading the others, and if so, I encourage them to do just that. In placing this chapter last, however,

my hope is that the spaces of graffiti remain foregrounded in the readers' minds, and that the fluid and emergent nature of the tactical community partnership represented here is reflected in the formal construction of the book. "Warehouse" revolves around two writing spaces: an abandoned warehouse in Quincy, Massachusetts, and a bench in Opelika, Alabama. In the warehouse, I consider the ways this study came together methodologically, as well as my own identity and history with graffiti writing. I detail and reflect on the intersections between partnership and ethnography and further explain the production of this book and its Community Interludes. At the bench in Opelika, I reexamine the writing spaces explored in this book and position them as a provocation to teaching and research in rhetoric and composition.

1

Boston(s)

We can never walk into a cityscape that has not already been
inscribed by others and that is not always already inscribed on us.
Richard Marback (2003, 143)

Boston

On an October day, I'm standing around the counter at Kulturez with
WERD. He begins to tell me about the challenges faced by graffiti writers
in Boston. "There are a lot of kids out here who, because of how things
are set up, burn really bright for a short amount of time and then you just
never see them again." Why? I ask. "Boston hates graffiti."

This isn't the first time I've heard this phrase. Meeting writers, inter-
viewing writers, writing with writers, this phrase was a regular refrain,
a sort of mantra on the risks of writing. Within it, writers identify an
antagonism and distinction between themselves and Boston, the city's
name standing in not only for a geographical location but also for the
social, legal, and rhetorical forces conspiring in the production of space
inhospitable and often hostile to graffiti writing. *The way things are set
up.* And it's not that one group hates graffiti. It's that *Boston* hates graffiti.
The brevity of the phrase belies its complexity. In it, writers identify what
confronts them: not an easily identifiable agenda opposed to graffiti but
a diverse, overlapping, often overwhelming mass of texts, attitudes, and
urban governances that, in messy union, work to limit rhetorical oppor-
tunities. Hating graffiti means more than distaste. Rather, to borrow from
Welch (2012), it involves a wide-ranging effort to *"curtail* rhetorical spa-
ciousness," to limit opportunities for the production of alternative writing
spaces (36).

To this point in the book, I've framed graffiti as productive of alternative writing spaces that draw forth different public arrangements, exemplary of spatial production and multiplicity rather than expansion and revision. But before we get to these emergent spaces, they first need to be situated within the context out of which they arise: Boston. Or more precisely, these writing spaces need to be understood as an alternative to some *thing*, connected-but-distinct-from some *where*. This need is reflective of my larger desire to ground conversations on the contexts of, and limitations on, public and community writing within the specific conditions of place. Writing always already exists within the context of multiple, often contradictory, spatial productions, and we need to spend more time understanding those productions to understand the risks and rewards of particular iterations of public and community work.

To that end, here I read representations of graffiti across diverse strategic venues: local newspapers, legal codes, antigraffiti campaigns, reporting tools, and more. In these readings, I construct a portrait, albeit a limited and sometimes fragmented one, of dominant literacy landscapes in Boston intimately connected to segregation, historical legacy, citizenship and education, and neoliberal spatial restructuring. If graffiti writers are engaged in the production of writing spaces, I argue that so too are urban authorities and concerned citizens whose reactions to graffiti reveal the state of writing in the city: what is welcome and what is not. This results in what Alison Young (2014) might call Boston's "legislated city," a version of space "in which a particular kind of experience is encapsulated and produced through the regulation of space, temporalities and behaviours" (41). To use language familiar to those of us in rhetoric and composition, here we see a writing space where writing is "permitted in designated areas only" (Brodkey 1996). In the texts examined here, and in many others, an urban space is written and attitudes toward writing activated. This is a story about place and writing.

Of course, I am one of many writers to recognize that graffiti exists within various and increasingly complex wars (e.g., Austin 2001; Dickinson 2008; Ferrell 1996; Iveson 2010b) and "moral panics" (Kramer 2010) over urban space. That these conflicts are also rhetorical, that they are ultimately about persuasion over the appropriate uses of space, has not

gone unnoticed. Tim Cresswell, especially, has found that reading popular representations of graffiti can help us unpack something about the values and ideologies of the larger space: that in graffiti's transgressive nature, it reveals, often in strategic texts, the normative values of place. Cresswell (1996) finds graffiti in early media coverage, mostly in the *New York Times*, "referred to variously as garbage, pollution, obscenity, an epidemic, a disease, a blight, a form of violence, dangerous, and a product of the mad, the ghetto, and the barbarian" (37). This in turn ingrains in the civic consciousness an understanding of graffiti as a disorderly threat not just to the materiality of the city but to the idea of the city itself as a place of order.

In an attempt to unpack those larger attitudes toward writing, here I read representations of graffiti in Boston within and against larger place-based narratives of the city. While Cresswell focuses on the metaphors that often get associated with graffiti, I examine how entrenched narratives of place are mobilized in or against moments of rhetorical divergence, like graffiti. In this way, I situate this "war on graffiti" as a very specific war of writing (and) space: a war over who gets to produce the writing spaces of a city and infuse them with meaning. The challenge is how to construct this portrait of Boston, this relationship with literacy to which graffiti provides alternatives. In other words, I had to start by asking: How is Boston, as a writing space, defined?

Boston is an old city. Settled in 1630, it has since its inception played an almost paradigmatic role in the shaping and reshaping of American identity. In *The Hub: Boston Past and Present*, Thomas O'Connor (2001) organizes this history around four prominent identities: Melting Pot, Cradle of Liberty, Athens of America, and New Boston. Sifting through the data for this chapter—through the various invocations of "graffiti" I gathered in newspaper archives, on street signs, in legal codes, and other venues of strategic public texts—I was struck by how these narratives of place O'Connor convenes continually popped into my head, how frequently graffiti is positioned as an implicit threat to these renderings of Boston. I came to see these identities as more than a way to organize the history of the city, etched in historical stone. Rather, I came to see them as very much alive, mobilizing and morphing at times when Boston makes sense of, and often rejects, changes to its writing landscape.

Not that change comes easily to Boston—it never did. Indeed, it was when confronted with change that Boston all too often displayed a mean and selfish spirit that belied its reputation as the Cradle of Liberty and the Athens of America. Proud of its intellectual accomplishments and conscious of its cultural preeminence, Boston seldom welcomed any sort of change that would threaten what it has so carefully built. (O'Connor 2001, xii–xiii)

Graffiti, I learned, is a bold example of that change that is not welcome.

In what follows, I trace this production of dominant writing spaces through these narratives, using them loosely—and, to be clear, decidedly differently than O'Connor—to structure the chapter. In the Melting Pot, we see writing spaces of banishment and division rooted in and reflective of longstanding segregation in the city. In the Cradle of Liberty, we see writing spaces that resist revision, a product-based rendering of Boston's role in the larger American story. In the Athens of America, we find writing spaces reflective of the city's relationship to citizenship and education, disciplining any writing, like graffiti, that threatens that legacy. And in New Boston, we find the neoliberal spatial politics of the city as they relate to writing, a drive toward commodification and frictionless mobility for capital. These narratives overlap, of course, and occasionally conflict. But as they are deployed, I find them aligning in the production of dominant writing spaces in which graffiti cannot be situated and thus must invent alternatives.

Melting Pot

As a spatial metaphor, a melting pot is a "place where different peoples, styles, theories, etc., are mixed together" ("melting pot," *OED*). It's a metaphoric whisking of elements, once distinct, now united by some common bond. These bonds are often place- and ideology-based, as is the case in the United States, where the metaphor holds significant civic importance. The melting pot serves as a rhetorical framework for making sense of the forged connection points between diverse peoples, cultures, and ideas.

It's not hard to see why the metaphor of the melting pot took hold in Boston. For one thing, significant abolitionist activity occurred here. It

was here, after all, that William Lloyd Garrison printed the first issue of the *Liberator* in 1831. Originally thought by Mayor Harrison Gray Otis to be nothing more than inconsequential antislavery extremism, the paper would prove monumental in its effects on the abolitionist movement nationwide (O'Connor 2001, 111–12). Events like these, and many others, generate a reputation, a "story of Boston as center of northern resistance to slavery," a story about the city that "stresses a commitment to freedom for all and a racially egalitarian city" (Doran 2015, 54). A *melting pot*.

This is the melting pot as aspirational narrative. But it is also a revisionist one, and to understand the *where* of Boston, it is important to understand how the Melting Pot constructs writing spaces of boundaries and banishment of difference. Unlike multiculturalism or identity politics, the melting pot foregrounds singularity and assimilation, while obscuring multiplicity and difference. To melt is not to celebrate but to render realities of difference invisible. Realities such as persistent segregation, which runs immediately counter to the aspirational idea of the melting pot and the image it strives to project: a racially equitable city or, at least, one where race doesn't matter. In 2017, the *Boston Globe* ran a series by The Spotlight Team titled "Boston. Racism. Image. Reality." The articles probe the ways that race, racism, and inequity intersect with pillars of the city.

> But this much we know: Here in Boston, a city known as a liberal bastion, we have deluded ourselves into believing we've made more progress than we have. Racism certainly is not as loud and violent as it once was, and the city overall is a more tolerant place. But inequities of wealth and power persist, and racist attitudes remain powerful, even if in more subtle forms. They affect what we do—and what we don't do. (Johnson 2017, para. 9)

In the face of such persistent inequities, the narrative of the melting pot becomes both indispensable and untenable in the preservation of the status quo. It's indispensable in preserving an image of the city as welcoming to all, despite evidence to the contrary. It's untenable given that evidence of longstanding segregation and divisions by race, class, and neighborhood.

These contradictions—a melting pot with rigid boundaries—cast a shadow over the writing spaces of the city. As graffiti writing, by not

abiding by entrenched boundaries and borders, insists on a public discussion of the appropriate place of people and texts, it exposes these fault lines by asking questions like: *Where is the place of writing? Why not here?* In turn, the Melting Pot sets graffiti up as writing that is *un-melt-able* and thus out of place. This displacement of graffiti outside of the Melting Pot works in two fundamental, if seemingly contradictory, ways: (1) graffiti as a threat to the harmonious urbanism that the Melting Pot implies, and (2) graffiti as a threat to the spatial divisions that have persisted in the Melting Pot. That is, within the writing spaces of the Melting Pot, graffiti is positioned as a threat to both togetherness and division, incompatible with the egalitarian image Boston seeks to project and the reality of a divided city.

Take for example a 1973 *Globe* article, "The Curse of Graffiti" (White 1973). Published during the explosion of writing in New York, the article is notable not only for bemoaning graffiti in Boston but also for its accompanying image (fig. 1.1).

The swastikas on the can and wall clearly depict racist public writing and appeal to the commonsense notion that neo-Nazis and other purveyors of racist ideologies do not belong in Boston's public spaces. *Melting Pot*. And yet, the article condemns *all* graffiti, from "local fools . . . writing their names in public places" to "individuals who go around spray painting Gay and Women's Liberation slogans on public buildings, monuments and walls."[1] The swastikas, then, inform a particular attitude toward all unsanctioned wall writing: that the spaces it produces, and the bodies that produce them, must be excluded from Boston. That racist wall writing stands in as the example only further reinforces this banishment, and in this way the absent body in the image is profoundly present, allowing a flexible, fill-in-the-blank urban anxiety. No matter who holds the can, no matter what they write, it is incompatible with the unity of the Melting Pot. It therefore must be excluded, banished to someplace else. Graffiti "can be amusing," the article's author admits, just so long as it is "in its place."

1. Jeff Ferrell (1996) has noted that negative public attitudes toward graffiti are often cultivated by collapsing discrete forms of wall writing under the umbrella "graffiti" in order to "obscure our understanding of the specific social and cultural contexts in which particular forms of graffiti evolve" (5).

AT LARGE / By DIANE WHITE

The curse of graffiti

Fools' names as well as faces
Are often seen in public places —

<div align="right">Anon.</div>

We first heard that little aphorism in a ninth-grade ancient history class, but of course we were too young at the time to appreciate its wisdom and probably too busy, too, what with carving our initials in our desks and writing clever sayings on rest-room walls.

But now that we're older we've come to see the truth in it. Not that we need much prodding to do so. All it takes is a turn around Boston Common or a quick trip on the Harvard-Ashmont MBTA line to see that fools' names are more in evidence than ever these days. Our history teacher, were she here to see it, would be outraged.

Graffiti is supposedly an ancient habit. Archeologists have found gamy sayings scrawled on the walls in the ruins of ancient Pompeii. Buts its venerability makes it no less offensive.

We feel equivocal and hypocritical saying so, but graffiti can be amusing, in its place. And its place, if anywhere, is on the insides of telephone booths and on the walls of public conveniences. We've been delighted by some of the wall writings we've found in ladies' rooms, things like "Leda was for the birds" and "Paranoia is a state of heightened awareness!" And we once noted with great pleasure that the one piece of graffiti inside a telephone booth at the Ritz was the simple notation, "Locke-Ober's — 542-1340."

1.1 "The Curse of Graffiti," *Boston Globe*, 1973. From the Boston Globe. © 1973 Boston Globe Media Partners. All rights reserved. Used under license.

So where is the place of graffiti in the Melting Pot? Outside of it, I've found, as other cities—New York and Philadelphia, primarily, the birthplaces of American graffiti—appear constantly in these representations as spatial harbingers if Boston does not remain fortified in its war on writing. It's interesting to note that in his work on representations of early New York City graffiti, Cresswell (1996) notes that one of the ways that graffiti is positioned as out of place is "by associating it with other places—other contexts—where either the order is different and more amenable to graffiti or disorder is more prevalent" (37). In Boston, these other places are New York and Philadelphia, the imagined writing spaces where graffiti might find a home, somewhere else. Not in Boston. Graffiti writing, these representations scream, might be in Boston. Surely, you've seen it. But it is not, and cannot be, *of* Boston.

This recurring presence of New York and Philadelphia—particularly in relation to trains, which I address at more length in chapter 4—signals a desire to preserve an urban identity uniquely Boston and not of the writers. In the aforementioned article, "The Curse of Graffiti," the author writes, "In Boston the problem is not nearly as serious as it is in New York and Philadelphia." In a 1975 article, "Boston Graffiti—1975 Edition," a Parks Department general superintendent is quoted as saying that the graffiti problem in Boston, the result of "paint-gun artists," while substantial, has not quite reached crisis level: "I never saw so much in my life as I saw in Philly. Even private homes were marked up. And in New York they had to keep armed guards around Grant's Tomb to keep people from writing on it" (Sweeten 1975). A 1985 article notes that while there has been a notable uptick in "N-Y style graffiti" in Boston, the problem is "still a far cry from New York, where subway cars are festooned with brilliant colors and ornate designs, and no wall seems safe from a furtive squirt of paint" (Kindleberger 1985). In a letter to the *Globe* published in 2000, a native New Yorker now living in Nevada discusses a recent trip he took to Boston.

> To prevent Boston from looking like New York, I suggest you immediately initiate a zero-tolerance policy that is strictly enforced and made known to the youths of Boston . . . Graffiti invites criminal activity, lower real estate values, and the cleanup is a waste of tax dollars . . .

If Boston became known as a city that is tolerant to graffiti vandalism, the vandals would come from across the country to leave their individual marks.

Boston must resist the spread of graffiti; it must build borders. If not, it becomes another city. It becomes a place where writers come from *somewhere else*.

It feels almost obvious to note that in these appeals to other places where graffiti might belong, the writers themselves are racialized as other, un-Boston and outside of the Melting Pot. As Cresswell (1996) notes, locating writers elsewhere is deeply racialized, with writing not just considered "out-of-place because it is misplaced figuration; its 'otherness' is also connected to its assumed source, the ethnic minorities of urban New York" (43). Though graffiti in Boston has undergone demographic shifts and rifts in its history, it remains a racially diverse community of writers, a reflection of graffiti's history more broadly.[2] I was conscious of this diversity as I conducted this research, aware that as a white man in the field, and in the archives for this chapter, I run the risk of erasing this diversity in ways that reflect my own identities and privileges. I knew that the ways that writers are represented, in books, articles, or the mainstream texts examined here, have implications for the larger production of writing spaces and whether those spaces are equitable or exclusionary, something I discuss at more length in "Warehouse."

To see how writers are frequently racialized out of the Melting Pot, we need look no further than the word "vandal" deployed above. Young (2005) notes that referring to writers as vandals "aligns them with the barbarian horde who bring chaos and destruction to the gates of the city (with our cities being imagined as 'Rome,' centres of learning and tradition)." The response of the enlightened city "required to these vandalistic threat is defence: exclusion and eradication" (58). The invading writers, a trope that borrows from well-established racist border rhetorics, pose a threat to

2. See Gastman and Neelon (2010) for Boston (278–79); Snyder (2009) for subculture history more generally (2–4, 29).

the togetherness of Boston and to the ability to write, define, and protect borders. If the Melting Pot implies a writing space of togetherness, graffiti's perceived threat requires, ironically, the building of more walls.

This border-walling does not stop with appeals to other cities. In a memorable Ann Landers (1978) column published in the *Globe*, Curious in Upper Darby (again, a town just outside of Philadelphia) writes, "The graffiti in and around the city seems to be the work of someone from *another planet*," to which Landers replies that she, "too, [has] wondered who the graffiti freaks are and how they manage to 'decorate' the city unobserved" (emphasis added). In other words, graffiti might exist somewhere else, outside the Melting Pot. Indeed, it must. Philly. New York. Maybe Mars. But it does not belong here.

To accomplish this displacement, spatial boundaries, especially between the suburbs and the city, are continually invoked, the bodies of writers continually racialized, to create resentment toward and among groups of writers. This works both ways. Suburbanites are told to fear the spread of graffiti into their communities in articles with titles like "Graffiti Mars Suburban Views. Peer Pressure a Tactic in Fighting Back" (Vigue 1994). More often, though, graffiti writers are represented as entitled, privileged, white suburbanites entering urban spaces to write, as is the case in a 1993 article titled "Suburban Kids 'Bomb' City Graffiti Scene."

> "They call it bombing the ghetto," explains Sgt. Nancy O'Loughlin, head of the MBTA's Vandal Squad, which has arrested 60 writers since it was formed this summer to crack down on the resurgence of graffiti. "They drive in from Milton or Duxbury or Somerville, usually groups of six or more, 98 percent of them white, they paint whatever they can, and then they screw. Why do they do it?," she sighed. "They want to be black gangsters because that's the thing to do right now." (Jacobs 1993)

Here we see Blackness being weaponized to cultivate a fear of mobility while simultaneously erasing Black writers' sustained presence in the community. A 1997 *Boston Herald* article about graffiti replicates this racist rhetoric, titled "Graffiti Gangsters: City Battles Army of Spray-Can Artists." In the article, writers are said to "travel from their suburban towns and cities to 'ghetto blast' or 'bomb' inner-city Boston neighborhoods to

earn the 'prop,' or respect, they crave from displaying their 'work' in high-profile locations" (Donlan 1997).

These borders, defended in part by representations like these, also rely on strict graffiti laws, an active vandal squad, robust antigraffiti campaigns, and removal (or buffing) programs. For example, PART IV, Title I, Chapter 266, Section 12B of the General Laws of the Commonwealth of Massachusetts offers a definition of a "tagger" as an individual who "sprays or applies paint or places a sticker upon a building, wall, fence, sign, tablet, gravestone, monument or other object or thing on a public way or adjoined to it, or in public view, or on private property." Notably broad, this action-based definition collapses a vast array of different rhetorical acts under a common legal code, thus expanding its applicability. It also contains a notable absence: "A police officer may arrest any person for commission of the offenses prohibited by this section without a warrant if said police officer has probable cause to believe that said person has committed the offenses prohibited by this section." By removing the warrant, the law allows police officers to more flexibly enforce a policy to eliminate graffiti by criminalizing proximity to a particular piece of writing, by presence within a particular space or neighborhood. Within the space of the Melting Pot, writing graffiti is a crime, and proximity to the spaces it produces are enough to warrant police suspicion and action.[3]

To further prevent community from forming across boundaries, the Melting Pot must immobilize writers to prevent that aforementioned border crossing. This is not an abstract thing; it is immediately evident in the graffiti laws: "Upon conviction for said offense the individual's drivers license shall be suspended for one year." This entwinement between graffiti and driving was done, seemingly, with the explicit intention of preventing interneighborhood mobility.

> That is why the state's tough vandalism law, passed three years ago with
> a maximum 3-year jail term, delays teens prosecuted for vandalism from

3. Alison Young (2014) has a more robust discussion of the consequences of this warrantless search policy in a similar graffiti law, Victoria's Graffiti Prevention Act (112).

obtaining their driver's licenses, Fleming said. "We figured with subur-
ban kids, if you take their cars, they're done." (Donlan 1997)

It's in these moments that we see an almost perfect opposition between
the city imagined by graffiti and a city imagined by the Melting Pot. It is
not just the graffiti itself that is criminalized but the circulation of writing
and the bodies of writers. In these moments of legal backlash, a fractured
rhetorical space is produced, one that relies on division to eliminate, or at
least limit, opportunities for unsanctioned public writing.

Who enforces this image of the city? Among others, the aforemen-
tioned vandal squad, a subset of law enforcement known nationally and
internationally as particularly strict in punishments of writers. Recently,
the *Globe* has reported that "the graffiti battle is big enough to keep four
city employees working full time in the field" (MacQuarrie 2017). Names
of individual cops circulate like urban legends, and these individuals have
advised other cities on antigraffiti measures and helped write the graffiti
laws in the state, widely considered "among the strictest in the nation"
(Woolhouse 2018). Along with the exploits of individual cops and the
lengths they will go to ensnare writers within legal webs, the vandal squad
has bolstered its reputation through a long line of high-profile arrests, both
of Boston writers and of writers visiting the city.

When a prominent out-of-town writer was arrested in Boston in 2008,
she was described as a member of a group of "terrorist taggers" and a
"globe-trotting graffiti goon," two deeply racialized descriptions that spa-
tialize her out of the boundaries of the Melting Pot (Sweet 2008). Another
out-of-towner arrested was Shepard Fairey, famed street artist best known
for his Obama "Hope" poster.[4] On February 6, 2009, Fairey was on his
way to the Institute of Contemporary Art (ICA) in South Boston to a sold-
out event commemorating the kickoff of his exhibit, *Supply and Demand*.
Fairey had spent the previous days in Boston and, on February 4, had even
met and taken pictures with Mayor Thomas M. Menino. On his way to
the ICA, in a taxicab, Fairey was pulled to the side of the road and arrested
on an outstanding graffiti-related warrant (Cramer and Ellement 2009;

4. For work on rhetoricity and circulation of "Obama Hope," see Gries (2015).

Valencia and Shanahan 2009). Fairey's arrest led to him publicly apologizing, paying a $2,000 fine to a neighborhood group, and vowing to never carry tagging materials in Suffolk County, except for use in sanctioned shows (Ellement and Ryan 2009). Other writers have spent time in prison, done countless hours of community service, and paid exorbitant amounts of money once they have been caught up legally. This enforcement produces a certain spectacle of discipline around the rhetorical boundaries of the city.

These spectacular approaches to graffiti enforcement extend into graffiti removal efforts, most notably the "Graffiti Busters." The city's official graffiti removal taskforce, the Graffiti Busters has, according to its website, "removed graffiti from more than 1,000 locations in the City of Boston" (City of Boston 2019). Naming the city's graffiti removal program "Graffiti Busters" invokes *Ghostbusters* and the spectral feeling of invisible or incorporeal writers illicitly altering the cityscape. In this appeal to the supernatural, writers are, again, outside of the Melting Pot: not from this world but belonging to another. It's useful to recall Michael Warner's (2002) definition of publics as being composed of strangers, not in the "foreign, alien, misplaced" sense of the term but as "already belonging to our world. More: they *must* be . . . They are a normal feature of the social" (75). As ghosts, graffiti writers are literal strangers, as not belonging to this city, as an abnormal, and therefore dangerous, feature outside of the public.[5]

This appeal to the supernatural is not confined to the Graffiti Busters. In 1980, the *Globe* ran an anonymously authored article titled "Acts that Vanish," a striking piece that expresses a curiosity with the appearance of graffiti writing and the notable lack of appearance of the writers themselves. Noticing a writer named "ZOLLO," the author of the article writes, "But the art is not as interesting as the artists. Think a moment: Have you ever seen them?" The ways that writers can go unnoticed signals

5. Ferrell (2017) also describes the ghost-like nature of the writing processes of graffiti writers: "Graffiti and street art are in this sense ghosts in the machinery of the contemporary city" (33). It's also worth noting that in graffiti parlance, a ghost is a wall that has the remaining traces of graffiti after the wall has been buffed or the paint has faded with age (Kindynis 2019).

something larger, and potentially more troubling, about urban space: its multiplicity. "Perhaps," the author writes, "it is that all of us are weaving our way through an elaborate time warp. But why don't our weavings ever coincide?" The *wheres* of graffiti, visible yet distant to Bostonians, collide and contradict with ideas about the city and its writing, as if of two different worlds. While the figure of the absent and potentially time-and-space bending writer might be a curiosity here, it can also cause alarm. Perhaps the most striking of these representations is a 2006 article, "Back Bay Neighbors Draw a Line on Graffiti." In the title, we see the sort of line drawing, boundary demarcation that puts graffiti and the reactions it provokes in tension with the Melting Pot mythology. The article begins with a bang.

> They strike at night. While Back Bay sleeps, the vandals creep around the parked Volvos, Audis, and Lexus sport utility vehicles and toward the elegant brick buildings. In white, black, and neon-green paint, they leave their mark in the alleyways. By morning, when dwellers of this historic neighborhood wake up and head to their cars, they find out who has been on their property. (Cramer 2006)

In the horror-laced rhetoric and intense protection of the propertied class, graffiti is represented as posing a unique and singular threat to the neighborhood lines of the city. In light of this, *lines must be drawn.*

The ways that the Melting Pot is mobilized against graffiti in these representations is complex, multifaceted, and slippery. The Melting Pot purports to present a space of blending and togetherness and uses that image to justify exclusions and boundaries. The contradictions are brought to bear in attitudes toward writing: that all writing belongs in a particular place, and some writing always belongs somewhere else. As writers produce new writing spaces that don't adhere to these same networks of mobility, they are confronted with this tension. In this sense, these representations do get one thing right about graffiti: the writing spaces that graffiti imagines, don't belong in, or to, the Melting Pot.

Cradle of Liberty

Boston's role in American history is singular. Reminders of this legacy dot the city in the ubiquity of monuments, plaques, statues, and other

material references to Boston's role in the authoring of America. This corner is where Griffin's Wharf once sat, site of the Boston Tea Party. Don't step on the seal at the corner of State and Congress. That's where the Boston Massacre occurred, 1770. That stone obelisk visible from the Orange Line? That's the Bunker Hill Monument, commemorating a battle fought in 1775. These monuments, and many others, are a source of pride among residents and visitors alike, arguments for the city's "irrepressible spirit, bent toward freedom and equality" (Doran 2015, 54). This is the Cradle of Liberty.

Carole Blair's (1999) work on the materiality of rhetoric and monuments asks us to contend with what texts do rather than simply what they mean, and what these reminders of the Cradle of Liberty do is produce particular writing spaces that extends a rhetorical sensibility over the city (23). "Memorial sites," Blair notes, "by their very existence *create communal spaces*" (48).[6] And within this communal space, an official identity and a sanctioned telling of Boston's history is told and affirmed. Beneath that affirmative quality, however, is a prohibitive one. In telling a particular story of space, memorials and monuments can often times shrink, rather than expand, rhetorical spaces. Lefebvre (1991) recognized that monumental spaces are never simply "a sculpture, nor a figure, nor simply the result of material procedures" but also active participants in determining "what may take place there, and consequently by what may not take place there (prescribed/proscribed, scene/obscene)" (224). Monuments, memorials, statues, plaques. Each signal something that has happened there, what can happen there, and what cannot be allowed to happen there. They affirm and reject, build and prohibit. What is being memorialized is written, these spaces announce, and future writing in this space challenges not only the material supports for public history, but the history itself.

The writing spaces of the Cradle of Liberty resist revision to this history, and thus these monuments serve as valuable rhetorical locations (*topoi*) in stoking antigraffiti sentiments. As monuments are never just

6. For more work on public memory, materiality, place, and monuments, see Dickinson, Blair, and Ott (2010); Sanchez and Moore (2015).

hollow material but part of an active process of writing identity and history, then graffiti's irrepressible drive to revise and rewrite threatens that production. If the Melting Pot produces writing space of banishment and division, protecting longstanding urban boundaries, the writing spaces of the Cradle of Liberty rejects revision, protecting histories of the city through a control over the writing that circulates.

It's worth noting at the outset that graffiti writers have a fairly strict code that includes not writing on any piece of urban space that carries significant historical value. Some writers do not adhere to this rule, of course, and at various times during this study, writers did overstep this boundary. But these were exceptions, and though many writers are hesitant to assign "rules" to graffiti, most share a broader code of (spatial) conduct. BAST tells me, "You respect people's houses. Don't fuck with shit that has some kind of civic meaning or historical import. You just don't do that shit."[7]

Despite this, mentions of graffiti in mainstream press, often editorials or letters to the editor from concerned citizens, situate it as a threat to these spatialities of history and identity, particularly its role in American history. "We were appalled at the trash and graffiti in Boston," one writer submits, "and consider the Freedom Trail a disgrace to the nation" (McCarthy 1979). Another, taking note that "many of the statues in the Boston Garden were covered with graffiti," writes that though "some Bostonians may take these monuments and edifices for granted, I assure you they are very meaningful to Americans elsewhere" (Wood 1981). These references span decades. In May 2017, the *Globe* ran an article documenting graffiti that appeared during renovation on the Longfellow Bridge. The article bemoans the writing on such an iconic structure, with its salt-and-pepper towers, its name a reference to Henry Wadsworth Longfellow's "midnight musings on its wooden predecessor, the West Boston Bridge."

> The Longfellow Bridge was intended to be more than a target [for graffiti] when it opened in 1906. Instead, the half-mile span, initially called the Cambridge Bridge, embodied the Brahmin ethos that Boston was a cultured city of world-class ambition. At the time, the bridge's

7. For the "rules," see Ferrell and Weide (2010, 54–55), and Powers (1999, 154–55).

construction was designed to show even Boston's public infrastructure
would be stamped with grandeur. (MacQuarrie 2017)

In these public references to graffiti, citizens read of the underlying threat
graffiti poses not only to the materiality of these spaces but to the grand
and ambitious history they memorialize, a history deeply woven into
the American story. Boston remembers. Graffiti revises and, eventually,
obliterates.

The Cradle of Liberty gets mobilized in moments of potential revi-
sion. The city's history becomes prominent in representations of graffiti,
a (singular) history that must be defended (against other histories). As just
one illustration of this mobilization, I want to pull in a brief example from
my fieldwork.

Located in Brookline, the Coolidge Corner Theatre is an indepen-
dent, nonprofit theatre that has been a staple in the community since its
opening in 1933 (Quinn n.d.). From 1977 to 1989, it was owned by Justin
Freed. During this time, Freed put on a diverse range of programs that
reflected his interests in film, jazz, and art; in a 2009 profile in the *Globe*,
these years are described as the "halcyon days" of the theatre ("Justin
Freed's . . ." 2009). One of these events was the premiere of *Wild Style*, an
early hip-hop film instrumental in bringing graffiti and hip-hop culture
to a broader audience. I first heard of this premiere, and some community
backlash, when talking with BAST in an early interview I did for this
book. Intrigued, I visited the theatre shortly after. In the basement by the
restrooms, I found a small display that commemorated the event, along
with invitation to find additional images of the event on Flickr and an
email address for Freed, whom I contacted and interviewed at his Brook-
line home.

In 1983, the theatre, along with the Orson Welles Theatre in Cam-
bridge, premiered *Wild Style*. When Freed began the process of plan-
ning the event, the film's management company contacted him. "They
said, 'We're going to send this crew up to do publicity. How about if they
paint a mural on the outside of the theatre?'"[8] The crew sent to promote

8. This episode is mentioned in Gastman and Neelon (2010, 128–29).

1.2 Wild Style at the Coolidge Theatre. Photo by Justin Freed.

the event would prove legendary: Fab Five Freddy, TRACY 168, LADY PINK, and LADY HEART. The group ended up staying in Boston for a week, promoting the opening and doing publicity. And painting. To generate interest in the film, the group produced a mural on the west-facing side of the theatre (fig. 1.2). The group also painted a mural at the Orson Welles Theatre, which burned down in 1986 after popcorn-machine oil ignited.

Freed remembers this time with excitement and fondness, telling me stories of Freddy bringing his boom box into radio stations for interviews and a spontaneous trip through Boston's neighborhoods in search of "fuel for inspiration." All along the trip, Freed was there, along with his son Michael, documenting with his camera.

> FREED: I just loved them. We had the greatest time. I mean, you can see in some of the pictures I'm acting like a total fool.
> It was just very, very fun for me to be part of this energy and this new wave of doing things, this new approach to expressing

one's self in an environment. It was just a delightful time until they had gone back. About a week later I started to get complaints.

The complaints were about the new mural at the Coolidge. Many residents of Brookline did not see the mural as becoming of the neighborhood or of the history embedded in the theatre.

FREED: The town fathers, whoever they were, said it was a public nuisance. The mural was on the side. If you go along the alley, it was just a clean, beautiful thing.

CHARLIE: [looking at pictures] It's such a great wall.

FREED: It was a perfect spot for it, and I refused to remove it. Then they were going to fine me, and they were going to put all kinds of sanctions on the business. It was a "shame on them" kind of situation. It was really stupid. I'm just really glad I chronicled what I did.

CHARLIE: How long did you go back and forth with them until you eventually just buffed it?

FREED: A couple of weeks. Then they were tightening the screws. It was a losing battle.

CHARLIE: What about the community around the theatre?

FREED: You know, this whole hip-hop culture was very new to the scene. I didn't have a groundswell of support for it. It was a bizarre thing for this community. It's just a shame that it went down that way.

CHARLIE: You talked about them turning the screws and eventually getting you to erase it. I guess I'm asking why they described it as a nuisance.

FREED: A public nuisance.

CHARLIE: I would just like to hear your thoughts on their motivation behind removing it, or if you remember anything else from your interactions with them.

FREED: It was like I was defacing public property. And, "Even though that's your wall, it's a public wall." Boston's a very puritanical place. This represented anarchy to them, and it was frightening to them. "Let's keep Brookline nice! Let's keep those people out! We don't want to attract what that stands for." That's as best as I can go into their mindset.

Despite the immediate backlash to the sanctioned writing, the event was discussed in several outlets at the time. A major piece was published in the *Globe*, a feature on LADY PINK titled "Graffiti Is Her Business," accompanied by a picture of LADY PINK completing the mural on the side of the theatre. The profile details the nineteen-year-old writer, from her brand of feminism (". . . she fancies herself as tough and independent, succeeding in a male-dominated medium") to the prices her legal works fetch ("'My works go for $5,000 and down,' she brags, 'and I'm working on doing better.'") It also mentions the wall: "The Coolidge Corner work is full of jubilant squiggles, slogans, and rudimentary figures. The Sistine Ceiling it isn't. We all know that, but, the question remains, is it art at all?" (Temin 1983).

In the response to the Coolidge episode, we see both an official and unofficial answer. The question of art, at least in this case, seems largely decided by assigning words such as "squiggles" and "rudimentary."[9] It's not the Sistine Chapel, that much is clear. But, more importantly, it has no place in our neighborhoods, no place on landmarks like the Coolidge. No place in, or on, our history. And in this rejection, we see how the Cradle of Liberty is mobilized to resist revision, to reject alternative writing spaces, and to structure a theory of writing that is permanent, unalterable, *product not process.*

This attitude about writing—which graffiti, at its most fundamental, rejects—must be taught, must be instilled. From here, we have to visit writing spaces perhaps most familiar to those of us in rhetoric and composition: classrooms. We have to visit the Athens of America.

Athens of America

According to "Boston by the Numbers 2020," a report by the Boston Planning and Development Agency, the city is home to thirty-one colleges, universities, and community colleges. In 2018, 139,000 students were enrolled in four-year colleges and universities, and another 13,500 were enrolled in the two community colleges. The report also notes the high

9. For the significance of "squiggles" used as an assessment of graffiti, see Young (2005, 56).

rates of education among residents, with 51.4 percent age twenty-five or over holding a bachelor's degree or higher (Boston Planning & Development Agency, Research Division 2020, 17). Along with neighboring Cambridge, home to Harvard University and Massachusetts Institute of Technology, Boston is an educational hub. It has been so throughout its history. In 1635, Boston Latin School opened, the "oldest public school in America with a continuous existence" (O'Connor 2000, 37).

The concentration of schools, its educational history, and its rates of education cohere in Boston's reputation as the "Athens of America," a cultural and political narrative that positions the city on the cutting edge of training sophisticated, sensible, and productive citizens. This has its roots in the city's seventeenth-century founding, when Governor John Winthrop, as part of his vision of a "city upon a hill," was committed to designing institutions that would "foster the kind of education and learning that would ensure that the religious and moral principles of the Puritan colony would be carried well into the future (O'Connor 2001, 15). Along with its schools, its museums and libraries, from the Museum of Fine Arts to the Museum of Science to the iconic Boston Public Library, Boston has all the makings of a modern Athens: a city with resources for the training of informed citizenship.

As part of this narrative, schools become central material and metaphorical writing spaces, places and symbols of Boston's continued role in educating citizens. Schools are writing spaces that instill the discipline that the Melting Pot and the Cradle of Liberty rely on. They are where students are taught how to write and where writing should be, the appropriate styles and places of writing. And so it is in relation to schools that the Athens of America is most directly mobilized against graffiti and the writing spaces it produces, spaces that stand decidedly outside of this academic disciplining of writing and space.

This mobilization is done, primarily, in two ways: material and curricular. Materially, graffiti is a threat to the institutions themselves, in ways not unlike the monuments of the Cradle of Liberty. Graffiti's presence threatens the materiality of schools and, through this, their Athenian function: a sign that schools have grown so run down, students so unruly, that they cannot possibly be effective in cultivating desirable forms

of citizenship. As just one of many examples, a 1982 *Globe* article titled "Undoing Vandals' Work" describes the deterioration of English High, where nearly "every square inch of wall space in corridors and stairwells is covered with graffiti—obscenities, racial epithets and student names." The article is accompanied by a photograph of a student painting over graffiti and a quote from Kevin McCluskey, School Committee president: "You would need a custodial staff of 45 just to keep up with the energy students put into vandalism and graffiti" (McCain 1983). Graffiti in schools is a sign of disorder, of misplaced energy, of a youth out of control in one of the places meant to instill discipline. Writing should be happening here, of course, but writing in its place.

Because schools are where students should be learning the appropriate place of writing, graffiti also reflects a curricular breakdown. For example, in 1984, a mural of Frederick Douglass in the South End was painted over, prompting the *Globe* to run a letter by a concerned citizen contemplating the connection between this act and the education system more generally.

> This giant mural, a portrait of Frederick Douglass, ex-slave and famous Abolitionist, was painted by resident artists Arnold Hurley and Gary Rickson in 1976. This work of art has been profoundly admired for its significance for community relations and for its excellence as art . . .
>
> Why has some misguided, possibly ignorant and careless person committed such willful destruction to our effort to eliminate racism and work toward the benefit of all people?
>
> I have heard that graffiti art is being taught in a school in the South End. Could it be that a condescending attitude of some well-meaning educator has contributed indirectly to this mindless destruction? (Swan 1984)

In this episode, we see the Cradle of Liberty, the Melting Pot, and Athens of America converge in the production of a writing space inhospitable to spontaneous writing. The writing over the mural is read as a blow to racial harmony. It is read as a threat to the city's history. But perhaps most alarmingly, it is read as potentially stemming from our schools. If schools are teaching graffiti, then schools are not teaching students to know their place, to understand the appropriate places of writing. A 1987 article titled

"Students Write in Classroom, Not On Walls" celebrates a South End school "once covered with graffiti," proudly displaying "the talents of its students with paper and pencil instead of a spray can," the result of a "bring the graffiti inside" school initiative (Rothenberg 1987). Curriculum, and the sanctioned spaces of writing, restored.

Representations of graffiti in or around schools spiked in the 1970s, during "busing," a series of school desegregation policies prompted by a June 1974 ruling by Federal Judge W. Arthur Garrity Jr. These representations often focus on racist graffiti. I consider school desegregation and these representations more directly in chapter 4, but one example here is worth repeating. From an October 1974 article titled "Boston, Busing and Leadership":

> When South Boston High let out last Friday, 150 State Police were on guard as the whites trooped out, the buses pulled to the curb and the blacks came out and into the buses. Graffiti scrawled on walls a block away smelled like Selma, Ala., in another era: "This is Klan country, N[. . .]ers drop dead." (Evans and Novak 1974)

Just like graffiti writing must be from New York, where it belongs, racist graffiti must be from somewhere else, too: Selma, where it belongs. Graffiti becomes the rhetorical vehicle for writing that threaten Boston's reputation as a city cultivating enlightened citizenry. Whether it's the threat that graffiti poses to the materiality of the buildings themselves, the racial tensions it exposes around schools, or the curricular breakdown it foretells, graffiti is incompatible with the Athens of America, with the writing spaces it cultivates, one where writing and writers know their place.

New Boston

In 2011, the *Boston Herald* ran an article titled "Pike Tagged for Trouble," in which city and state officials discuss responses to the damage done to Boston's reputation and economic prospects by the persistent graffiti that appears alongside the Massachusetts Turnpike.

> "It's disrespectful to have graffiti at the entranceway to the Hub," said City Councilor Matt O'Malley. "I wish whatever punks are doing it

would show some more class and knock it off, because this is the great-
est city in the world. We need to make it a clean and welcoming place,
and that sends the wrong message." . . .

The Pike scribbling sends an ugly message to tourists and out-of-
staters traveling the main thoroughfare into the Hub, said former Pike
board member Mary Connaughton.

"This tarnishes the gateway for our fine city," Connaughton said.
"It's an eyesore that erodes civic pride and should be banished from the
urban landscape." (Crimaldi 2011)

Graffiti here is a sign of a larger political and economic breakdown, one
that might deter future investment and tourism that relies on a cityscape
that communicates order. Invoked in this way, graffiti threatens the place-
based narrative of New Boston. Broadly understood, New Boston is a nar-
rative of renewal and progress, one that has continually surfaced in the
political rhetoric of the city since the late nineteenth century. Persisting
today, New Boston renders the city in a perpetual state of innovation,
rejuvenation, and progress (Doran 2015, 54–55, 72). Gaining significant
traction when it was invoked by John B. Hynes in the 1949 mayoral race,
New Boston continues to surface strategically to establish confidence in
the political and economic institutions of the city (O'Connor 2000, 228).

Meghan Doran (2015) has written that New Boston also serves an
effacing function; when instances of urban trauma—such as busing and
gentrification—run counter to what New Boston promises, it adjusts,
smoothing over the cracks in the façade.

To repair this disruption—to hold onto the image of a liberal, egalitar-
ian city, the [busing] crisis itself has become a part of the new Boston
narrative. The city remains on the verge of new-ness—always almost
diverse, cutting-edge, and transparent. The new Boston is defined vis-à-
vis the old which in turn yields a prescription for what lies next. The old
Boston—racist, corrupt, parochial—needs deep introspection and full
reform, while the new Boston—tolerant, transparent, innovative—need
only be tweaked to continue its march toward progress. (73)

As Doran notes, when New Boston renders a city on the up and up, it simul-
taneously classifies unwanted urban perils as part of an "Old Boston." If

neoliberal New Boston is "transparent," then Old Boston is paint covered and opaque, unable to deal with problems, unattractive to investment.[10]

New Boston, like other neoliberal processes, works to privatize space and eliminate any differential qualities. In relation to writing, this involves eliminating texts that perform juxtaposition or irony, buffing in the service of projecting order and spatial transparency. Of course, (writing) space is never actually transparent, devoid of politics or obfuscations, but is rather presented as transparent to disguise arrangements of power. Within these arrangements, texts like graffiti, writing that reveals borders and presents the possibility of new spaces, must be buffed. This process is what Lefebvre (1991) calls "abstract space," capitalist spaces that eradicate difference and present a façade of similitude, working to "grind down and crush everything before them, with space performing the function of a plane, a bulldozer, or a tank" (285). Within this logic, any aspect of urban life that invites questions of its interested nature—*Who wrote that? What does it say? Why did they write that? Why can't they write that here?*—must be elided to make the streets smoother for residents, for capital, for gentrification, for corporate development, for New Boston.

Given this, it might seem a bit strange to say that within the writing spaces of New Boston, writing opportunities abound. Unlike the Melting Pot and the Cradle of Liberty, New Boston produces the opportunity for new writing to continually enter the cityscape. But these opportunities are reserved just for those with the capital to afford the space. As Young (2005) has written, "For the contemporary city is awash in signs: the city swims in signage at a depth far beyond any that graffiti writers could achieve" (71). For those with property rights, applying names to space via signage is a process authorized and regulated in strict detail, all to render the city (ostensibly) orderly and *New*. The Boston Planning and Development Agency provides an exhaustive series of guidelines for adding a new sign or replacing an existing one. For example, the guidelines for Downtown Crossing, a shopping and business district, include a range of charts, graphs, maps, and lengthy sections of technical language in order

10. For documentation of this turn from so-called old to new, see Botticelli (2014).

to "clarify the effectiveness of sign advertising for individual concerns and also improve the visual quality of the Downtown Crossing neighborhood" (Boston Redevelopment Authority 2011, 7).

This emphasis on "visual quality" is significant here; as Ferrell (1996) has argued, when authorities make appeals to desirable style, they inject an "aesthetics of authority" into urban space, a "sense of beauty grounded not only in control of property and space, but in the carefully coordinated control of image and design, in the smoothed-out textures of clean environments" (180). "Aesthetic discipline," as Maggie Dickinson (2008) calls it in her work on neoliberal restructuring in New York and its crackdown on graffiti, is part of neoliberal spatialization, in that it limits "who is allowed to initiate projects in the public sphere and who is not," an exclusion "tied to common conceptions of race, class, gender, and youth" (40). Maintaining an institutionally sanctioned way to name space produces writing spaces that visualize discipline and control the rhetorical opportunities available to writers without property.

Digging deeper, an individual interested in naming space learns that each neighborhood has unique guidelines in order to "ensure that storefronts and signage complement the surrounding neighborhood while still allowing business owners to express their individuality and promote their goods and services" (Boston Planning & Development Agency n.d.). That is to say, signage guidelines not only enact a control over urban naming; they also enact a rhetorical differential, a visual means of establishing differences between neighborhoods. In visually signaling difference, genres like the signage guidelines further naturalize specious distinctions, an urban segregation that is, as we've seen in the Melting Pot, immediately connected to the mobility of individuals, groups, and texts. By instilling an aesthetic discipline—one that correlates to neighborhood segregation—the city presents neat, ordered, transparent writing spaces: New Boston, open for business.

It is within the context of New Boston that I have to do that thing that most books on graffiti have to do: mention the broken windows theory. When graffiti writing challenges an ordered rhetorical landscape, as it is wont to do, authorities often invoke broken windows to further position graffiti as a threat to New Boston and its privatized writing spaces.

Formulated by James Q. Wilson and George L. Kelling (1982), the idea of the broken windows theory, and the policing strategies it inspires, is that seemingly small quality of life crimes in the aggregate create spaces more attractive for additional crime. As such, every effort should be made to eliminate these infractions, like buffing graffiti, before they accumulate.

Boston itself has a long history with broken windows. Through figures like William Bratton—former commissioner of the Boston Police Department and chief of police for the Massachusetts Bay Transportation Authority, as well as the chief of the New York City Transit Police and New York City Police commissioner—Boston was an early and enthusiastic embracer of Kelling and Wilson's work.

> "We in Boston not only embraced [broken windows] back then, but we've expanded on it since," says Police Commissioner Kathleen O'Toole. (Brook 2006; see also Kaplan 1997)

Despite the significant impact of broken windows in Boston, a 2015 *Globe* article critical of the theory quotes a lieutenant detective as saying that the Boston police no longer practice broken windows policing, focusing instead "on community policing and gathering information about serious offenders in the city" (Cloutier 2015). Still, as part of the rhetoric of New Boston, it is important to recognize broken windows as a persistent and pervasive narrative in the production of, and justification for, ordered, neat, and privatized writing spaces.

> "I just wish they'd get a canvas," said Allston-Brighton City Councilor Mark Ciommo. "It's the broken windows theory. It makes a neighborhood . . . look unsafe, and if it's not addressed, then people seem to be invited to increase their bad behavior." (Ciimaldi 2011)

If New Boston requires the production of clean, transparent writing spaces, then graffiti writing, or any form of unsanctioned writing, not only portends violence but slows the economic and political prospects of the city and thus must be (re)moved to a canvas, to some*where* else.

It is worth noting that the broken windows theory has been widely discredited in academic research for failing to establish causality and for

concerns with study design (e.g., Harcourt 2001; O'Brien, Farrell, and Welsh 2019). Interestingly, Boston-based researchers have played a significant role in challenging the theory (e.g., O'Brien and Sampson 2015). Graffiti writing, specifically, presents challenges to the assumption that low-level infractions lead to more serious crime. Graffiti challenges this in myriad ways, whether through its presence in "cool spaces" of consumer consumption (Snyder 2009); its foundational differences with other acts of "disorder," such as stone throwing (Young 2005, 62); its production of a "liquid" city that rejects the fixity of urban space so fundamental to broken windows (Ferrell and Weide 2010, 60); or its distinction from gang membership, despite persistent conflation between the two groups, as we see in the above representations (Bloch 2020).

Still, despite these challenges to the core tenets of the theory, broken windows remains entrenched as a means to read urban space and graffiti. Crucially, as Ferrell and Weide (2010) note, "The broken windows model has succeeded in enforcing and exacerbating the existing marginality of homeless populations, people of color and other long-time urban residents" (60). Indeed, in his work challenging the evidence, theoretical foundation, and the rhetoric of broken-windows policing, Bernard E. Harcourt (2001) has noted the "increased complaints of police misconduct, racial bias in stops and frisks, and further stereotyping of black criminality" (7). In this way, broken windows mobilizes and further concretizes divisions within the Melting Pot, perpetuating segregation and the construction of sociospatial difference in urban environments.

Once graffiti is positioned as a threat to the potential future of the city, it is relatively easy to enlist a general public in the eradication of writing. The writing spaces of New Boston must be protected by a type of concerned citizen, a figure mobilized by antigraffiti campaigns that situated writing as a detriment to the quality of life in the city. This is not to be confused with Rosa Eberly's (2000) work on "citizen critics." The concerned citizen here, though frequently cast into the role of critic, forecloses, rather than expands, writing space. This citizen mobilization is evident in the countless antigraffiti letters to the editor and op-eds, some of which I've explored here. It is also clear in a wave of antigraffiti posters I saw circulating in 2016 (fig. 1.3).

I found some graffiti, it's not even good
Case #101001413953

GRAFFITI

BOS:311
File a complaint...
or a critique

To report graffiti
download the BOS:311 app
Mayor Martin J. Walsh

1.3 The Critique of Graffiti. Photo by Charles Lesh.

Fundamentally, posters like this pit graffiti writers against other urban inhabitants in a debate over appropriate uses of space. Nonwriters are asked to place graffiti on a value spectrum, good versus bad, and make an assessment of the writing based on that criteria. Not exactly the most pedagogically sound rubric. But the rubric's intent, of course, is not sound assessment but, rather, a material and discursive challenge to the graffiti writer's claim to space shrouded in a quasi-academic appeal to aesthetic or rhetorical deficiency. What "good graffiti" might entail is likely sanctioned graffiti, murals that, as Iveson (2007) puts it, "reinscribe a respect for private property relations, and the consequent control by owners over the appearance of public spaces in which they are located" (135). The assessment of writing implied in this poster has little to do with an actual assessment of writing; that would require community knowledge, locally honed. Rather, the assessment is entirely spatial, on designations imposed on it not by the writers but by the externalities of private property and permission.

This poster also invites urban dwellers to become part of a citizen network to eliminate graffiti through police reporting, to produce and preserve the writing spaces of New Boston. This, like the rubric, in academic language: "File a complaint . . . or a critique." In their role as critics, individuals reporting graffiti, and other quality-of-life violations, take part in effectively diffusing the disciplining of urban spaces across residents as part of everyday life. This diffusion is articulated clearly in the first line of the city's official graffiti removal form, which residents fill out to remove any piece of illegal writing from a public or private property: "WHEREAS, the City of Boston (the "City"), in furtherance of the best interests of the residents and business communities within the City, has initiated a City-wide effort to remove graffiti from public places and privately owned properties" (City of Boston 2021). As citizens take up these texts and produce their own in response, they are taken up into a specific argument about "best interests," about the interests of "residents" and "business communities" aligning. It's side-taking, but it's also space-making (see Dryer 2008).

Participation in this spatial production is supported by a significant digital infrastructure. As referenced in the poster, Boston 311 is a reporting service for nonemergency issues provided by the City of Boston since 2015

(Herndon 2015). The 311-type programs have been rolled out in cities nationwide to more directly connect urban inhabitants with authorities. From Boston 311's website:

Help make Boston more beautiful

BOS:311 enables real-time collaboration with citizens, "deputizing" mobile users to become the city's eyes and ears. Citizens report pot-holes, graffiti, and other issues from anywhere in the city using their mobile phone. ("View Reports" 2021)

Citizens are explicitly drafted as police proxies, deputies, in the fight against graffiti. That citizens are encouraged to report these unsanctioned texts via cell phone (calling, tweeting, reporting through an app, or sub-mitting a form) further situates it within the neoliberal orientation of New Boston. Available on the App Store and Google Play, 311 allows citizens to photograph, report, and take action on graffiti in ways not unlike calling an Uber, ordering delivery, or texting a friend. As concerned citizens report cases of graffiti, 311 displays images of the writing to a list of outstanding reports. These reports are publicly visible, and once the city removes the graffiti, it posts an image of the removal. In compiling and curating this large repository of writing and buffs, the city confirms the concerned citi-zen's ability to produce its textual landscape.

Beyond the centralized repository of 311, antigraffiti actions by citizen enforcers take the form of neighborhood groups and associations—with names like the "Graffiti NABBers"—that work alongside city officials to rid certain neighborhoods of this urban blight (Sanfeliz 2008). Even more locally, individuals are often celebrated in the mainstream press for their work removing graffiti. The *Globe*, for example, has routinely published stories of groups, often students (Athens of America), removing graffiti from their neighborhoods, schools, or other locations. The newspaper also publishes stories of individuals engaged in antigraffiti campaigns them-selves, situating buffing as a selfless act of citizenship. One notable exam-ple of this lone-buffer rhetoric is Michael Dukakis, the former governor of Massachusetts and presidential candidate, who is said, in several articles, to take an individual approach to graffiti removal (e.g., Mooney, Cassidy, and Phillips 1999). New Boston relies on this dispersal of authority, that

the production of spatial transparency is not just the work of authorities, but the work of everyday citizens, and Michael Dukakis. We all have a role to play in eliminating writing (spaces), these representations argue, in making a landscape open and amenable to capital, open and amenable to gentrification, one that announces that the city is well in control by an efficient and productive governance.

It can be difficult to tell where the limiting of writing spaces originates. What these representations have been successful in instilling, though, is a general hostility to graffiti, what it represents, and its perceived threat to urban viability. This brings us back to where we started: *Boston hates graffiti*. Recall the Longfellow Bridge article referenced above (MacQuarrie 2017). The comment section is, in my admittedly unstructured reading, representative of comment sections on many articles on graffiti. It shows a general public hostile toward writers, fantasizing about forms of punishment.

> TWENTY1TWELVE: Caning. Like in Singapore.
>
> GEOBRAINTREE: Not strong enough . . . I say cut off the hands of anyone who is caught like they do for stealing in other countries. No repeat offenders!
>
> HANSORIBROTHER: Shoot a few while they are in the act. Of course you need to record the shooting on video. Actually you don't need to really shoot a tagger, just make it look like it.
>
> DEWITT CLINTON: The solution to this problem lies in the return of the guillotine. I think a public execution, on the bridge, would be an excellent deterrent. Off with their heads!!!
>
> RIGHTON1: Spray an explosive coating on the granite, if there is such a thing. You might get a few instances of graffiti, but that will stop shortly.

Though these responses are no doubt hyperbolic—and there are several responses that defend the writers, and more that, at least, do not want them executed—they are far from unique. They reflect the continued viability and volatility of antigraffiti sentiments in the city, one carefully cultivated and legislated for decades, often to the benefit of those with warrant and permission to write. The writing spaces of New Boston are

ones of property and permission, of order and discipline, where writing is allowed if it corresponds to economic and political prospects.

Bostons

Each of the narratives explored here interpenetrate to form larger, dominant writing spaces in the city, normalizing and controlling literacy opportunities, protecting and perpetuating particular histories, legacies, and economic and political prospects. Yet it is important to note that, like the graffiti community itself, these attitudes are not fixed in time. Graffiti writing is a longstanding but constantly evolving set of writing practices that have boldly challenged Boston's public spaces for decades. Even as street art and forms of legal graffiti become more accepted, accessible, and well-financed in Boston (Whyte 2019), the residue and the continued mobilization of antigraffiti rhetorics persist. Graffiti writing still has no place within the writing spaces I've sketched here, and it is in this very place-less-ness that allows us to uncover something about the rhetorical politics of the city more generally: what writing is welcome, what writers are welcome, and how identities of the city are constantly being produced and reinforced through writing.

And yet, as I argued earlier, the rhetorical work of graffiti is not dedicated to finding a place. Graffiti, as I see it, does not reform, revise, or expand the Melting Pot, Cradle of Liberty, Athens of America, or New Boston. Rather, it imagines new constellations of writing spaces, new venues, participants, and outcomes of rhetorical work that might, together, reinvent the city along new narratives of place. These new spaces force a recognition that the commonsensical nature of Boston's writing spaces is merely illusory, masking the contractions and multiplicities always already inherent here. Graffiti writing reveals other cities of writing, other writings of *where*, "enfolded within the legislated city" explored here, different spaces and places that provide different ways of being and writing (Young 2014, 52). Graffiti writers, that is, also write Boston. Or, more specifically, they write Bostons.

I mentioned in the introduction to this chapter that I hoped the reader would find more here than a story about Boston and graffiti, that it would

also be a story about place and writing. As I constructed this portrait of Boston, the field of rhetoric and composition never seemed too distant. In 2000, the *Globe* ran an article documenting Peter Elbow's impending retirement from the University of Massachusetts, Amherst. The article outlines Elbow's approach to freewriting, and it came up in my research because of the first sentences: "Professor Peter Elbow is a pro-graffiti kind of guy. He encourages students to 'make a mess'" (Goldscheider 2000). Of course, freewriting is not graffiti, and I can't speak to whether or not Elbow appreciates graffiti writing. I hope he does.

But in this moment, it's interesting to ask how those of us in rhetoric and composition answer the questions posed by graffiti. If Boston responds to graffiti in ways that reveal its larger theories and values of writing and space, then the ways that rhetoric and composition answers the question of graffiti seems to be a similarly generative location to unpack our values of writing. We are, after all, responsible for and complicit in many of the classrooms that dot the Athens of America. We are a field that continually teaches students the appropriate places of writing, the rhetorical situations to which they must respond. Freewriting in a classroom is not graffiti, but perhaps it is as close as we get in our most routinized teaching strategies. Frank Farmer (2013), in his work on anarchist zines, writes that when we introduce alternative genres of publicity into our writing classrooms, "we create an opportunity to introduce students to an alternate vision of democratic participation, a different understanding of *publicness* that they are unlikely to find in our institutions, our textbooks, and, for the most part, our pedagogies" (88). These alternate visions might run counter to the Athens of America and our role in it. I take this up in more detail in this book's conclusion, but it is worth flagging here that, in this Elbow example, when graffiti does appear in our classrooms, it is ridded of its resistive and productive spatial qualities, placed within and policed by the margins of dominant academic discourse. It's just another way to teach writing, in its place.

I want to close on one last representation of graffiti, as it sets up the work of this book from here on. In 1971, just as the graffiti movement was gaining serious momentum in New York, Philadelphia, and other cities, the *Globe*, as part of its "Book of the Day" series, ran a review of Robert

Reisner's 1971 book, *Graffiti: Two Thousand Years of Wall Writing*. Reisner—who is credited with teaching the first-ever college course on graffiti, at the New School for Social Research in New York—considers graffiti historically, from caves to bathrooms. The title of the review ("Graffiti Lasts and Lasts") is in reference to the long view that Reisner takes in his history. It also foreshadows the last paragraph of the review, which summarizes the implications of Reisner's book and the eighty pages of graffiti examples he includes at the end:

> It all proves one thing: The graffiti is mighty and will prevail no matter how many authorities white wash the wall. (Kenny 1971)

It seems fitting to bring this chapter to a close on that point. To prevail in a city like Boston, graffiti must invent its own writing spaces, each with its own identity, history, and relationship to public discourse, with its own attitude toward writing. These spaces are here, in Boston and its surrounding cities. But they are also elsewhere, outside the portrait of a city presented here. In contact with and influenced by this portrait, surely, but importantly distinct from it. Like the spots writers make for themselves. The bibles they carry with them. The trains they take and make into writing spaces. The warehouses where writers write and the benches where writing finds readers.

The rest of this book is about the writing of other wheres.

Community Interlude 1

Piecing

As we've seen, Boston's relationship with graffiti is complex and specific, rendered meaningful through a complex of place-based narratives that shape the city and situate its writing. It's ever-evolving, different today than it was yesterday and will be tomorrow. It is also constructed. Writing the previous chapter, I was constantly aware that another researcher, another writer, at another time, might construct this portrait entirely differently.

Because of this ineffability, I'm sure that no scholarly inquiry can ever really offer an adequate portrait of the place or place-less-ness of graffiti here. Nor do I think any researcher can offer a comprehensive overview of the spatial productions at work in any moment of public or community writing. Boston's relationship with graffiti is not something you simply uncover and represent. It's also something that is *experienced*. It's something that is felt.

This first of four Community Interludes provides perspectives—both from direct readings of the previous chapter and from the interviews—on that relationship between the city and graffiti, responses from a few writers who have experienced it. As I explain in the following chapter, "piecing" denotes the literacy work of writing, reading, and interpretation surrounding the production of a "piece," an elaborate and time-consuming genre of graffiti short for "masterpiece." Here, writers add additional pieces to the previous chapter's puzzle.

> BAST: I love Boston. It also infuriates me. As a Bostonian, I get immediately defensive when outsiders try to critique my hometown, even though I'll go on at length about its shortcomings.

Every community has fractured and competing identities that are reflected in its cultural outputs, but there is a uniquely Bostonian brew that this chapter captures nicely, especially in regards to graffiti culture. The sentiment that WERD expresses about writers being reviled by our neighbors rings true to me, even though I haven't been an active writer in years. And, while he was talking about the city's ire toward kids with spray cans, that same internecine antipathy can be felt among and across so many other communities throughout the city. As the song says: "We hate every-motherfucking-body. (Even ourselves)."[1]

Even so, the fact that the city of Boston hates graffiti does not mean that we Bostonian graff writers are not also a fundamental part of our city. It just means that we know that our polity rejects us and that we inhabit a kind of DuBoisian double consciousness. We're writers because "fuck this place" with its yuppies and Brahmins, and we're also writers because it's our home and we want to leave our stamp on it. Because, of course, we love our city and its history, too, and we revel in our own slice of it. Writers are nothing if not excavators and preservers of the past, historians of the evolution of style and the hotness of spots, protectors of the culture. So, I'm guessing that many graff heads toggle between ignoring the hate (apart from the legal stress and the buff) and bemoaning it—like, can't the city just have some legal walls and stop hanging lifelong felony records on kids?

With the intensity of this ire, perhaps it's apt that the first metaphor for Boston is the melting pot. As with the rest of the United States, Boston can certainly be the homogenizing cauldron implied by the imagery of the melting pot: a deeply assimilationist place that compels integration into the dominant culture. When you enter a crucible, you can only reemerge as an unidentifiable component of a uniform whole, because what

1. Ripshop (featuring Kool Gee and Edzo), "Out Y'all Mind."

cannot be assimilated is literally burned away or skimmed off and discarded. The metaphor works for Boston in this uncomfortable reimagining of its original intent, but I bet that Boston sees itself more like our iconic Roxbury Puddingstone—an agglomeration, conjoined through immense and ancient pressure and made solid enough to be our city's bedrock, even as its components remain distinct. Regardless of the metaphor, Boston definitely falls short on embracing otherness, and writers are definitely an "other."

Boston's Puritan past can help us understand this tendency—when your community is founded by people exiled for their conservative religious extremism, it's easy to imagine that pattern repeating through the centuries. Consequently, we're great at excluding people. The strict notion of the outsider is so New England. If you know any Mainers, they can tell you about "from away" where non-Mainers are permanently outsiders. Live there for fifty years and you can still be from away. This isn't that different with graffiti; in my youth many writers in Boston had a chip on their shoulders about the kids coming in from the suburbs. The parochialism bleeds into everything, I guess—even as the city reviled all of us for being writers, we reviled each other on the basis of zip code.

Of course, those tensions were about more than just municipal boundaries, because Boston (again, like the rest of the country) is massively segregated by race. It was so fascinating to feel the visceral racialized antigraffiti fear in the source material from this chapter, especially Nancy O's casually racist nonsense about writers wanting to be "black gangsters." There are so many layers here, but at its ugly heart is the implication that (purportedly all-white) writers are awful because they want to emulate something these cops see as embedded in Blackness. And the piece of this bigoted narrative that felt so perfect in its shittiness was the claim that all writers are white. That erasure of writers of color is just another extension of the buff. Once again, black and brown people absorb all of the animus but none of the credit.

So then, while we're thinking about laws, let's also think about liberty. The notion of Boston as the Cradle of Liberty got me thinking about who has access to free public expression in our city. Massachusetts state law says that Charlie is committing a felony if he " . . . willfully and maliciously or wantonly, paints, marks, scratches, etches or otherwise marks, injures, mars, defaces or destroys the real or personal property of another including but not limited to a wall, fence, building, sign, rock, monument, gravestone or tablet . . ." (Massachusetts G.L. c. 266, §126A). However, my guess is that if Charlie was wheat-pasting a concert flyer, or slapping up a union campaign sticker, or even stenciling a "guerilla ad" on a sidewalk, he'd be much less likely to get bopped than if he was catching a marker tag. I don't know how many nonwriters have been charged under this law for the actions I described but I'd bet that there is a yawning absence of people who aren't "taggers" being charged (or even arrested) for these crimes.

Apart from the ads and stickers that litter our city with impunity because they're not viewed as the work of graff writers, there's at least one piece of public expression that meets the definition of the law but is only celebrated and never punished: the Smoots on the Mass Ave bridge.[2] Why is it that a bunch of MIT frat kids can write a name 364 times on a piece of public property and have it feted as part of the culture of that institution, whereas if I started to paint BAST FNF right underneath each smoot, I'd be in a CPD cruiser before I got halfway across the Charles? Undoubtedly, the Smoots are graffiti—unsanctioned writing—but they're read very differently coming from MIT kids. Admittedly the tradition started in a different time, but still, I can't imagine throwups on a bridge in Boston getting lovingly repainted every year without consequence. Perhaps it even goes beyond just graffiti and aligns with the larger Athens

2. See https://en.wikipedia.org/wiki/Smoot.

narrative—if our city is an extension of the academy, then something so gritty and blue collar as graffiti could never be accepted. Boston can embrace the nerd graffiti of MIT, and even the literal street art of Sidewalk Sam (even as they both meet the definition of graffiti), but the kid with the spray paint is too discordant with our elite identity to be accepted.[3] This is about unequal access to the liberty we claim to celebrate—some of us get more than others. Same as it ever was, I guess.

So, where are we left with our identity facets? The New Boston. The neoliberal capture of our city by commercial interests—a trend we see globally. The whitewashing, literal and figurative, that brings us right back to the homogenizing melting pot. This vision is both depressing and unsurprising—Boston's always been an uptight place (remember those Puritans), so a desire to quash disorder and preserve the status quo makes sense. But alongside that impulse you'll always have a countercurrent of people that hate the status quo, and so I am hopeful for a Boston where writers politicize the craft. Perhaps writers can organize into the next wave of culture jammers, fighting back against the homogenization of space in the service of capital.

After all, who else is asking why public spaces and public property are constantly infiltrated by private interests. Why is it OK for advertising to show up all over the Common or the T, even though the people have no say over it? And why do we have no recourse for our own voices to be heard in these public spaces. Why can't kids write on boring gray bridges without getting jailed, while the forces of capital have free reign over the same (commonly owned) spaces?

In a *New* New Boston, the people can assert themselves, and maybe writers can show the way. Rather than being cowed by the "see something, say something" snitch mentality that things like the 311 app try to inculcate, we could use those same channels

3. See https://en.wikipedia.org/wiki/Sidewalk_Sam.

for civil disobedience. What if we all deluged 311 with reports of Trump posters or racist bank ads as graffiti in need of removal?[4] I know that I find those more offensive than a nice wall of chrome and black dead letters. When our public square only allows private voices to be heard if they buy their way in, those of us with no capital are left with no space for expression—our ownership of the commons is estranged. That is what drove me to be a writer— I just wanted to be seen and heard in a world that ignored me. So, let's hope the world has more writers barreling down the block demanding to be heard, even in the face of the hate, and the buff, and the cops. We need unapologetic public dissent more than ever, even if it's just the next generation of kids getting up. Hit me up too.

———

REACT: At this point in my life, I generally try to avoid stirring up graffiti controversy. I'm in the middle of my fourth decade of involvement in graffiti in this city, so I'm officially over dealing with that part of our miserable little subculture. Which is funny because I apparently did nothing but stir up controversy when I was younger. I was looking through old books recently and I realized that I was awful. I was such a jerk. Over the past ten or fifteen years I feel like I've done a pretty good job at transitioning into the graffiti elder role, but even that doesn't make me immune to criticism. I still hear it from people for different things I've said or done. Thankfully, I don't have the time or energy to get stressed about it, so I've learned to just take it in stride.

It's with that attitude I'm wading into a topic that I recognize is probably going to annoy someone.

In reading this chapter about the city I was struck by the inescapable fact that in the war between the sanctioned and

4. See https://www.boston.com/news/local-news/2019/03/21/td-bank-ad-dorchester.

unsanctioned, sanctioned is on a real winning streak in Boston. In a way, it's great. I honestly can't believe what the scene is like here. Locals like Caleb Neelon, VISE, PROBLAK, MARKA27 and DEME5 (among many others) are producing high-quality, sanctioned work all over the city. It's really great to see. Additionally, the graffiti/street art fan in me is also happy to see permanent murals in the city by the likes of El Mac, Jeff Aerosol, RISK and ASTRO. Wandering from Northeastern to JP you could spend three or four hours looking at murals. That's just one of many hotspots in the city now. Slightly further afield, Lynn is plastered with walls thanks to the Beyond Walls project and Pow Wow has done the same to Worcester.

If you'd told me even twenty years ago that the graffiti aesthetic would be embraced by the community in this way; even in the international, big-wall form that we see at mural festivals around the world, I'd have laughed at you. Fast forward to now and there have been weeks in recent years where more sanctioned murals were executed in the city than were executed in the city in the whole decade of the 1990s.

On the flip side of all of that progress, the unsanctioned side of the ledger feels like it's in decline. Granted there are still individuals and crews putting in a lot of illegal work and you can still see truly great work develop on the streets (e.g., FUCK WITH LOVE) but over the past few years things have slowed down. Don't get me wrong, I don't think that there's any direct connection between the rise of the commissioned wall and the decline of the streets, but the comparison is striking.

And you don't have to go very far back in time to find a time when Boston had a thriving scene. The 2000s, in some ways, were Boston Graffiti's golden era. Between the battalions of homegrown talent going on a decade-long rampage and an extra special wave of out-of-towners coming in for school or just to hit the trains, Boston graffiti in the 2000s was a vibrant, incredibly competitive environment that fostered the development of at least a couple dozen truly great graffiti writers.

Without that competition and without the stress and paranoia of the bomber to drive creativity, I worry about the scene here getting stale. Yes, we have a great mural scene full of international superstars, but that also means we're being bathed in that international style.

How does Boston's style, Boston's voice in this subculture survive that influence without the balance of the streets to add energy and vitality into the system? If society succeeds in shutting down or stifling the unsanctioned voice, where does the next generation come from? We have very little in terms of safe, unsanctioned space for people to explore. We have Graffiti Alley in Cambridge and . . . not much else.

In a lot of ways it parallels the development pressure in the city and the unmanaged drive toward a neutered skyline full of luxury condos and lifeless neighborhoods. We live in a city where a landmark like Doyle's can shut down because of rising rents, robbing a neighborhood of a vital community center and its liquor license finds its way to a steakhouse for convention-goers in the Seaport.[5]

My hope is that on both fronts we can find a balance. We need the convention-goers and the steakhouse. We also need a place like Doyle's where you can go after softball or whatever and have a drink and dinner at a neighborhood place.

I love the fact that this city has embraced the graffiti aesthetic and is creating a vibrant scene for public art. I just hope the underground can rise up to meet it to keep the fire of creativity burning hot.

———

VISE: I'm going to tell you a story. As a kid, I was kind of an introvert. I had all of these creative ideas in my head, but I didn't know how to execute them. I come from a large Jamaican family, twelve uncles and aunts. One of my uncles, Danny, was my age. He had a

5. Doyle's was an iconic, 137-year-old Irish pub in Jamaica Plain.

charismatic personality, funny, creative, and full of the confidence
I didn't have.

One day, when I was fourteen years old, I was visiting Danny
and he was writing DEVIOUS everywhere. He later shortened to
it DEVS, but back then it was DEVIOUS. He said it was graf-
fiti. I'd seen graffiti on the street, but I didn't know much about
it. He said to me that if I wanted to do it, he would give me a
name. Because I was a perfectionist, he told me I should write
FINESSE. Similar to him shortening his name, I shortened mine
to FANES. I wrote it everywhere. FANES. FANES. FANES.

The act of doing graffiti and repeating letterforms over and
over, in blackbooks and on walls, opened up a world of creativ-
ity. It made me look at my environment differently and to find
opportunities to express myself creatively in everything. Every
thing, every space, has potential for creativity, to be changed.

I learned from DEVS, but I was also inspired by books and
magazines. In one particular book, *Subway Art*, there's a pic-
ture of an old New York train that read, "STOP THE BOMB,"
painted by LEE in reference to the Cold War. This stood out to
me, because I always thought that graffiti was only about writing
your name creatively. I didn't realize it could have social mes-
sages, too. I actually taped that train up on my bedroom wall and
it was there for years.

There was an old, rundown basketball court down the
street from my house in Quincy. I went to the court and wrote
FANES. Really simple letters, in Jamaican colors, and I added a
cartoon character pointing at the letters.

Later on that day, I got arrested. The *Boston Globe* ran an
article that used me as an example of how graffiti was destroying
neighborhoods. I thought I was making this basketball court look
better, to express myself and share this creativity.

Boston Globe, 1994: The paint on the basketball court at Suomi
Road and Smith Street in West Quincy was still wet when a
police cruiser pulled up to a 16-year-old walking down a street
several blocks from the site.

The young man was wearing a knapsack containing four cans of spray paint, gloves and shoe polish.

"He didn't even deny what he had done, he told us he was adding beauty to the basketball courts and he even had a receipt from a hardware store for the cans of paint," said Quincy Police Chief Francis E. Mullen . . .

Graffiti, a fad usually associated with city walls and playgrounds, has become a suburban phenomenon too, one that shows signs of becoming a growing problem. (Reid 1994)

The ironic thing, months later, they built a brand-new basketball court. It made me realize that there is power to this stuff. I really started to see graffiti as a social tool.

Fast forward, I changed my name to VISE, which means Visually Intercepting Society's Emotions, one image at a time. I started doing more socially engaged work. A friend of mine, a graffiti writer STER, was going to college for graphic design. That inspired me to do the same. Working with Chaz Maviyane-Davies, I learned to mix what I was doing with graffiti with these new, socially engaged design skills. I started doing work that took the philosophy of graffiti and tried to intercept how people think about the world and social issues that threaten humanity, like unarmed Black men and women getting shot by police. The stuff that is important to me.

In 2014, Julia Roth and I launched the "Up Truck," which was a socially engaged, mobile art studio. We'd drive around different neighborhoods and offer people a platform to express themselves with spray paint, the tool that originally inspired me. Again, I was in the *Globe*, this time on the front page, for inspiring my community instead of destroying it. It's funny how perceptions change. I think the Up Truck was responsible for shifting a lot of perceptions and attitudes toward graffiti and street art in Boston and the greater Boston area.

I could have quit that first time I got arrested. Instead, I've dedicated myself to producing social-justice oriented artwork, work that also allows others to tap into that world of creativity that

1.4 VISE at Northeastern University. Photo by Sami Wakim.

was opened to me through graffiti, and to see the world differently. One of the murals I've done was commissioned by Northeastern University (fig. 1.4). I was the first Boston artist to be a part of that campus project. It's a kid, picking up a can of spray paint, and the world of imagination and power that comes out. It is a testament to what graffiti and creativity has the power to do.

From the Interviews

RENONE: We are an old city, and there's a lot of history here. There are a lot of historic buildings here. There's a lot of racial divide here. There are so many elements that bubble up. They appreciate their architecture and their older buildings. They like things the way that they are.

That's why Boston is such a conservative city compared to other cities. We, they like to keep things the same all the time.

To them, graffiti in itself is this blatant disrespect of authority. If we are painting buildings, they can't get past that.

Graffiti is an answer and it's a response to conditions set. This is our answer to it: to make something out of nothing. Out of trauma comes beautiful creativity. That's what is happening, but they're just looking at it as blatant disrespect.

TAKE: For the most part, Boston's reaction to graffiti has been negative. It has always been negative. Boston, as a system, is an old town. There is a lot of old things here. Even in terms of New York, graffiti is considered art. In Boston, you're considered a criminal.

I don't want to overplay that card, because on top of that it's a little bit different. Graffiti is not just an art form. But in terms of the train of thought people are on, it's amazing how small it is toward graffiti. They are close-minded to graffiti because it's an urban thing. It you look at an antigraffiti commercial, it's a person of color with a spray can, you know what I mean? Just this dangerous-looking kid. That's a mentality that stuck in Boston.

TENSE: I think Boston has a very antique and rustic type of mentality. They want to keep things in a certain version of their original form. But nothing that we see in front of us is in its original form. But they want to keep things to a certain degree in its original form. Keep all of the walls tan or beige, just plain, or whatever. Keep these fucking old, military buildings clean and stuff.

And when you're a graffiti writer painting on them, they don't like that. It just seems from a very antique mentality, in my opinion. It's just that stale mentality, where it's like, "We don't want anything new coming through here." Boston is just kind

of stagnate and such. They try to add new things, but they don't like to take away the old.

I don't even want to touch on race and segregation because that's a whole other area of it. But really, I think it's just the age and antiquity of it. They want to keep things rustic and un-urban. Boston is like your old grandmother that you're just waiting to croak because she just won't give up those old ways.

2

Spot

Spot (n.)
 I. A stain or blemish; a flaw.
 a. A moral stain, blot, or blemish; a moral flaw.
 II. A mark or dot; something distinguished by this.
 a. A small, usually roundish, mark of a different colour or
 appearance from the surface on which it appears.
 III. A place, and related senses.
 ("Spot," OED)

Walks

In 1842, Charles Dickens took a walk around Boston. Having recently arrived in America aboard the RMS *Britannia* and overcoming some "detention at the wharf," Dickens strolled into Boston on an effulgent Sunday morning. Being Sunday in Boston, Dickens was first struck by the "many offers of pews and seats in church" but quickly turned his attention to the sights of the nineteenth-century city.

> To return to Boston. When I got into the streets upon this Sunday morning, the air was so clear, the houses were so bright and gay; the signboards were painted in such gaudy colours; the gilded letters were so very golden; the bricks were so very red, the stone was so very white, the blinds and area railings were so very green, the knobs and plates upon the street doors so marvellously bright and twinkling; and all so slight and unsubstantial in appearance—that every thoroughfare in the city looked exactly like a scene in a pantomime. (Dickens 2004 [1842], 34)

Here, and elsewhere, Dickens reads Boston. He reads what is written and how it is written. Intentional. Legible. Coherent. The plaques, commercial

signage, and other texts he encounters welcome and entertain him, and the well-kept, almost stage-like aesthetics parallel what Dickens finds so becoming of the locals: "The tone of society in Boston is one of perfect politeness, courtesy, and good breeding" (66). As a city, a text, as a group of people, Boston "cannot fail, I should imagine, to impress all strangers very favourably" (35).

Many, many years later, on a cold March night, BOWZ and I take a different walk, reading different texts, with different plans for writing. After finishing up at a local bar in Cambridge—we both order the "Hobo Special," $8 for a 40-ounce bottle of malt liquor and a hot dog—we decide to head toward Central Square. It's late when BOWZ and I leave, and the air outside cuts through my winter coat. The coat is worn and thin: my grandpa's old jacket from the wax factory, red and black lumberjack. BOWZ zips his own coat to his chin, adjusts his Nike Air Trainers. He shakes my messenger bag, a constant companion on these late-night walks. "What's up?" I ask. "Listening for cans rattling," he tells me, laughing.

We set off, cutting through side streets as we make our way to a Pete Rock concert at the Middle East, a music venue. We walk, and we discuss walking. "Do you find yourself walking around differently, as a graffiti writer?" BOWZ tells me that writing orients him to the city. You don't just see where writing is. You see where it could be. You look for pockets and cracks where other writers might have gotten up. To encounter graffiti is more than just reading letters, more than reading style, he explains. It's about imagining how the writer got *there*, how they made it a writing spot in the first place.

We pass Modica Way, an alleyway in Central Square designated as a legal graffiti spot.[1] I point out how the writing has spread to the rooftop, and BOWZ immediately explains to me how he would go about climbing the building. As he imagines his movement from one architectural feature to the next—none of which are intended for climbing—the building looks different to me: less a permanent structure and more a fluid series

1. Legal graffiti spots have grown more common in Boston, and elsewhere, and many writers write in both legal and illegal spots. The Lab, a spot I explore below, is a legal graffiti spot.

of affordances and possibilities. We trudge on in the cold, carving our path through a network of side streets that connect the various squares of Cambridge: Central, Harvard, Inman, Kendall, Lechmere, and Porter. Each time we encounter a building with an adjacent alleyway, elongated entrance, or lighting conditions that allow a certain degree of privacy from the street, BOWZ whispers, "Yo, hold up," and disappears into the structure. I look out.

We make our way toward the Middle East, our travels marked with tags. When we arrive, we meet two other writers outside, one of whom asks BOWZ if he has a fat cap, a spray-can modifying tip that produces a wider burst of paint. BOWZ rifles through his backpack, retrieves the cap, and hands it to the writer. "Careful though, that spot right there is hot," BOWZ says, pointing to a police patrol car parked on the opposite side of Massachusetts Avenue. After the two writers give us their admission wristbands, BOWZ and I descend the stairs into the subterranean venue, reattaching the wristbands, as Pete Rock starts a dizzying set.

At first glance, these walks, separated by nearly 175 years, have little in common beyond geographic proximity. Next to each other, though, they tell of radically different orientations to the city and its writing. They tell of strategic and tactical movements, as Michel de Certeau (1988) might put it, of distinct-yet-interrelated ways of reading the city, and different ways of writing it. To put it in terms familiar to those of us in rhetoric and composition: Dickens experiences Boston as a product, as a text to be read so that conclusions can be drawn and assessments made. BOWZ sees Boston as a process, texts being written, open to revision. Inscribed versus inscribing. Boston as pristine, historical, and *written*. Bostons as emergent, multiple, as always already *being revised*.

To this point, I've argued that graffiti provides an alternative framework for understanding the relationship between writing and space: that space is at once a venue, participant, and outcome of writing processes. Graffiti produces writing spaces beyond, but still connected to, an iteration of Boston that privileges the preservation of historical identity, neighborhood segregation, and the academic disciplining of writing, often to the benefit of neoliberal spatial interests. Here, I attend to one form of graffiti's alternative spatial production through the lens of graffiti "spots,"

a term designating countergeographies of writing organized around community notions of access, publicity, mobility, value, uptake, and style. Rather than "making space" within the portrait of Boston presented in the previous chapter, I argue that writers circulate community genres of writing—like bombing and piecing, genres I focus on in this chapter—that destabilize the rhetorical space of the city past the point of rupture.[2] In this epistemic break, alternative spots of writing emerge that, when constellated together, perform and envision a more participatory, multivocal, and mobile, if imperfect, vision of urban literacy.

To take the reader inside these spots, we will take a series of walks, emergent mobilities produced by writing. These walks are not always temporally linear. We'll bounce in and out of memories and years in an attempt to replicate the experience of walking for a graffiti writer: never just a matter of moving between geographic points but filtering that movement through a learned, rhetorical relationship and history with space and the writing that constitutes it. The first walk takes us to a warehouse in Quincy, Massachusetts, where I establish "making spots" as a disciplinary (re)orientation to the relationship between writing and space. From there, we'll walk down side streets and main thoroughfares, bombing with writers as they make spots in high traffic areas. We'll also walk to more established spots, less visible to a broader public but crucial community spaces sustained over time by writing. And we'll conclude with a walk into Boston, imagining what a remapping-via-spots at work in this chapter might mean for our work as researchers, teachers, and theorists of writing.

Making Spots

I wake up on a cold morning in December, sick as a dog. A sinus infection, I fear, made worse by sleeping on a friend's couch in the back room of a drafty apartment in the South End. I roll over and check my phone.

2. In considering bombing and piecing as community genres—genres that circulate to produce community writing spaces—I am drawing on the work of Catherine Schryer (2002), who argues that "when we examine genres as trajectory entities or flexible constellations of improvisational yet regulated strategies that agents enact within fields it is probably useful to think of genres as actions or verbs" (95).

Mercifully, no notifications. BEAN and I had been texting the night before about painting, but I suspect it'll be called off. It's snowing hard. I can't imagine we'll make the trek all the way out to Quincy to the warehouse spot.

I text BEAN, and he immediately starts typing his response. He's going, he tells me. He wants to paint and promised a few other writers he'd meet them. I'll be there, I reply, pulling on as much clothing as I can find and taking a pull from a half-empty bottle of cold medicine. As I walk out onto snowy Massachusetts Avenue, I blow warm air into my fist before checking the bus app on my phone. I walk to the bus stop and take the #1 bus to the Orange Line. Orange to Red. Walk from the Red to the warehouse.

On the Red Line, the train rattles as it becomes elevated. My eyes are glued to the windows, taking in all of the writing and the long stretches of gray, buffed walls. I begin to see the outlines of a massive SENSE memorial, writing so big that if you aren't sure what you're looking at, it appears to be nothing more than random spurts of black paint. My phone buzzes with a text. BEAN is already at the spot with MEC, a local writer I haven't met, and LOST and MAR, two out-of-towners. When I walk into the warehouse, I hear Joe Budden's (2015) "Love, I'm Good" blaring. The song is a hip-hop postmortem.

"We need a new president, where the fuck is Eric B?"

As the writers start their pieces, I walk around and introduce myself and my research. LOST, from New Jersey: "This is what graffiti is all about. Meeting people and spots to paint." BEAN yells his agreement from the other room, and before he starts painting, I ask him to define spot for me.

Spot is super broad and can have a few meanings and be used in a few ways. But at the end of the day it just comes down to where you are painting. Making plans to paint, the first question a writer will ask is "What spot we painting?" Or, maybe you'll get a text from a writer: "Yo, I found a dope spot." Or, maybe someone will see something you painted and will text you, "I see that spot you did on Broadway."

There are different types of spots, too. When talking about somewhere chill that you can take your time and not worry about being seen, we will refer to it as a "chill spot" or "piecing spot." Or, you can have

2.1 BEAN Warehouse. Photo by Charles Lesh.

somewhere highly visible and dangerous to paint, like a highway or street-side, and it will be a "hot spot." (fig. 2.1)

As BEAN notes, spot is a community-sponsored term for a location of writing. It's capacious, standing in for a vast range of writing spaces with different rhetorical affordances and limitations. In their work on "spot theory"—to my mind the clearest articulation of what spots mean to the graffiti community—Jeff Ferrell and Robert D. Weide (2010) note that spots are selected by writers given a range of what we might call rhetorical considerations: audience and visibility; longevity and durability; availability and competition; and seriality and accumulation.

Yet there is something more transformative at work here than simple selection. Rather, spots are where you write but also what happens when you write. Because cities and, as I've argued, urban narratives, are never

static, spots are best understood not as fixed locations of writing, but, as Ferrell and Weide (2010) note, as "moments in the social process through which the city and the world of graffiti develop in a dialectic relationship" (50). As writers remake "city spaces into graffiti spots," they participate in a radical break, an "alternative spatial epistemology, collectively remaking the meaning of the everyday urban environment and setting in motion those aspects of it not already on the move" (60). Spots, then, are at once location and production, and as writers continually compose them, spots begin to take on their own logics, principles, rules, etiquettes, and histories. An attention to these spots, walking to and through them, provides a glimpse into alternative spatial ecologies that exist for writers and allows us to consider how we might recalibrate our own understanding of public writing to account for the unique sets of principles through which publics organize their writing spaces.

In this way, spots are exemplary of the relationship between writing and space I advocate for in this book. Spots are not just where writers write, the important material and metaphorical locations of composition. Instead, spots are the *wheres* that writers write: diverse locations of writing constitutively tied to texts. When BEAN says, "I see that spot you did on Broadway," he signals the spot's dependence on writing: that he made that spot by writing, that there are no spots without writing.

It is important to note that making spots is a rhetorical act of *alternative* spatial production, a radical break from the contours of Boston's dominant writing spaces that privileges property rights, sustains segregation, and preserves a singular history, citizenship, and identity. Spots are spaces written differently. As I've argued, while "making space" implies a nested relationship to the larger writing space of the city, making spots implies the production of new, emergent writing spaces, constellated together, and in tension with, but boldly distinct from, larger urban-rhetorical politics. If the Melting Pot, Cradle of Liberty, Athens of America, and New Boston won't abide graffiti, then writers produce different writing spaces, nodes within an alternative cartography that remaps the city along community-sponsored routes, landmarks, pedagogies, and histories. Spots provide a hyperlocal and geospatial framework for understanding productive public and community work. In other words, walking to a warehouse in Quincy,

you gain a lot more than access to a place of writing. You gain a new perspective on what it means to write space itself.

Highway

Let's take another walk. Around 12:00 p.m., I'm standing opposite the Ruggles train station, watching a bus to Mattapan depart. To my right, the bright, shiny buildings of Northeastern University. To my left, the bus stop: weathered, taking passengers to the far reaches of the city. As I take the last drag on my cigarette, my phone vibrates. It's a text from NIRO, a writer who has been getting up a lot lately. It reads, "You down for tonight? Big plans."

Around 1:00 a.m., we leave NIRO's apartment, tossing all identification on his desk: school IDs, licenses, etc. "It's just more questions the cops can ask us if we get caught," he explains. He tosses me a pair of black rubber gloves that I quickly put into my pocket. "You don't want to get paint on your hands." We look suspicious: NIRO, openly carrying a five-gallon jug of reddish-pink paint, markers rattling in his pockets; me, with a smaller jug of dark red paint in my messenger bag, two paint rollers jutting out.

On the porch, NIRO pulls out his phone. "OK, so this spot isn't on Google Maps, but here is where we're going." He points to a beige area on the map, a cartographic margin. "Let's stay off major roads," he says, and we discuss escape routes, just in case. *One, exit the way we came in, and run. Two, exit through a second hole, farther down the fence, and run. Three, run along the tracks, through the train yard, and hide.*

As we walk toward the spot, we pass a house that has recently caught fire. "I've been thinking about hitting those front boards," NIRO explains. "It doesn't matter; it's all coming down anyway." We turn on a side street and freeze as we see a taxi idling. We approach cautiously and see the passenger, visibly intoxicated, lying on the ground next to the car. The driver is standing over him, on the phone. Calling the cops? "We should hurry," I say, and we scurry past the scene. As we approach the spot, we encounter a string of throwups and tags; NIRO reads the wall, telling me stories about the writers.

In the parking lot. We crouch behind an abandoned truck for five minutes, making sure no one has seen us. Better to get spotted now, before the writing starts. With his black hat pulled low over his face, NIRO turns to me and whispers, "OK, let's do it." We cut through a small hole in a second fence and emerge alongside the Massachusetts Turnpike, a highway humming with 2:00 a.m. Boston life. *New Boston: the gateway to our fine city.* Ducked low to obscure my presence from the traffic, I look left and see the reason for our mission: a wall.

NIRO sets off to work. He moves fluidly, setting up the can with the darker paint in front of the wall. Stepping back, he says to me, "For rollers, it's important that you figure out the dimensions of the letters. If the letters are off, you're fucked." A roller is a large, often simple representation of a writer's name, so called because it is composed using roller brushes and wall paint. "Do you think I should just do four huge letters, or add an E at the end?" I tell him to go with four, he agrees, and immediately starts to outline an O.

I clear beer bottles and other highway trash and sit in a position where I can see the wall, the highway, and the parking lot. My role tonight is lookout. As NIRO fills in the R, a state trooper drives by. "Yo, down," I whisper, and we both get low. The car whizzes by. I'm not certain he hasn't seen us. NIRO keeps writing. The letters NIRO crafts are roughly twelve feet high and, in total, thirty feet long. When he finishes the last piece of the fill, he steps back and admires his work. "This thing is fucking huge, man," he says to me, laughing. We quickly pack up the materials, cut back through the fence, and make our way back into the dark, humid Boston streets.

Back at the apartment, we discuss the size of the piece. "You didn't even have to go over anything," I say. "Except for that one black tag," he says, "but I didn't recognize it. Who does a black tag on a highway spot like that? You can't see it, because it's on that buff dark gray color." As we look at pictures we've taken of the wall, NIRO says, "That's got to be as big as the NEKST roller that used to be there." I ask what he means. "That was the same spot where NEKST had that huge roller back in the day!" He shows me a flick of the roller that the iconic late writer had composed,

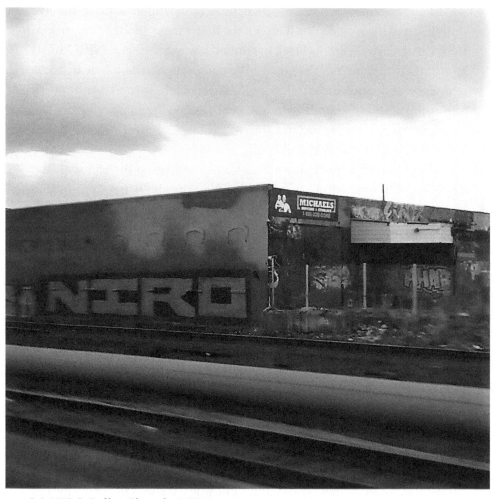

2.2 NIRO Roller. Photo by NIRO.

long ago buried beneath other names and buff paint. "Writers are going to see that, man. I can't wait. They *know* that spot" (fig. 2.2).

When I get back to my apartment, I sit down at my desk to write field notes. As I type, I remember a scene a few months earlier: MYND, SPIN, and I sit in an apartment living room, leafing through blackbooks, smoke curling in the air. SPIN is telling me about hitting the Fairmount Line recently, a commuter line that stretches into Dorchester, Mattapan, and where we are today, Hyde Park. "You know they just buffed that whole

shit?" he asks. "It kind of sucks because all that TEAZE shit is gone now. He had a lot of old shit out there with RELM. They had that whole line destroyed. So, yeah, we've been smashing it up, trying to get some new shit on there. I just flicked these ones. Want to see? Right up the street."

SPIN pulls out his phone and shows us: large, precise rollers alongside the train tracks. As I flip through the photos, I ask him to define *bombing*.

> SPIN: I don't know. That's traditionally what they called it in New
> York. When they talk about some fancy-pants mural, you wouldn't
> really call that bombing. But if you were going to tear shit up
> and . . .
> MYND: Destroy.
> SPIN: Yeah, like put up a bunch of tags on Blue Hill Ave. or go do,
> like we did, those monster fucking roller pieces. I'd call that
> bombing. I wouldn't call that piecing . . . Bombing is quicker,
> usually a lot hotter. You bomb a spot you wouldn't want to stand at
> for hours and hours and do a painstaking, mad tedious piece that
> would take a long time.

Bombing denotes the act of rapidly writing your name across a wide variety of spots, a foundational yet tactical genre of writing that privileges repetition, speed, and consistency over stylistic intricacies. Bombing is best understood not as a discrete circulating text but an accretion of writing that, in its excess, constitutes the form. There is an affective dimension to this excess; as Edbauer (2005a) notes, this aggregation—"the feeling of *too much* or *more than normal*, or an experience of something *got around*"—is essential to ethos construction for writers (144). Just as no one text can sustain a public, no one text can sustain a bombing mission or a writer's reputation. It is in this very excess, this generation of getting around, that writers subvert some of the underlying assumptions of New Boston.

> SWAT: Graffiti levels the playing field. Anyone can put their name on
> anything if they pay enough money . . . You can put your name
> anywhere on anything. You can put it on TV. Movie posters.
> Everywhere. There is a broadcast of brands and names all over
> the city. And graffiti is the same thing, except for the individual.
> Without sanctions. Without dollars. In protest of that system.

If New Boston produces writing spaces of order and property rights, of constructed transparency and frictionless mobility for capital, bombing, in its aggregation, produces opaque spots of excess, effulgence, and common use, palimpsestic provocations on the interested nature of writing space.

Whenever out bombing with writers, I was always struck by a keen sense of *kairos*, of identifying the most effective time and space for a rhetorical act. Bombing is fundamentally *kairotic* writing, particularly in Thomas Rickert's (2007) more spatial sense of the term. Drawing on the earliest senses of *kairos*—as "the place on the body where penetration (as by an arrow) is easiest"—Rickert contends that while the importance of temporality to *kairos* is clear, "just as important, the opening through which the shot must pass is quite clearly *a place*" (73–74).

> NIRO: Same exact thing with tags. I've physically changed tags or done different styles of tags just to fit into this little strip area or to fill this huge type of mailbox. I would do a different tag to fill a whole mailbox than I would to do something next to a piece or someplace down a fire hydrant. There's a different purpose to filling the thing or to having some type of other location . . . I kind of think of it as an interaction with the environment, instead of like, taking it over.

NIRO here echoes a point made by Andrea Mubi Brighenti (2010), that "for a bomber, norms about writing should be generated entirely from considerations within the field of writing itself" (322). In these *kairotic* considerations, bombing takes many forms: from tags (simple representations of a writer's name, often done with paint or ink markers) to stickers (adhesives with a writer's name, prepared at home for consistency and easier application to the urban surface) to throwups (bubbly representations of a writer's name often with two colors of spray paint) to, as we have seen, rollers. "More an activity than a style," as BOWZ once described to me, bombing encapsulates all of these textual forms, and variations of each, providing counterpublic writers with flexible, tactical, site-specific strategies for writing. It's almost tautologous: the form bombing takes is constitutively tied to the spot that it, ultimately, produces for itself.

Beyond excess, the style of these hot spots positions them outside of the aesthetics of dominant space: the orderly, smooth patterns of New Boston and the disciplined writing of the Athens of America. Style is, of course, something we talk about a lot in writing studies, but asking graffiti writers about their own personal styles yielded some of the most vivid and instructive descriptions of writing I've encountered. Here's just one example.

> CHARLIE: What's your own style like?
>
> RELM: That's a hard question to answer. I don't know if I should write a whole long-winded paragraph on Style like Werner Herzog or a concise Lyrical snippet on Style like Raekwon the Chef. Style is what moves you. It's meant to invoke a particular emotion or bring you to a certain time and place. My style is Lynn Style. It's aggressive. It wants to fight. It packs a shank. It's ready to chase a bum down an alleyway for trying to beat me for $10. It wants to eat a pizza to the face . . . Walk in the party, kick a hole in the speaker. Pour out your beer. Break the bottle and use it as a weapon. I tell my style to chill out all the time. It don't listen. It roots for the villain in the movies and fights pit bulls.

We are far from New Boston here. What RELM articulates is a resistive rhetorical practice in relation to more strategic texts, that through nonstandard typographic patterns, writers disrupt the way that urban space is mediated textually. Let's go back to the start: *Charles Dickens can't read these texts.*

As writers engage in the literacy work of bombing, they often produce, as BEAN notes above, "hot spots." Hot spots are spots of high risk and high reward: broadly visible locations, accessible by multiple audiences, including other writers, an unaffiliated public, authorities, and concerned citizens. The work that NIRO and I do coheres in the production and perpetuation of a hot spot, the wall being once the location, participant, and outcome of our writing. It is, materially, where we write, the vast brick wall affording size and visibility. The spot participates, too, in the writing process, our work necessarily responding to the fluidity and dynamism of the location: from the cars whizzing past to the writing that already

exists there. The spot is also an outcome of writing. As writers compose it, as it is sustained over time, that spot takes on its own history as a writing space. They *know* that spot. It becomes its own monument to community writing, but unlike the monuments of the Cradle of Liberty, this wall announces its potential for revision. As it is written, the wall is less a monument to history and more a monument to the struggle for visibility, to the struggle for writing space.

These spots communicate different things to different people, and as we've seen, what makes a spot "hot" is audience multiplicity: some hostile, some friendly, some affiliated, some not. While bombing is primarily oriented to other writers, there is also great community value in producing spots that are visible to a more general, unaffiliated public (Ferrell and Weide 2010, 51). Still, graffiti is oftentimes written in a way that intentionally obfuscates authorship to those outside of the community. This is what Bruce (2019) calls visual noise, "an expressive form of communication that remains opaque to some viewers" (91). These texts are available to a broader audience but not fully legible to it. Even more so, it's not just that these unaffiliated audiences don't possess the required literacies but also that, as Young (2005) notes, graffiti writing "displays illegibility" (66); it announces illegibility boldly to would-be audiences (see also Gopinath 2015).

This intentional resistance to, and frustration of, broader readership pushes back on an underlying goal of public writing as it is traditionally understood, at least in rhetoric and composition: as a means to reach both a targeted readership invested in a given issue and a broader readership that might be persuaded to engage. Yet I agree with Iveson (2007) that it would be a mistake to read this public illegibility in a way that classifies graffiti as private writing. Indeed, as writers compose these community genres, they do public work, simultaneously composing "a sharp distinction between the *different public audiences* of graffiti—the desired audience of other graffiti writers, and the wider audience of non-graffiti writers" (144). Iveson draws on the work of Michael Keith (2005), who argues that this tension between legibility and illegibility across public lines is what makes forms of writing such as a graffiti "precious," in that "they transform the mainstream through writing over it, yet at the same time exclude the mainstream from their—the graffiti writers'—discourse" (152).

In the same vein, as I inhabited and helped produce these hot spots, they felt "precious" to me precisely because they were communicating spatial multiplicity to a broader public. Visibility here is more than just a rhetorical resource for the fame or credit of an individual writer, it is also for a more dispersed awareness that different writing spaces are possible and, indeed, being written all the time. As Farmer (2013) notes in his work on anarchist zines, these spaces are "not likely to appeal to any and all strangers," but they "will appeal to some strangers who are responsive to its call and who can imagine themselves inhabiting that space, even if only for a while" (64). For some writers, bombing is an act of resistance against the colonization of space. For others, it is an artistic practice divorced from political possibility. What I am interested in here are the spaces produced by the act, and while these spaces do not have a singular politics, they are political in their existential insistence that all readers be aware of the contours, politics, affordances, and limitations of space as currently constituted. If the Melting Pot, Cradle of Liberty, Athens of America, and New Boston together produce an ostensibly aligned and coherent Boston, hot spots throughout the city produce the opposite: a Boston multiplied, of many voices, a recognition that writing never exists in one space but at the intersection of multiple, and oftentimes contradictory, ones.

My thoughts on bombing as spatially productive public writing are informed by the many walks I took with writers. As part of these walks, Kulturez was a frequent node. One morning around the counter at Kulturez before a walk, WERD and I discuss the alternative spatial sense that bombing requires, that heightened and mobile sense of writing possibilities. After rambling through my thoughts on *kairos*, space, and walking, WERD matter-of-factly replies, "Oh, you mean the eyes of a graffiti writer?" I ask him to explain.

> WERD: I can't walk anywhere without looking for tags. If I am walking down the street and I look up and there is a sticker on the back of a sign, I am going to see the sticker and I am going to notice it. And I'm going to take note of it mentally. So, if I see it again, I'll think, "Oh, ok, I've seen this here or over here." Writing makes me look at areas differently.

What WERD identifies here is that the production of hot spots relies on a different way of reading space, one honed over time to see every space as malleable, every space as a potential location for writing.[3] This theme appeared constantly in my interactions with writers.

> BAST: Yeah, I mean, as a graffiti writer, you have a kind of defiant antiauthoritarianism. In some ways, the fact that [the police] had such a hard-on for graffiti made it kind of a fun game. Like, "Fuck you guys." Me and BEYA, one time when we were getting arraigned in Brighton district court, we managed to get lighters into the holding cell, and tagged in smoke on the ceiling of the holding cell.
>
> There is a great story about RELM where he managed to throw a sticker onto the legal pad of a prosecutor during arraignment or sentencing or whatever.

> The *Boston Globe* reported, "While the Lynn native awaited trial, he managed to put up seven stickers bearing his 'tag' name 'Relm'—a kind of pre-fab graffiti grown popular in these harried times—on the courthouse corridors. As the prosecutor argued fervently that Relm be convicted, there, somehow stuck to the back of his legal pad was a pink-and-white Relm sticker." (Jacobs 1993)

In these memories, and in their appearance in the mainstream press, BAST, BEYA, and RELM demonstrate the *kairotic* dexterity required for making hot spots: utilizing nontraditional tools, composing within spaces unintended for public comment, recasting them as writing spots. That the cell and the prosecutor's pad are spaces explicitly designed to shrink

3. Scholars have made note of this shift in seeing, each describing it in slightly different ways. For example, Brighenti (2010), drawing on the work of Iain Borden, describes it as a view of "urban space and architecture not as things but as a set of affordances, as process of production, as experience and event" (317). Mark Halsey and Alison Young (2006) call it a "variance in ocular orientation" (286). Ferrell and Weide (2010) note that this sort of spot selection requires a complex knowledge of shifting urban cartographies, "an intimate knowledge of back alleys, freeway interchanges, interconnecting rooftops, patterns of light and human movement, neighborhood policing tendencies, lines of visibility, major routes of commuter travel, and phases of urban development and decay" (49).

rhetorical spaces—to bring them more in line with New Boston—only adds to their significance. In bombing, the jail cell, the legal pad, and the wall become spots, sites for alternative, unsanctioned writing. To write well requires paying attention to holes in fences, to the backs of signs, to houses that have recently caught fire, and to escape routes.

This reminds me of another walk I took, this time to a coffee shop in Jamaica Plain on a December afternoon. I meet up with RENONE, a graffiti writer most active in the late 1990s. She and I are discussing Boston, laughing at the city's notoriously winding, incoherent street system.

> I know people who are driving around and are like, "I don't understand! How do you get from point A to B in Boston? Why don't you use the GPS?" It is 100 percent because of the years I spent walking the city bombing. I know back ways and alleyways and what things look like and how to get anywhere in this city based on that, in particular. Or how to sneak into places or how to get into places, which I probably wouldn't know if I was just a nonwriter. I wouldn't know how to be stealth and how to sneak in and how to get by certain things.
>
> Even now, when I'm in public spaces, I'm looking for an escape route or how would I get away. I think I'm able to look at [the city] more productively than someone who has never had to look for an escape. Because there have been plenty of times when we've had to run to get away from police or people.

In RENONE's answer, we see the eyes of a graffiti writer leveraged in a larger form of spatial reorganization. The emphasis on looking at Boston "productively" through the lens of spots denotes a process of alternative world-making, new orientations to urban life and mobility outside of those dictated and disciplined by larger narratives of the city. By bombing, writers destabilize the fragmented writing spaces of Boston so rooted, as I've argued, in segregation and neighborhood identity. So while writers most regularly write individual names, the presence of these texts in the aggregate build community and string together the movements of different writers from different places. In doing so, hot spots renetwork the city along alternative, community-sponsored mobilities; writers' movements are not directed primarily by entrenched patterns or politics of mobility but by emergent opportunities for writing and reading. This literacy remapping is never solid,

finished, or entirely outside of dominant spaces, as I elaborate on below. As Ferrell and Weide (2010) note, "Graffiti writers do indeed remap the city as they move through it—but their map remains always in motion, more a liquid display than a fixed grid of the city and its spaces" (59).

This liquid quality seems exactly the point, setting these mobilities outside of the fixity that the Melting Pot ironically depends on. Writers don't melt difference, but they do, as Ferrell and Weide (2010) argue, "liquefy the city's official arrangements" (60), thus challenging the organization of city life constituted in significant ways by difference and reimagining mobility around rhetorical concerns. In separate interviews with me, PROBLAK and RYZE, iconic Boston writers, describe this reorganization through two metaphors of mobility: the passport and the gateway.

> PROBLAK: That was my passport. That spray can wasn't just twelve ounces of paint, where I can throw my name up a million times or get off the last stop and walk home. That can was my passport to other hoods that I could never get in to, you know what I'm saying? Blocks that you would only hear about.
> RYZE: I think one of the great things about graffiti in general is it often was a gateway to go into any other neighborhood or meet other kids that you normally wouldn't be associating with because of racial lines. But if you had graffiti, then all that other stuff fell away. So that was my experience, largely, with it. Graffiti was like the great equalizer.

Writing, and the reputations writers cultivate by writing, serves as a means to, as HATE once put it to me, "break the mold" of entrenched patterns of (im)mobility and textual circulation. "That's part of bombing," NIRO tells me, "going places that you would have never expected yourself to turn up." It seems fitting that writers like MBRK often use United States Postal Service stickers for bombing, canvases that at once allow writers an easier way to apply their names to a surface and, through the reference to the circulation-via-mail, call attention to their movement through space (fig. 2.3).[4]

4. This does not end at city limits, either. Writers will mail one another stickers (a sticker swap) and often take other writers' stickers with them and put them up in different

2.3 MBRK Stickers. Photo by MBRK.

 I do not want to paint an overly romantic portrait of hot spots in Boston, nor do I want to argue that together they form a utopian writing cartography, something wholly different than the Boston I portrayed earlier. As Iveson (2017) usefully reminds us, "Transgression of, or resistance against, the 'dominant' urban authorities is not necessarily democratic or just. It all depends on whether the alternative or 'local' authorities are founded on the equality of each with all" (92). Though I argue that hot spots, together, produce a more equitable, mobile, and multivocal literacy landscape, they are always already contiguous to entrenched urban politics. To ignore these points of connection would be to ignore the real and persistent fault lines that exist in the city, in the Melting Pot, and the ways

cities. For example, when MYND traveled to Mexico, he took a few stickers that SPIN and I had done and put them up, thus allowing us, by extension, to get up somewhere we had never physically been.

those fault lines can at times, as BAST notes in the previous Interlude, penetrate writing communities and the spaces they make in the form of division, parochialism, and distrust of change. It would also ignore that risk is distributed differently among different writers. As TAKE tells me, graffiti is ultimately written by people, and people exist within environments that can cultivate division.

> Graffiti, as much as it can be a unifying culture, it's still in the heart of the individual. That's where it lies. That's where it rests. That's where it's always going to be. So if you really want to appreciate it, and look at it, then you have to look at the individual who is putting that tag on that wall.

These divisions can be most pronounced along lines of gender and race, and I was aware that as a white male researcher in the field, these divisions were often attenuated. The NIRO walk above is a good example: as we cut through fences and side streets, I always carried my privilege with me. It is crucial to identify the ways these divisions coalesce to understand both the limitations and promise of spots as constituting an alternative writing city.

RENONE tells me that hot spots pose particular challenges and risks for women, especially women of color, due to the social cartographies of the city a bomber must navigate if she is to be successful.

> But on the downside, bombing in a place like Chinatown, which is a high sex-trafficking area, there are things going on. There are strip clubs. It was almost impossible some nights to go out there and do my thing without being bothered every second by somebody driving by, cars slowing down. And it wasn't the cops. It was the dudes that were like, "Hey, what's going on? Are you working?" Stuff like that.

Reading RENONE's words, I'm reminded of Doreen Massey (1994), who argued that "women's mobility, for instance, is restricted—in a thousand different ways, from physical violence to being ogled at or made to feel quite simply 'out of place'—not by 'capital,' but by men" (148). It's not just the capital in New Boston that dictates mobilities, it is also misogyny, racism, and other expressions of oppression that are not entirely absent from the graffiti community. Further, Nancy Macdonald (2016) has written that despite significant changes to the demographics within the graffiti

community over the last few decades, the language of writing, writing about writing, continues to contribute to its masculinist identity: terms like *bombing*, "drenched in combative imagery, tone and meaning, and this, in turn, transforms the writer, his/her quest and, indeed, their spray can into a symbolic weapon of war" (185). In all of these ways, the spots produced by bombing can replicate and have replicated divisions and violence of dominant spaces, creating what Ralph Cintron (1997) calls a "shadow system" that "has the shape but is not equivalent to the system itself" (176; see also Oliver 2014, 69).

This replication can also occur, and has occurred, along racial lines. Neighborhood identity remains elemental in the lived experience of Boston, and very real lines of racial, economic, and social demarcation exist between neighborhoods. These boundaries have influenced attitudes and actions within communities of graffiti writers. While this book is decidedly not a history of Boston graffiti, anyone who has spent any amount of time with writers has heard of a significant beef between crews, a conflict largely based on issues of race, privilege, and perceived border crossing reflective of entrenched racial segregation. "Boston was a racist state," TAKE tells me, and you "have that racial tension develop within the graffiti scene, too."

Yet even within this conflict, different patterns of mobility were forged. Out of it emerged the African-Latino Alliance (ALA), a historic graffiti crew that united Black and Latinx writers from smaller crews into a strategic, organized, and interneighborhood unit. TAKE, a member, tells me that ALA created, in a sense, "its own subway system." PROBLAK elaborates.

> The formation of ALA changes a whole lot of things, because if you left it up to our parents, we probably wouldn't be hanging with each other like that. If you left it up to the affiliation of the neighborhoods that we live in, we would never be around each other, let alone be allowed to. So that crew bridged a lot of gaps in both age and neighborhood.

Graffiti writing's need to move between neighborhoods, its need to circulate, remains an ideal. Though not always realized in a permanent sense, it remains a premise and promise on which to build radical and alternative rhetorical geographies of a *New* New Boston.

At the time of my writing this chapter, NIRO's roller, like the NEKST one before it, is gone, preserved only in memories, pictures, and now this chapter. But as it ran, it signaled to all who would read it that this city is being revised, that Boston is capable of revision. He wasn't fiddling, and Boston wasn't burning, but NIRO was imagining a new sort of city in the ashes of an old one, one where you might be greeted by many names and many spots.

Even so, hot spots are not the only type of spot writers make for themselves. The longer one spends time with the graffiti community, the more one learns about the vast and diverse network of writing spaces that compose alternative Bostons. Each of these spot types are composed with different genres, reflections of the affordances of the space itself. The remainder of this chapter has us walking to a few different types of spots and attending to the writing that produces them.

Sticker Spot

Another spot I walked to regularly throughout this research was the I-90 overpass on Massachusetts Avenue. You might remember it. It's the same one I walked across to get the picture of the SENSE truck. With its grayish railing and tall chain-link fence, it doesn't seem like much at first glance. In some ways, it is a likely candidate for what Marc Augé (2008) calls a nonplace: "If a place can be defined as relational, historical, and concerned with identity, then a space which cannot be identified as relational, or historical, or concerned with identity will be a non-place" (77–78).

Nonplace though it might seem, as a writing space, this spot holds a particular appeal to graffiti writers in that it brings together a constant range of different audiences: college students (due to its proximity to Berklee College of Music, Northeastern University, Boston University, and other schools); tourists (due to its proximity to the train station and historic Copley Square); and shoppers (due to its proximity to Newbury and Boylston shopping districts). To get up in this spot ensures that a text will be read by both other writers and a rich diversity of secondary audiences. It also ensures that the spot is hot, given constant foot traffic, a significant police presence, and direct visibility from the street.

2.4 BOWZ Stickers. Photo by Charles Lesh.

As a reflection of these spatial constraints, the spot has become known as a "sticker spot," a term that again signals the intrinsic link between writing and spatial production. With stickers, writers can rapidly apply their name to the railing while rousing little suspicion. Though routinely buffed by the city, stickers bearing the names of writers continually appear.

> BOWZ: I don't know, man. I was just over in the Mass Ave. area the other day, and there's a bridge that people started putting locks on.
> CHARLIE: Yeah, yeah. I was just there.
> MYND: I love that shit. I went over there myself.
> CHARLIE: That's the sticker spot.
> BOWZ: Yeah, yeah. I actually just put a sticker up. I like that area for that. Because there's a lot of college kids there, right? And Boston folk can say whatever about their college students, but there's a lot of openness there. And there's people trying to figure out what they like and why they like it. And graff is one of the ways that those kinds of things take off.
>
> You go to a sticker spot and it's not all graff writers. There's people who do advertising. And this is my product and it's the only way I know how to get it out to people. Nobody knows me. Nobody gives a fuck. I'm not a conglomerate. I can't buy a billboard. But, there's a slap. There's a sticker (fig. 2.4).

The Mill

Another walk. "Yo, it's *really* seventeen degrees outside," MYND tells me as we walk along a main road in Hyde Park. I'm visiting Boston from my new job in Alabama, and I haven't acclimated to the weather. "Since you left, we had a drought in Boston, and so a lot of these little water streams dried up," MYND explains as we hop a fence and start down a hill toward a babbling stream beneath an overpass. After some awkward maneuvering, I'm able to reach the water, and I'm immediately confronted by a shock of color. MYND and SPIN pieces. Now that the water has returned, it would be impossible to paint here (fig. 2.5).

I want to get a good picture, so I walk into the stream on some ice-covered rocks. Satisfied with the flicks, we climb back up the hill, hop a fence, and continue down the road. "Hold up!" MYND shouts. I look

2.5 MYND × SPIN. Photo by Charles Lesh.

down at a syringe a few inches from my left foot. "Welcome back," MYND says, as we both laugh nervously, keeping our eyes down as we walk.

About a half mile up the road, midsentence, MYND hops another fence. I follow. The wall leading to this second underpass holds a series of tags and throwups. A MYND black-and-white throw, and further down, two blue-and-white throws, SPIN and ARBOR. We continue on the sandy embankment below the bridge, and MYND tosses me a can of white Rusto. We take turns tagging.

Back on the main road, we approach The Mill, the reason for our walk. The Mill has been a chill spot in Boston for decades, with some of the most well-known writers from the city producing iconic pieces here. AEA (Anti-Establishment Artists), SPIN and MYND's crew, routinely do productions here. How has it stayed chill for so long, I ask. "Because the cops don't care about it. Out of sight, out of mind." He explains the logic.

Graffiti is going to happen somewhere, so it might as well be here, where "regular people" won't see it.

We hop over a low guardrail and begin walking on a dirt path toward the industrial structure. At a cut fence, MYND masterfully slips through the opening. As I slip through, my coat gets caught and rips. Red and black lumberjack. I am struck immediately by the immensity of The Mill. The first wall we see is an AEA production: six pieces in pairs of two, one on top of another (fig. 2.6). The styles are sophisticated, almost disarmingly so, and I take time to sort out the letters. Two of the pieces have been scribbled over. "We'll come back and fix them later," MYND tells me.

We walk through the entire structure. There are pieces from writers currently active, old pieces from writers I have only heard of, and throw-ups and tags in spaces less desirable to piece. We add to the collection of tags. In a corner, out of the way, I spot a TEAZE piece, a deceased, legendary writer from Boston. MYND beckons me to the rooftop. We climb a set of stairs and emerge on the decrepit roof, consisting primarily of wooden beams over a thirty-foot drop. We skip from one beam to the next, looking at the writing below.

Despite an almost full battery, my phone keeps turning off as I struggle to take pictures. It's cold. As we began to pack our bags, I quickly tag a pipe near the entrance, my bright pink paint-stick marker struggling on the abrasive, corroded surface. We emerge toward the commuter rail tracks, and I notice immediately that the pieces visible from train windows become much simpler. Above all of the pieces are dead letters that read "CIA KILLED JFK."

As MYND and I walk, we engage in the same sort of writing-oriented remapping I explore above. Our movements through space are not sanctioned but are, rather, hopping fences, wading through icy water, moving along the undersides of bridges. All of this is guided by a constellation of spots and by writing. And yet there is something different in this story from the ones above. As we move through the city, as we quickly visit spots, our movements are attracted by The Mill, the center of our walk's gravitational pull.

"Chill spots" like The Mill are somewhat rare: unsanctioned writing spaces that have been sustained across generations of writers. These spaces

2.6 SPIN × 4CAST. Photo by Charles Lesh.

are often produced in locations off the beaten path, in areas not likely to be visited, or even stumbled upon, by nongraffiti writers. Often, they are spots where "regular people," as MYND calls them, would not want to go, where they would not want to be associated with or seen: blemishes, stains, bridges, abandoned tunnels, shuttered warehouses, or isolated mills.

Unlike hot spots, which are produced by bombing, chill spots are produced and sustained in large part by "piecing," shorthand for the rhetorical work that surrounds the production of a "piece," which in graffiti parlance is short for masterpiece. A few months after my first visit to The Mill, I ask TAKE to define *piecing*.

> Piecing allows you to go wild and interpret an E however you want to see it and still get praise for it. If you took some of my Es and you wrote them as if they were just a letter in the alphabet, just signing your name, ordinary people would be like, "What the fuck is that? That's ugly." But because I put it there, and I put a 3D on it, and I have this dope fill, all of a sudden it has this flavor. All of a sudden, you're like, "Oh shit, I didn't know you could do that." I talk to the younger cats and say, "There's a point when we're learning to read and write when we're trained to look at things and say, 'Ok, that's the letter E. Or that's an A. That's how you're supposed to write it.' But as a graffiti writer, you have to toe this line of legibility so that it makes sense to the person looking at it, but it's funky enough to make them say, 'Yo, that's dope!' There's a science to toeing that line.

As opposed to "piece," which is the text itself, piecing denotes writing, reading, and interpretation. It involves taking standardized, strategic letters and readerly expectations—and indeed, as TAKE notes, a literacy education—and bending them right to the point of breaking.

> LIFE: Lettering in particular, the alphabet has a certain reason for the way those shapes are assembled. And they mean something, right? But then how far can you take them until they don't mean anything?

This literacy subversion makes sense because, as TAKE notes, you put it *there*, it's situated in a piece and in a chill spot.

This stylistic sophistication works to mark these spots as solely for the community; not only would nongraffiti writers seldom visit these sites,

if they were to encounter these texts—on the internet, perhaps, where images of chill spots often circulate (Ferrell and Weide 2010, 56; Mac-Dowall 2019; Snyder 2009)—they would still lack the literacy skills necessary to engage fully. They wouldn't be able to "read the style," as HATE once described it to me. In this sense, chill spots are community spaces because of their geographic locations and also because of the stylistic sensibilities that these locations afford. Consider LIFE's discussion of how graffiti writers engage in piecing within chill spots.

> But there is something about balance, when somebody could fucking write their name in a way that might take you a second. But you definitely saw one of the letters, and that got you hooked. And then you were like, "What?!" And it got wild enough, but it was still friendly enough to be like, "This is what I am. I am not combative. I'm not trying to hide from you. I want you to understand what I am and be respectful to the dope lettering that we've all come up with as humans."

One day while piecing at a warehouse spot, NIRO told me that pieces should be "conversation starters" with other writers. From then on, when I visited chill spots, I asked: what conversation is happening here?

Like all conversations, chill spots organize their own set of rules, their own uptakes organized around community-based determinations of textual and community value. In an email exchange with RELM, the legendary Lynn writer tells me that the fundamental rules of spots can be visualized simply:

> Some of the most important rules of the game are as follows. Throwups over Tags > Pieces over Throwups > Burners over Pieces. What that means is basically, if you go over someone, you better do something better than what they did or it's beef. The idea is to constantly elevate the art. To always push forward with a spirit of competitiveness and not let the toys overrun the spots. It's also to establish a hierarchy. The writers whose pieces burn the most will ride the longest.[5]

5. A "toy" is an insulting term for a writer who lacks abilities or lacks knowledge of the local writing scene.

What RELM articulates is a genre-based, community-based rule for graffiti writing; the way a writer interacts with, and takes up, existing writing is to identify the genre and either produce something more elevated or leave it alone. This is not a static rule that governs all spots, of course, as a host of other factors such as local history and shifting chronotopic conditions influence how writers interact with existing texts. But what is significant here is that writers learn these rules through their own experience with writing and with the community (Ferrell and Weide 2010, 55). That is, writers themselves, in pedagogical spaces of their own making, construct and learn systems of uptake that organize texts hierarchically and meretriciously, in ways that deviate dramatically from the rules that govern the naming of space in New Boston.

Chill spots provide temporary, if uncertain, stability, and allow writers to more fully engage in the literacy work of graffiti. If bombing produces spaces that announce location and multiplicity to a range of audiences, piecing produces spots that wink to other members of the community, announcing that something more is happening here, something to be read. In chill spots, writers engage in a literacy education far beyond the classrooms of the Athens of America. As they are sustained over time, through this reading and writing, chill spots begin to develop their own social histories beyond those emblazoned on the plaques, monuments, and memorials of the Cradle of Liberty. To that end, another walk.

The Handball Court

Talking to writers, chill spots, both past and present, were a topic of unending reflection. As just one example, it might be useful to walk to the South End, a neighborhood that has undergone, and continues to undergo, significant gentrification over the last few decades. There, you will find Peters Park, a legendary graffiti spot.

On an unseasonably warm day in May, I walk to Peters Park after receiving a text from BOWZ, who is there painting with GOFIVE, TAKE, and SOEMS. As I approach, I say hello through the chain-link fence and begin making my way to the entrance. From outside of the handball courts, I see the vast mural being completed. The background is

2.7 Peters Park in Process. Photo by Charles Lesh.

a collection of multicolor tiles and the foreground a woman draped in the American flag. Two birds appear on either side of her, each taking flight in opposite directions (fig. 2.7).

Talking with the writers that day, I learned something of the significance of this place. Peters Park is most closely associated with the ALA crew, and writers ground their histories of both the graffiti community and the larger city through histories of that space.

TAKE: Peters Park is part of ALA's history. It's tied to ALA's history. It's tied to so many different things. It's tied to gentrification. It's tied to racism. There are so many ways to talk about the wall.

But if you're talking about it as a graffiti writer, it was The Apollo. It was where everyone went to see the dopest shit. Or be part of the dopest shit. I remember being a kid, and you would have fifty, sixty, seventy people chilling in that park, just looking at dudes painting graffiti. Just hanging out. And when you talk about people, you're talking about people from different neighborhoods. Different fucking gangs. We're all here just to watch this happen. And even the kids that were from, say, the other side of the tracks, they came down to check it out. Everyone knew about it. People from outside Boston would come, outside of Massachusetts, and make a stop there. It was for Boston graffiti, it was the center of it. It became our Writers' Bench. Where we met new people, met up with old people. To be safe. To deal with whatever emotions we wanted to. Just to do dope shit.

In this history, we see the collision of places like Peters Park with entrenched place-based narratives. It is here, not in the classrooms of the Athens of America, where writers are channeling their writing energies. Writers come "from outside Boston" and from different neighborhoods, resisting the divisions of the Melting Pot. And in its history, in its ability to generate a historical narrative beyond those sanctioned by the city, Peters Park stands as a community landmark beyond the exclusionary historical narratives that are routinely memorialized in the city.

Despite the significance of this space, or perhaps because of it, Peters Park remains precarious, caught between the graffiti community's production of space and that of urban authorities. At the beginning, the space was tolerated (through community activism and support), but still technically illegal, demonstrating the implicit instability of these chill spots: stable, but only for a time. Unlike The Mill, Peters Park is highly visible, and visible within a rapidly gentrifying neighborhood.

CHARLIE: How did the city respond to it?
TAKE: I mean, the same way the city responded to most things when you deal with people of color, that they want to deem illegal.

There were plenty of times when the Boston police came and took our paint. There were times that the people walking their poodles would call the police on us because there was a group of Black and Puerto Rican people. Or because we didn't have permits. We had all of those issues. But luckily, we had people who fought for us, to continue allowing us to have that space.

In the episodes that TAKE describes, and the ones that show up in newspapers, the contiguous nature of chill spots is plain. Although they are community-produced, they are also suspended within the shifting social landscapes and narratives of Boston: gentrification, so-called development, racism, and other enactments of control, division, and discipline. This is painfully evident in a 2007 *Boston Herald* article documenting a $1.2 million dollar renovation project enacted by the Boston Parks and Recreation Department that removed the original graffiti wall from the park.

Members of the African American Latino Alliance, who have used the wall as their canvas for 20 years, are dismayed. They say the wall not only helped them elevate their artistic talents, it changed their lives by keeping them away from drugs, vandalism and prison.

Now the city wants to turn over a replacement wall to approved newcomers. In May, the Parks and Recreation Department bulldozed the Peters Park graffiti wall, replacing it with handball courts. In December, a mural for one side of the handball wall will be commissioned. Now the ALA must submit a proposal and hope it's chosen . . .

Last week, 20 ALA members went to Peters Park and stood on a patch of crushed rock, remnants of their wall. Lee Kleinman, a five-year resident of the South End, approached them with her poodle.

"I hope you're not planning on painting stuff on this wall that is offensive and racy. There are children who play in this park," Kleinman said. "This park has changed a lot. It's a wonderful place now." (Fiorentino 2007)

Peters Park, and spaces like it, deserve a far fuller discussion than I can offer here.[6] And, as I've already argued, it should be a writer that tells that

6. For work on Peters Park's role in the graffiti community, see Daniel (2017).

story, not me. But Peters Park shows how writers continually make writing spaces: venues, participants, and outcomes. Although they are constantly under pressure, these spots provide crucial community resources: a space to write, to revise, to socialize, to move, to learn, to read, to memorialize. As they exist, these spots offer a glimpse into different sorts of writing spaces. They offer hope for a new engagement with writing, new literacy work. New spaces for writing, new spots by writing. Two birds, taking flight.

The Lab

At 2:45 p.m. on another cold day in December, I leave Northeastern to meet GOFIVE at the Madison Park Vocational School, a Boston public school located in the historically Black neighborhood of Roxbury. On my walk, I navigate a familiar shortcut: *turn left at the police station; right at the housing complex; right at the Whittier Health Unit; cross the football field; and walk under the footbridge.* Opened in 1977, Madison Park is a vast and imposing campus. GOFIVE, a former student and now teacher at the school, once told me that school has the distinct feel of a prison, given its brutalist architecture and dull gray stone devoid of much noteworthy ornamentation.

The reason for my trip lies on the northern end of campus, beneath the distant view of the downtown skyline, where two school buildings meet in an incongruous pattern and form a courtyard in the interstices. The courtyard space is vast, roughly 150 feet long with walls as high as 20 feet on the south side. I enter the courtyard through its only point of arrival or egress: a driveway tucked under a pedestrian walkway. The physical makeup of the courtyard makes it an ideal chill spot for graffiti writing. Its substantial distance from any major roads ensures a degree of privacy and protection from unexpected pedestrians or police. The size of the courtyard and its concrete composition offers writers vast amounts of wall space, as well as a surface that holds spray paint remarkably well. As I enter the courtyard, I read GOFIVE's latest piece that reads "THE LAB," a nickname for this spot on account of its proximity to the school's science labs. As I enter the courtyard, I am immediately confronted with an array of pieces.

2.8 SENSE × GOFIVE. Photo by Charles Lesh.

The first time I visited The Lab was Labor Day in 2014. It was stifling hot, and each writer there—SENSE, TAKE, TIME, ODESY, IMAGINE, GOFIVE, and DAYZ—sought intermittent refuge from the sun. As an excuse to introduce myself to the writers I didn't know, I would routinely go and buy water from the nearby bodega. Trying to make myself useful.

SENSE, who I had met several times before that day, asked me how my research was going. When I mentioned to him that I was starting to introduce graffiti in my first-year writing course, he said, "Yeah man, this is my favorite kind of writing: a bunch of people with spray cans writing on the wall." I watched him write that day, the last time I had the opportunity to do so before he passed away (fig. 2.8). When I complained to SENSE

about the heat, he laughed. "Some people would rather be at the beach on Labor Day," he told me. "We'd rather be wasting away in this concrete jungle." I texted this to myself to remember the exact wording. The piece he painted that day is gone now, replaced by a fresh PROBLAK piece. One piece over another. The Rules.

As I wait for GOFIVE on this considerably cooler day, I walk circles around The Lab, taking flicks, reading the new pieces, the new styles. Only the TAKE piece survives from that first Labor Day. All of the other pieces have been reduced to layers in The Lab's palimpsest. Three kids of high-school age, likely students of the school, shuffle into the courtyard and begin taking pictures. We don't talk, but I hear excitement in their voices as they leave while discussing posting the pictures to Instagram.

GOFIVE rides in on an electric bicycle borrowed from his neighbor. He wears his characteristic work boots, jeans, hoodie, and winter beanie. We slap each other up and I hit the power button on my tape recorder and rest it on my left palm. GOFIVE tells me that, historically, the material-spatial affordances of the courtyard made it an active space for graffiti writers in Boston long before it was recognized as a legal spot. Years ago, the space was populated with collections of writing from well-known writers. It was writing that had motivated GOFIVE's initial interest in graffiti:

> When I was in high school at Madison, there were a few pieces down here. There was a HOPS piece here, a VEXOR piece there. That was my inspiration. I was like, "Yo, this is so dope." That was kind of how I started loving graffiti.

Upon returning to the school years after graduating, GOFIVE was discouraged to revisit the courtyard:

> When I started working as a substitute, I took one of my classes here . . . and it was just really shitty. There were needles. It was disgusting back here. There were some [graffiti] writers who would come here, but it was just throwups . . . Mostly, it was just scribbles. So, yeah, there were a bunch of scribbles on the wall. Human waste. Needles. Broken glass everywhere. And come to find out, some of the classes from [the high school] do experiments here. The cheerleaders used to warm up here.

> Pop Warner used to bring young kids down. And there are needles, all
> this crap, and there are kids down here.

The courtyard, through the years, had transformed into a different sort of
space: formerly a chill spot for producing, admiring, and reading graffiti
writing, for piecing, the place had become notorious for drug use, the
graffiti mainly "scribbles" by nonwriters.

This spatial transformation signaled to GOFIVE the potential for
another spatial revision. GOFIVE looked to piecing as the catalyst for this
transformation. He secured permission from the school to make this a per-
manent and legal graffiti spot; aware of the drug use, the administration
was willing to try anything. Writers from the GN grew (a crew with deep
ties to ALA) produced a first round of pieces. The spatial (re)production
via writing was almost instant:

> So, we took some brooms and started cleaning it up. And once we
> started [doing pieces in the courtyard], the school went crazy. Teachers
> said, "Oh my god, this is so beautiful. Can we get more?" It was a good
> start, and the courtyard has become a place to be.
>
> We've been here for three years. The first few months, it was nasty
> down here. After we cleaned it up, it pretty much stayed clean, until this
> year. We took a little time away so we wasn't here as much, but when we
> came back, I found two needles in the corner. But that's it. Before it was
> almost twenty needles, and now it's two. So it's good, but not perfect.

Being fully legal, The Lab is no doubt different from the other spots
explored in this chapter. In this sense, it's a fitting endpoint as we've moved
from the most emergent, least stable writing spaces to this, the most stable.
Because of this stability, and the subsequent visibility, the rules govern-
ing the spot are less unspoken and need to be communicated beyond
the immediate community. When I entered The Lab on that first day,
I was greeted by a wall reading: "The Lab. No! No!! Nooo! PAINTING
BY INVITE ONLY . . . PAINTERS, LEAVE NO CANS!! TOYS WILL
PREVAIL."

Despite this legality, The Lab still signals a direct link between writ-
ing and spots, between the circulation of texts and the productions of writ-
ing spaces. Piecing made this space a spot. We see here the ways spots can

reject dominant iterations of writing space, including those most familiar to us in rhetoric and composition. The Lab is an educational, pedagogical space; both its name and its location situate it within the Athens of America narrative. Yet this is decidedly different than any composition classroom in the adjoining school. Here, the writing is not governed by academic rules but by community-based determinations of value, uptake, and style. It puts the institution in a different relationship with the surrounding community. It's less a community-engaged writing space as much as it is an institutionally engaged one. Here, the *community engages the institution* and not the other way around.

In this engagement, a new vision of writing, writing pedagogy, and a theory of writing and space emerge, a vision based on community knowledges and practices, one I have attempted to trace on these walks. As we make our way to the walking bridge overlooking the courtyard, GOFIVE turns to me and says that these pieces make the school seem less prison-like and more like a space for creative activity, for writing. He adds, "It all started from what we did with graffiti." As we make our way to the bridge and look down over The Lab, we remark on the size of it, how it seems somehow smaller now that it is covered with writing. As the sun sets over the large smokestacks in the corner, GOFIVE shares with me a plan to paint them to look like a pencil, a pen, a crayon, and a marker. Writing tools, in The Lab.

Walks

In the preface to the first and second editions of his history of Boston, Walter Muir Whitehill describes a nameless traveler's approach.

> Even from the bridge one gets only a momentary hint of the shape and pattern of Boston, for with the pressure of fast-moving lines of traffic suddenly one is in the city. The brief happiness of the distant prospect is over. Unless one succumbs to the wiles of the traffic engineer and continues on out of town to the southward, one must come down from the heights and crawl through crowded streets. (1968, viii)

Bostonians understand this descent. Peering at the city from across the Charles River from Cambridge, Boston takes on something of a coherent

identity: a collection of patterns and shapes that, woven together, form an urban tapestry. Yet cross one of the bridges into the city and that coherence recedes into lived experience. As you walk, distant patterns become felt textures, and the ostensible rationality of distance is replaced with the fragmentation and multiplicity of nearness.

Just as the strategic and tactical scales that Whitehill imagines limit his portrait of the city—surely a lot happens between these scales—so too does my own rendering of the city through the various walks we've taken. Here, I've worked to show how writers produce an alternative city through the constellation of diverse writing spots, produced directly by their own literacy practices and genres of writing. I have only scratched the surface. If a spot is a fragmentary difference within a larger pattern, then this chapter itself is a just a spot of a spot, a slice of the constellation of spots that exist, have existed, or will exist.

Yet even with these limitations, spots can teach us something about public and community work, namely that through the sustained circulation of writing, new spots are invented and become new writing spaces that call forth different public arrangements and social landscapes. Spots ground our work on space, place, and writing more intimately in the experiences (and vocabularies) of writers working to make and sustain these locations and in the potential for more multivocal and participatory rhetorical landscapes where different writing is composed by different writers.

What is imagined by these spots is not a city in which writing circulates in the margins or in the spaces it has roped off and "made" for itself but a new kind of city organized around spots and all of the literacy work they require and afford. An attention to these spots, these emergent venues, participants, and outcomes of writing next to other, sometimes hostile, writing spaces, can help us puncture the seemingly transparent ways that cities and other spaces of writing (classrooms, writing centers, universities, etc.) are organized and to glimpse alternatives. By partnering with writers, walking with them as they produce these new constellations of spaces, our efforts might provide different models of engagement that afford new possibilities for community and public writing.

This is not easy. Our disciplinary access to the spots and spaces like them are often limited. But they do exist, however fleetingly and

emergently. In a time when cities are increasingly privatized (Brenner, Marcuse, and Mayer 2012; Mitchell 2003; Welch 2008) and even militarized (Graham 2011; Iveson 2010b), it is important as researchers to partner with writers in new and sometimes risky ways as they work to make alternative rhetorical landscapes. This might require new forms of community partnerships, ones that might look less like a writing group and more like looking out for cops at 2:00 a.m. on the side of a highway. It might require us to hop a few fences, to paint a few walls, to take a few walks. But, if Wells (1996) was right that we as researchers and teachers of writing must take part in building the publics and counterpublics we wish to participate in, then we also need to participate in building the spots we need. My guess is that we won't find them on Google Maps.

Community Interlude 2

Bombing

Spots, like the writing that produces them, can be temporary: here one day, gone the next. The walks we took in the previous chapter are almost certainly already revised, constellated by new spots, new writing. Pieces, tags, and throwups get written over in the collective urban palimpsest or by city officials who buff the writing with gray paint—so ubiquitous a sight in Boston that, if you aren't tuned in, you might think it serves some larger purpose in urban planning.

Though writers no doubt look for spots where their writing might survive—and, as I've argued, some spots develop a reverence due to their perseverance—LIFE once told me that he finds something empowering in this process of production, erasure, and reproduction, something creatively enlivening about the tactical, fleeting nature of writing.

> But there is a raw, good feeling when you know that something is going to go over it again. You kind of feel not so attached to it. You feel like you can just kind of let out anything. A lot of times your style evolves that way, because you are not so afraid.

As a teacher of writing, I hope to cultivate that attitude in students with their drafts. As writing continually springs up, the city reveals itself in a writing process, of always already being revised. The writings spaces of Boston will be different by the time you wake up. After a draft of this book was completed, SPIN texted me that The Mill—which he said used to

be called simply the "Hyde Park Spot"—was torn down as part of a larger neighborhood "redevelopment" project. *New Boston.*

This Community Interlude includes images from The Lab that I took with GOFIVE. Two writers—SPIN and RENONE—talk about their own writing processes and reasons for writing, their own experiences in this collective production of (writing) space.

The Lab

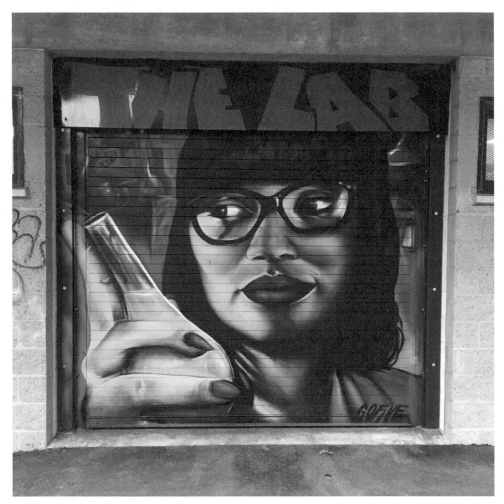

2.9 "The Lab" by GOFIVE. Photo by Charles Lesh.

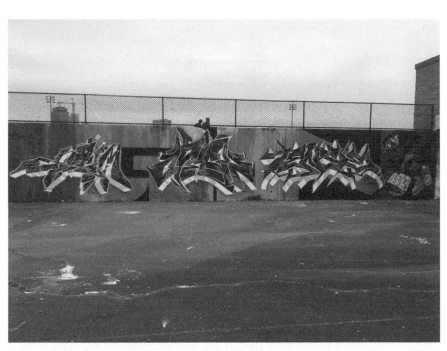

2.10 SOEM, ODESY, TENSE, PROBLAK. Photo by Charles Lesh.

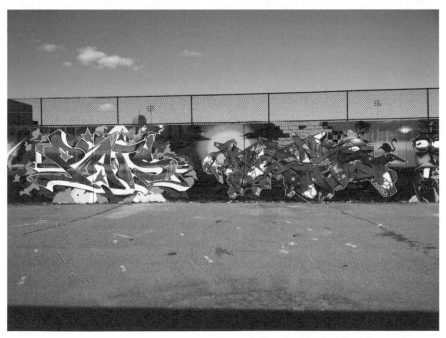

2.11 PATS × KEMS. Photo by Charles Lesh.

SPIN: I'll tell you about painting the old Forest Hills wall in Jamaica
Plain in 2007.

This place was always my favorite spot. I grew up in the
neighborhood and was looking at that wall before I ever wrote. It
was a long rambling wall with long sections made of sheet metal,
poured concrete, and cinder block. It faced the Orange Line as
you come into the last stop. There were some serious burners on
there that I knew were done at night because it was so visible dur-
ing the day. When I started really paying attention there was a lot
of old stuff on there that never got buffed and some more current
guys like SEM and COMA, ALONE and REZENT, TEAZE
and DANCE, EXACTO, PLUS, CHENO, TARGET, etc.

First halfway legit piece I did on there was in '99 with
MYND and CR. That rode for about seven or eight years. So in
2007, I went back to do a new one with 4CAST and IVEY. Since
there was such limited wall space, IVEY ended up painting a cou-
ple of hundred feet down the wall to the left of me and 4CAST.

Everything was going smoothly when at about 4:00 a.m., I
could see a light coming along the bike path across the tracks
from us. I was well aware that State Police patrolled that area.
We got very quiet and just watched as it got closer. When the
light was almost directly across from us I realized it was a tricycle
and the rider was none other than Louie. You'd always see this
guy riding all over the city on his tricycle making this loud ass
wailing sound every three or four seconds as far back as I can
remember really. This night at 4:00 a.m. with no one around,
he was silent. As we realized it was him we both started wailing
like him. In response he immediately took over the wailing. He
continued doing it as far as we could see and hear him.

We went back the following night because IVEY didn't
finish before it got light outside (always a slow painter). Plus
we wanted to clear out some trees and underbrush so our stuff
would be more visible when the leaves grew in in the spring.

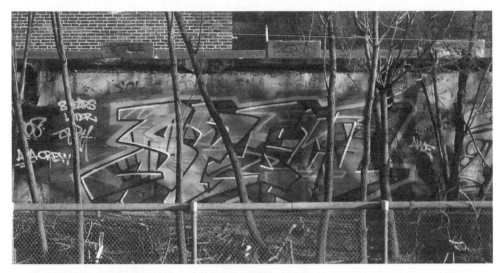

2.12 SPIN, Eight Years Later. Photo by SPIN.

We got MENT to roll that night too. He was painting some less involved stuff standing on a fence way to the left of us three. Everything was going smoothly when suddenly MENT was running by us yelling, "5–0 Bounce!!" I was like what the fuck? 5–0 in here? really? I instinctively started running behind him and when I looked back there were two headlights, in the spot, on the path bouncing along toward us. It was surreal.

We bolted and when I got out to the street I kept going. I was thinking there is no way in hell I'm going down for this. I ran all the way past the station and hopped in a parked taxi with a snoozing driver. I said, "Rosi, son," and was on my way (fig. 2.12).

RENONE: For this interlude, I really wanted to interview my friend, the writer DANCE QUEEN. To me, DANCE was the epitome of a true ride or die. She was always down to paint or go on an adventure. Bombing alone was always the best for me. But second was going out with her. I met her during her breakup with TEAZE. I was also in the middle of a breakup with my

boyfriend at the time, so it was kismet that we found each other.
I was in awe of her talent. Her characters to me were the most
beautiful things. Her apartment was filled with paintings by her
and TEAZE. They were all so interesting and varied and crazy
and dope.

Together, we would go to the club, usually Lansdowne. True
to her name (and the other thing we shared), she loved to dance.
We would stash cans in a secret spot and retrieve them when the
clubs closed. We would bomb all the way back to her apartment
in Mission Hill.

There are too many bombing stories to tell. It was with
her that we almost got killed by a commuter rail train next to
the Mass Turnpike. It was with her that I filled a shopping cart
full of empty cans of paint. We took turns pushing each other
around our neighborhood, putting on old clothes to appear like
old men so that we could paint in Mission Hill unbothered and
late at night.

It was her who threw a chair across a bar to intimidate a
dude (another writer) who wouldn't leave us alone and was
encroaching on our writing time. She would've punched him,
and no doubt knocked him out, if I hadn't reeled her in. It was
with her that we rode on the backs of some guys' Harleys when
we needed a ride home and the trains stopped running. It was
too far for us to walk.

We listened to, encouraged, and motivated each other.
When the rest of what seemed like our whole world at the time
was talking shit, or crumbling around us, we had each other's
backs. As a general loner, she was the closest thing I had to a best
friend and a paint partner. Those nights were a golden hour, one
that we will both never experience again.

One night, walking around aimlessly with her, she pointed
out to me these HUGE advertising signs. I had passed them
daily, knew they were hand painted, but had not given much
thought to them. She pointed out her full name in the small,
right-hand corner. She had been commissioned to paint many of

these signs in and around Boston. To her, it was no big deal. To me, it just shined more light on her talents and abilities.

It also changed the way I look at spaces. Seeing her name on buildings used to be a comfort to me, and on these signs, it still remains a comfort to me. If I am in a neighborhood and see her work, I'm put at ease. It creates an intimacy with the areas, as if she is still out there with me. I talked to her about this a while back. She was supportive, but for her, it was all a memory that got lost and caught up in other things. After she left Boston, things were not so great. But that's her story to tell. She's alive and well, and I am very proud of her.

I'm reminded that we as women need to lift each other up, hype each other up, and tell our own stories and histories, as it's not going to be shared if we don't. WE must take up and carve out our own spaces and make them safe for others who follow behind us. I couldn't imagine talking about my own writing without mentioning her. She was that for me, way back then. Now, it's my turn to make sure her legacy isn't forgotten, either.

3

Bible

Bible (*n.*)
 I. Senses relating to Scriptural text.
 1a. The Scriptures of the Old and New Testaments.
 2. A textbook, an authority (of religion, politics, etc.); a
 sacred book.
 3. A large book, a tome, a long treatise.
 4. (Nautical slang) A small piece of sandstone used for
 scrubbing decks, a holystone.
 II. Senses relating to libraries.
 5. A collection of books; a library
 ("Bible," *OED*)

Cambridge

Let's go back to Kulturez. It's a dreary, rainy day in May, and my socks
are damp as LIFE, BONES, and I stand around the counter. As I set up
my audio recorder, the conversation has already begun: about my project,
the current state of graffiti in Boston, and the career that LIFE has had,
from bombing Dorchester and brushes with the law to a celebrated art
career that has transcended mediums. The conversation quickly turns to
blackbooks, and LIFE tells me the story of the first time he encountered
one. As he reflects, he paces back and forth around the shop, alternately
tapping his fingers on my own blackbook—which, as it often is, is sitting
on the counter—and adjusting his black Kangol hat.

> One of my first memories of a blackbook, I was in the company of
> CLICK. He's one of Boston's legendary, oldest writers. I was at DYC,
> which was a youth club in Dorchester that I used to go to. It's a Boys-
> and-Girls-Club type thing. So DYC had this graffiti piece in the back.

They used to have a crew called NSP, North Side Posse, just like the rappers and dancers at that time who used to hang out there. I was part of NSP later. CLICK did this graffiti mural in their back room, the place where they used to practice dance moves and shit. Big Daddy Kane times and that shit! There were these dope letters, "North Side Posse," in pink, light peach, and a maroon outline or something like that. It was just the dopest dead letters, and *CLICK* did it.

And later I remember he came up. He was in there and he had a bible. He had a blackbook with him, and it was crazy. It was all pen and markers and pencils, with tags all over the front. It looked like a bible, like some sacred object type thing. It was bumped up and stuff. I was like, "What's that about?" Things were coming out of it, glued on stuff. I could tell that there were pages that had stuff on them. So, I actually go over his shoulder—I was just a young kid at the time, like twelve, thirteen—and I remember he opened up the pages and it flipped out. He had made a centerfold kind of thing in a blackbook. And it was trains and fucking train lines twisting through the city and all this fucking dope lettering. Some of the rawest graffiti I ever saw. I couldn't believe it.

So, I was like, "That's fucking dope." And I remember knowing. I kind of associated it. I knew he was a graffiti writer and I knew that must be the way he practices.

As LIFE concludes the story, he starts, almost instinctively, to write in my bible: a quick, red and white rendering of his name, smooth, flowing, and effortlessly cool (fig. 3.1). LIFE style.

Readers familiar with the work of Clifford Geertz (1973) might recognize the intricate layers of research here. Me, an ethnographer studying graffiti writing, watching LIFE write, listening to his stories. LIFE, many years ago, an aspiring writer, adopting a familiar stance. "The culture of a people is an ensemble of texts," Geertz writes, "themselves ensembles, which the anthropologist strains to read over the shoulders of those to whom they properly belong" (452). If Geertz is right, if culture is ultimately written, then LIFE's early memory locates the blackbook—or *bible*, as Boston writers call it—as one of the community's foundational texts. And, as I'll argue here, one of its most important writing spaces.

Broadly defined, a graffiti bible is a collaboratively authored notebook that, while individually owned, circulates through networks of writers. In

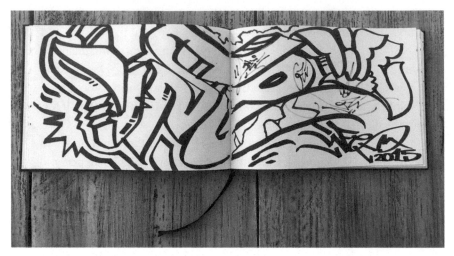

3.1 LIFE Bible. Photo by Charles Lesh.

bibles, writers practice their own writing, share writing with others, and archive writing. Masking this complex social function is a relatively uniform and inconspicuous material makeup. Typically, a bible is a hardbound notebook with blank pages ranging in size from 6" by 8" to 18" by 25", with the most common size, in my experience, being 8½" × 11". The exterior of the book is almost always entirely black—unless a writer chooses to tag it, as in LIFE's recollection—with little to no exterior ornamentation besides a pebbled finish. There is, of course, room for object variation. Some writers I have met carry red blackbooks, blackbooks with pages of train outlines (which I discuss in chapter 4), or just collections of loose-leaf paper held together by paperclips. Still, the typical bible resembles a nondescript composition notebook.

Despite this mundane appearance, bibles house a series of dynamic, coterminous, and overlapping writing spaces, each a venue, participant, and outcome of writing in ways not unlike the constellation of spots explored in the previous chapter. And like spots, each writing space within the bible differently reflects and promotes core community writing goals: style development, circulation, and preservation. I organize this chapter around these writing spaces within the bible, referring to them with terms I've adopted from writers: the practice page; the traveling gallery;

and the talismanic archive. I argue here that these spaces serve as additional cartographic nodes in an emergent writing city, a *New* New Boston as BAST calls it, beyond the dominant spatial politics of Boston explored earlier. As we drop in and out of scenes in this chapter, inhabiting these spaces, we'll find alternative pedagogies and pedagogical spaces, alternative mobilities, alternative aesthetics and economies, each of which position the bible as a rhetorical elsewhere to the exclusionary writing spaces of Boston.

Still, there is something different here. As writing spaces, spots are visible, or at least accessible, to a broader audience and generate much of their rhetoricity based on that announcement of location, that announcement of "Here!" Bibles, though, are intensely fortified and shielded; they are strictly for writers. As such, they skate that blurry and constructed line between private and public writing.

It might seem odd to focus a chapter of a book about (counter)public writing and spatial politics on a notebook rarely seen outside of the community. Yet this lack of visibility is precisely the point. If we are, as I advocate in this book, to attend to the ways that writers are all the time engaged in the production of writing spaces, then the diversity of the spaces we attend to will grow considerably: not just those most visible in our scholarship, our institutions, or our towns but also those emergent, sometimes ephemeral, and risky spaces that exist outside of our disciplinary gaze. That is to say, community writing spaces don't always look like kitchen tables, recreation centers, street corners, public squares digital or analog. Sometimes they look like a group of writers, huddled in a circle, furiously passing around a series of nondescript, blackbooks. Although this might not involve directly writing *on* the city, it nevertheless contributes to the writing *of* the city, the cultivation of a city's diverse writing spaces and landscapes.

Bibles

Though they go by many names—piecebooks, sketchbooks, bibles, and others—blackbooks have been around since the very earliest days of graffiti writing. Traces of their existence are evident in early graffiti media. The iconic 1983 documentary *Style Wars*, for example, shows groups of

young writers at the "Writers' Bench," Grand Concourse 149th Street Station in the Bronx, passing around blackbooks and discussing writing (Silver 1983). Craig Castleman (1982), in his analysis of early subway graffiti in New York City, likewise recognizes the seeming ubiquity and social function of these writing journals:

> Every writer would like to be known as having good style, and most writers devote long hours to practicing piece design in sketch pads and notebooks. Many writers also spend a great deal of time sitting in subway stations watching and criticizing the pieces that go by, passing around their sketches, and "autographing" each other's "black books" (hardbound sketch pads that almost all writers carry with them). Many writers put a great deal of care into these autographs, and a writer who does an exceptionally fine drawing in one of them is said to have "burned the book." A "burner" in an autograph book reflects well on both the artist and the owner of the book. (21)

Blackbooks have been around and continue to serve as a social conduit through which writers practice and network with other writers. As a general rule, I've learned that where there are writers, there are blackbooks.

It is curious that despite this historical and contemporary significance, blackbooks have received relatively little attention in the vast scholarly literature on graffiti.[1] They have not been invisible; scholars like Jeff Ferrell (1996), Gregory Snyder (2009), and Jessica Nydia Pabón-Colón (2018) have all differently recognized the individual and social roles that blackbooks play. More often, though, I find that blackbooks are treated in scholarly literature as a means to get at something else, a step in a writing process that eventually leads to other, more visible writing.[2]

1. The blackbooks have fared better in popular publishing. For example, Sacha Jenkins and David Villorente (2008, 2009, 2011) have produced three books that reproduce examples of blackbook pages. Colin Berry's (2001) article in *Print* magazine, "Black Magic," which I came upon late in this research, is an excellent source on the significance of blackbooks in graffiti communities and the myriad roles they serve.

2. Or the blackbook has been treated as largely a vestige of the past that has now been effectively replaced by social media as the primary means through which writers access the work of other writers (e.g., Ross et al. 2017, 416). I tend to agree with Pabón-Colón

I think this is a mistake, though an understandable one. Most work on graffiti approaches the subject with an emphasis on urban space, the ways that writing morphs and adapts alongside a city's evolving spatialities (e.g., Ferrell and Weide 2010). But this rhetorical dexterity extends beyond the discernible boundaries of the urban. This is unsurprising to me; writers, as Iveson (2007) notes, "have demonstrated a remarkable capacity to 'map' new opportunities for 'getting up'" (126). Community writers have a way of doing this, and work in rhetoric and composition has long attended to writers developing and circulating texts within spaces of their own making. Frank Farmer (2013) sees it in anarchist zines. Carmen Kynard (2010) sees it in "sista-ciphers." Paula Mathieu and Diana George (2009) see it in street papers. Steve Parks (2010) sees it in community publishing. Attention to graffiti from a writing studies perspective invites us to attend to the ways that texts themselves provide infrastructures for community space, to the ways that writers use writing to formulate not only oppositional discourses but also writing locations in which community voices can circulate.

As one such space, the blackbook holds an almost revered stature within the graffiti community. Writers *love* their bibles. TAKE and I talked about this affection that writers have for their bibles, and he described it like this: "My wife legit knows, all of my old blackbooks are in a bag in a specific place that is close to a fire exit." In case of emergency, save the blackbook. Boston writers honor this significance by commonly referring to blackbooks as bibles. Upon first moving to Boston, I was surprised to hear this term. As I elaborate in "Warehouse," I first encountered a blackbook in Buffalo, New York, where I grew up. Early in high school, I was staying temporarily with a friend because of a series of family evictions. At his kitchen table one night, he showed me his blackbook and introduced me to graffiti writing. Though I never became an active graffiti writer, since then, I have regularly maintained my own blackbook. Moving to Boston and beginning this study, once I gained a certain level of trust with

(2018), however: "The Internet has not replaced a marker and a clean piece of sketch paper, but it is an added space where writers can practice, share, critique, and communicate with one another" (112).

writers, I was regularly asked, "You have your bible?" I had never heard the term applied to blackbooks before.

The usage of the term, though its origins are shrouded in mystery, makes a certain sense. There are, of course, the Puritanical roots of Boston, so steeped in biblical adherence. "In the early stages of Boston's history," Thomas O'Connor (1991) writes, "it was always the rule of the Bible that came first" (25). More so, perhaps, the word signals the centrality of the book in shaping community identity, particularly in Boston. Boston hates graffiti, remember? In a city so aggressively antiwriting, spaces like the blackbook are crucial, and in (re)naming them "bibles," writers in Boston signal the urgency and centrality of the writing space within a specific geographic context.

Throughout this study, I asked several writers for their own thoughts on the term, as I was eager to capture their own theories on how it connects to the larger spatial project of writing. The answers varied. Some connected "bible" to a deeper, spiritual understanding of the book. Others offered personal interpretations of what the bible means to them, in their own writerly development and lives. Others contended that the term was a way of foregrounding the social nature of the space, that the bible was a location where writers come together in the production and interpretation of texts and histories. And still others simply remarked that they called them bibles because writers around here have always called them bibles and that I shouldn't give it much more thought than that.

All of these answers are nonetheless instructive in offering a community perspective on the importance of the writing space itself. To that end, before visiting the practice page, I want to give an uninterrupted glimpse into writers' own insights on the term and the writing space.

> HATE: And my books were sacred.
>> That's why we call them bibles, too. This is a blackbook, or we call it a bible. "Where's your bible at?" This is my bible, man. I don't fucking give it to no one. Sacred to writers. Your bible is everything.

<p style="text-align:center">⸺⸻⸺</p>

> LIFE: There are people whose bibles, those books are sacred.

BAST: In Boston, we call them "bibles." So, they are imbued with
that, I won't call them holy or sacred, but they are certainly talis-
manic. There is certainly something special about them.

ACOMA: We wanted to look at it like that. It was a bible. Bible was a
name that we gave it because it was so important. The bible is a
very important thing, you know? If I die, and two hundred years
from now somebody finds [my bible] they can probably learn how
to tag like me. You know, somebody found the Bible, you learn
how to live like Jesus did. That's why, you know? Cause we just
wanted to build it up to be like, "Yo, this is my bible."

TENSE: Because that's the book of your life, you know what I'm say-
ing? It's the book of your style. It's supposed to be. There's other
writers in there, but it's supposed to be the book of your life, your
style, and what you do.

And you pass the bible around so that the other graffiti proph-
ets can write their messages. And write their throwup, and do a
burner in there, or tag in there, and do their thing in there. And
then you have history in there . . . That was all written in graffiti.

TAKE: That's where we put our scriptures . . . I never really thought
about why we call it that specifically, but I can understand where it
comes from. My blackbook, my bible, believe it or not, that got me
through good times and bad times. Arguing with my parents, I'd
go to my blackbook and I'd rock a piece. One of my blackbooks is
twenty-odd years old. It's been through two-thirds of my life. It has
been on my desk while I'm happy, sad, crying, the loss of a friend,
the birth of a child.

But for me, it's my holy book, man. It is a bible. It's what you
carry with you everywhere. It allows you to, it shows that you
are adhering to the scriptures of this religion. That's what it is.
That's a blackbook. You bring it out and you show your pieces and

everything like that. You're showing your verse. You're reading your verse to this other person. You're telling them your gospel.

———

CHARLIE: Why are they called bibles? Is it just a Boston thing?

DS7: Yeah, because the bible is black. And it has important documents. Yeah, it's like the holy grail of your work. It's the fucking bible, man. It's important.

———

CHARLIE: You mentioned bible, as far as you know, is a Boston-specific term, right?

RYZE: One hundred percent.

CHARLIE: Do you have any sense of why?

RYZE: That's a good question. Initially, I never thought that they were called anything else.

I would just say that it is referred to as your bible because it's your soul. It's your teaching, it's your letter style, it's your progression, it's your everything. It's personal, like a diary. It's everything in there. When you flip through someone's blackbook there are always messages to the world. You can find out a lot about someone.

It's very personal, which is again why I wasn't always eager to show someone my blackbook. I don't want it passed around at parties. Someone might say, "Oh, what's this?" And the answer is that it's an emotional statement about where you were at when you did that particular piece or whatever it is.

That's the thing: when you get to flip through someone's bible, especially someone who has really been a lot of places, there's so much in there.

Yeah, it's a story.

———

PROBLAK: And it's funny that cats call blackbooks "bibles," because it's what you hold close, like the Word. This is your testament. It's in that book.

The Practice Page

I'm at Kulturez during a lull in customer traffic. MYND is working, wearing a pair of Jordan 6s he recently received in exchange for some artwork. "Thought you'd like these," he tells me. The counter at Kulturez is a case study in contrast. Inside, there are neat rows of markers, spray-paint cans, bibles, stickers, and other graffiti tools. The outside is a palimpsest of tags and stickers, textual remnants of other graffiti writers who have passed through this space. On top of the glass case, an orange sticker reads "PLEASE NO LEANING THANK YOU."

As I flip through flicks stored on MYND's deteriorating Android phone, he begins paging through my bible. After commenting on a few pages, mostly critically, he arrives at a throwup I had recently done. I was privately hoping that he would see it. "Man, that C is sorta funky! And I mean that in a good way. Now, how can we improve it?"

Pulling an orange Sharpie and his own, oversized bible out from under the desk, he begins to revise my C, changing the rhythm of the letter by connecting it to the H. After identifying elements of the C that he absolutely wants to preserve—the boxed upper half and the circular lower—he writes out a new version of the entire text.

The new CH is not only smoother but "faster," he explains, requiring only one motion to complete. A one-liner. He hands me the Sharpie and I replicate the motion, writing out a nearly identical CH, or at least to my eye. I do this a few times on the page and MYND, satisfied with the new letter structure and my ability to produce it, says, "That's good. Feel free to run with it." I say, jokingly, "Yeah, just don't tell anyone that you gave me this letter." "I take my secrets to the grave," he replies, turning his attention back to the computer (fig. 3.2).

This scene is far from unusual. Hanging out at the shop, flipping through bibles, critiquing and revising texts were the most common activities of this study. It's also a scene that feels strikingly familiar to me as a teacher of writing. I suspect I'm not alone in this feeling. A first draft, a collaborative workshop, a revision. There's writing pedagogy here in this community space.

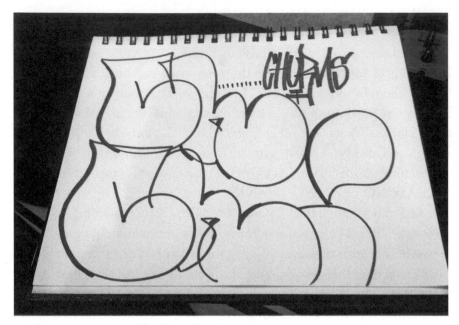

3.2 Practice Page in Bible. Photo by Charles Lesh.

As MYND and I engage in this writing process, we produce a particu-
lar biblical space: the practice page, a pedagogical space of writing and
revision far from the classrooms of the Athens of America described ear-
lier. Here, by reading, critiquing, revising, and practicing, we produce the
bible as a pedagogical space for *community* style development, where writ-
ers learn and refine their ability to produce a range of genres of graffiti—
from tags to throwups, from dead letters to pieces—that connect them to
the history of graffiti in the city. If the Athens of America educates students
to write in ways that align with larger place-based narratives, the practice
page teaches writers that a different relationship to the city is possible.
As RELM puts it: "Blackbooks are breeding grounds for new styles and
style sharpening: a place to experiment and branch out." The language
of space abounds. Bibles are "breeding grounds" for innovation, a "place"
for invention and experimentation, a spot where writers can hone their
writing. "Those are the pages you practice on," PROBLAK tells me. "You
become so focused on that one page. You start to understand, 'Damn, this

paper was perfect, until I put my first line on it. Now it's *immaculate.*"
This is the practice page.

The previous chapter showed how the histories, politics, and identities
of spots like The Lab rely on writers continuously returning to the place
to write. The practice page is, I would argue, where writers develop this
spatial sense. Here, writers develop an almost subconscious need to see
their name, over and over, in a writing space, and through this repetition,
begin to intuit that the production of space relies on this repetition. Dani-
elle Endres and Samantha Senda-Cook's (2011) work on the rhetoricity of
place in protest movements has emphasized that repetition is necessary
for "long-lasting additions to the meaning of a place," a frequency-based
model to understand the ways that rhetorical action shapes larger place-
based identities (270). This need is learned in the graffiti community, and
the practice page is one of the places where writers learn it. As writers
develop and workshop new styles, they visit, and produce, the practice
page, "over and over and over and over and over again until it becomes a
bad habit," MYND tells me.

In this repetition, the bible becomes a central location in the pro-
duction and innovation of style. This is especially true early in a writer's
career. One afternoon, in a garden apartment in Brookline, I'm talking
to HATE, an early writer from Lynn. After talking about the project, he
retreats to his bedroom and brings out a cardboard box full of bibles, flicks,
and other graffiti artifacts. Pulling a bible out, he tells me that he used to
have many more, but the rest were lost in a fire. He looks pained as he
reflects on this loss. Still, flipping through the surviving bibles, there is
an excitement in our conversation. I ask about his relationship with these
books, these bibles, what they mean to him now and what they meant to
him early on in his writing career.

> Oh yeah, oh yeah, always had [a bible]. This is the first thing you learn is
> to get your blackbook or your bible and start rocking it out, start develop-
> ing your styles. Having the blackbook is your foundation. You develop
> your style in here. And you're constantly sketching, you're constantly try-
> ing to outdo yourself, and you're constantly trying to develop something
> newer. And that was the beauty about writing: you always wanted to be
> different than the other guy.

As writers inhabit the practice page, repeating their names over and over, they begin to develop both an ease in writing—important when they bring their work into more precarious city spaces—and a sense of how different letter styles can circulate different messages, an interplay between form and meaning. SPIN likens practicing in the blackbook to the practice and meditation of calligraphy:

> [Calligraphists] would meditate on it. They would practice the form hundreds and thousands of times. And they'd be thinking about the form, what it means, and the strokes. It's like a different orchestra playing the same composition. There are different ways to do it. There is subtle meaning in the form.

SPIN's description of the constant, repetitive development of style harkens back to one of this chapter's epigraphic definitions of bible, as a stone used for scrubbing the deck of a ship. Like a crewmember repeatedly running the stone over the deck, writers continually run through their names on the practice page, slowly eroding any resistance until the production of the name and its repetition, like the deck, is smooth, effortless, and passed over with little friction (fig. 3.3).

The practice page provides the chronotopic conditions necessary for this type of dwelling; it provides a pedagogical space in which to examine the "subtle meaning" of their writing outside of the hostile and shifting writing spaces of Boston. Unlike the precarity of a spot, the practice page remains relatively constant, a stable and reliable material location where writers find venues for their writing.

> REACT: So, styles. People could do things [in blackbooks] that you couldn't necessarily do elsewhere. We had less legal walls for certain periods. Certain periods you have them, certain periods they go away. When your places are sketchier, you have less opportunity to be neurotic about the finished nature of your work. So blackbooks allowed you to do illustrative quality executions of your concepts. And so, you could, even if you would look at someone's blackbook and you were going to take ideas from it, you could see the distillation, the full distillation of their concept,

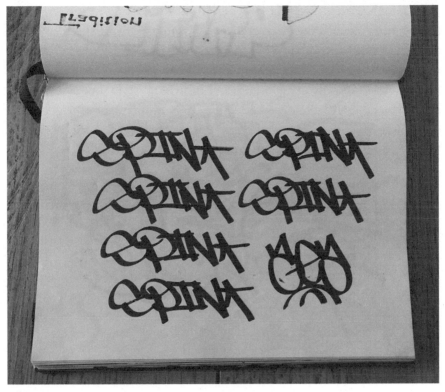

3.3 SPIN in Author's Bible. Photo by Charles Lesh.

as opposed to the hint of it that you could maybe get from the highway or whatever.

As writers dwell in the practice page, they, as Nedra Reynolds (2004) might put it, "Inhabit their texts by spending hours of time within them; they know where everything is or have memories of building it" (167). Reynolds advocates for the cultivation of material and metaphorical spaces in which students, writers, and readers might dwell, places where "we can retreat to, places that make us feel safe and allow us rest" (174). These spaces of dwelling, solely for writers, are crucial to community and public work for writers engaged in practices excluded from dominant literacy landscapes. Graffiti writers don't have many writing spaces in which to dwell. The bible is one of them.

Though writers dwell for long periods of time alone within the practice page, it's a decidedly collaborative, community writing space, as is evident in MYND revising and sharing style with me earlier. Ferrell (1996) notes that this collaborative invention is baked into the very character of blackbooks, "not only as repositories of individual style, but as common ground for collective creative production" (69). In the practice page, forms of community pedagogy emerge, iterations of alternative classrooms where the rhetorical work of graffiti is learned.

> TAKE: If you're analyzing it, it's a gateway to a whole new style. If you're appreciating it, man, you're just seeing where it can take you. A blackbook is the most important part of a writer's, at least their initial, beginning. It's the basic.
>
> What I love doing now is getting people's blackbooks, especially dudes that are starting out, and doing dead letters in their book. Just to show them, "Yo, if your style can be as clean as my dead letter, then you're on the right way. But if your letter style can't beat this, you need to keep hitting that blackbook."
>
> CHARLIE: So, it's almost a teaching space?
>
> TAKE: Yeah, it can be.

> BEAN: When I got into graffiti, I had a couple of people who were good dudes, who pointed me in the right direction, luckily. Like DEK 2DX.
>
> He was ruthless. But, I'm super grateful. He taught me everything I know and I definitely would never be anywhere close to where I am now in graffiti without him.
>
> He would have me write in blackbooks for hours. And then he would look at it and say, "Nope. Wrong. Wrong. Wrong. Wrong. This doesn't look right. This looks like shit. This is terrible."
>
> And I'm not being sarcastic or exaggerating. He would mark it with red pens.
>
> CHARLIE: Like a writing teacher!
>
> BEAN: Yeah. Or he would just do a big circle around something I was working on and just shake his head. Yeah, he was pretty ruthless about it. But yeah, it was like an apprenticeship.

Even after writers develop their initial styles, pedagogy in the practice page continues to be a key attribute of the space, mostly in the form of competition among writers. Writers often describe bibles as sites of intracommunity competition, as a place to both learn from and attempt to one-up other writers inhabiting the book. LIFE tells me that when writing in a bible, you are "kind of battling everyone else in the book, in a way. They'd try to make the dopest shit they could because most of us are very ego-based. But it's also a big organism. We are all together in this movement."

It is in this pedagogical quality of the practice page where divisions between private and public begin to break down. In fact, it's most accurate to consider the practice page a "publicandprivate" space, to borrow from William Burns (2009), a writing space "in which notions of public and private are so closely linked that to separate the terms and experiences would be to lose sight of the interconnectedness and reciprocity of these relationships" (31). While writers work constantly in their own bibles to develop styles, it is always with the knowledge that the writing can, and likely will, be read and critiqued by other writers. In this sense, the blackbook finds resonance with other notebooks studied in rhetoric and composition as sites of breakdown between private and public distinctions. In his work on composition students' journals, Ken Autrey (1991) notes that while the "usual assumption is that the journal is written to the self, perhaps the future self," the student, knowing that the instructor will inevitably read its contents, writes in the journal "to the instructor as a secondary if not a primary audience" (84). Peter Medway (2002) considers the notebooks used by architecture students, a "fuzzy genre" that, while seemingly used by just one student, is made up of texts that don't "reflect the privacy of their production and use" (144). In her work on friendship notebooks, Laura Micciche (2014) describes how the collaboratively authored books "made me want to feel again and again the thrill of writing with and for others and to occupy the ambivalence of writing in secret, yet for a wider audience" (17). This precise thrill imbues the writing in the bible: at once for practice and knowingly accessible to other community members through style. All of the writing in the book surely will not become public, but it reflects that potential, that thrill of circulation.

The practice page is a core community writing space, a space of pedagogy and style development and transmission. Other writing spaces of graffiti, both within and outside of the bible, rely on the practice page. It is within the stability afforded by the practice page where writers learn and craft new orientations toward the larger city. It is here where they learn of writing's role in the cultivation of space, that through repetition and style, new forms of citizenship, new writing spaces, and new arguments over urban space are possible. It's a classroom unlike anything seen in the Athens of America; here is a classroom produced and organized by the community, with community models of assessment and response.

Traveling Gallery

As I enter a long, nondescript gallery space, I feel a series of skeptical eyes. BONES had told me about this gallery event but wasn't able to attend himself. I'm worried that I won't know anyone. I make my way around the room, looking at the displayed pieces: a staggering array of canvases, repurposed street signs, and other surfaces adorned by stylistically advanced graffiti writing by some of the city's most famous writers. I take pictures as I walk, peering over my shoulder toward the entrance in hopes that a writer I recognize will enter. No one yet.

In a room with little ornamentation, save the graffiti being displayed, the center table and bench stand out. There, I recognize a familiar sight: a group of writers sitting and standing in a rough circle, hunched over, passing bibles around, reading and writing.

I walk up, and writers begin closing their books, blocking the pages from my view. *Who is this guy?* "He's cool," CADET says, a young writer who I have met a few times at Kulturez. After introductions are made, writing resumes. The ownership of these bibles isn't immediately clear. Occasionally, a writer steps in and reclaims a book, but mainly, the books float from writer to writer, with no interruption. As writers pass bibles, they engage in constant conversation, explaining the decisions they make in their writing, commenting on pages as they flip through the book. A writer I don't recognize explains to me why he freestyles every piece he does in a blackbook. He tells me that this is where new styles are formed.

I pull my own bible out of my messenger bag and start circulating it. As the new book hits circulation, writers immediately converge, eager to hit it. Each time a new writer flips through, they stop on pages with well-known writers and comment on the quality of the book. "This is a fire book!" one writer exclaims. Another asks if he can take pictures of a particular page. One writer asks where I've met the people in the book. "Friends of mine," I say. "Those are good friends to have," he replies, laughing. Several writers hand me their bibles, asking me to write in them. I do. They write in mine. We exchange.

CADET and I exchange books and I do a quick CH throwup, similar to the one MYND and I worked on. We talk about the letters in our names, and how we share a C. I explain that I think Cs are the most difficult letters, and I begin writing different variations that my Cs take. CADET laughs and says, "You have Ns and Rs! You're fucking crazy! Cs are easy." Another writer asks to hit my book. "I'm fiending for books to hit, man," he tells me as he sits down and begins to piece.

Another lap around the room. I rejoin the table and strike up a conversation with NIRO. I have never met him, but I have seen his writing around the city. We immediately exchange bibles and start writing. NIRO's bible is a dark red color, and he has tagged "SEEING RED" on the book's fore edge. After another writer and I tag a page of the book, I hand it back to NIRO. "Much appreciated," he says, walking away. I take my book back from him, glancing at the page he's completed. Leaving the table, I slip my bible back into my messenger bag. LIFE is outside smoking a cigarette, and I walk to meet him.

This scene represents a departure. No longer at Kulturez, the bible has moved into new and more precarious spaces. Out in public, it is susceptible to prying eyes, and writers are forced to control its circulation with a concentrated skepticism. Trust becomes crucial. "It's an unwritten kind of validation," REACT explains to me, that when you exchange blackbooks, what you are implicitly communicating is "I trust you in this secret underground." The implicit trust of blackbook circulation is embodied in the cipher, a sociospatial formation deeply rooted in hip-hop and Black culture. Historically a place where emcees would gather to freestyle and improvise rhymes, a cipher provides a location for collaborative

knowledge production and, in its circularity and protections it affords, supports solidarity and community. Carmen Kynard's (2010) work on the "cyber sista-cipher" positions ciphers as modern-day hush harbors, camouflaged spaces where Black rhetoric, identity, and counterstories can circulate and coalesce within exclusionary institutions, like academia. Ciphers are crucial community spaces; spaces often existing physically within exclusionary landscapes but providing glimpses of emergent, alternative social identities, rhetorics, and ways of being. Ciphers can be precarious, but as they exist, they form powerful alternative epistemologies of space in which other writing and knowledges can circulate, where new modes of belonging are centered. Gwendolyn Pough's (2004) work on Black women in hip-hop richly explores the notion of a cipher as a place of belonging from which to mount broader public critiques. It is also an action: "*To cipher* means to understand, to figure out" (41). As graffiti writers form ciphers, they practice a mobile form of spatial production, producing writing spaces where, for a time, they can figure it out, together.

Blackbook ciphers are nearly ubiquitous whenever large numbers of writers gather. During shows or hangouts at Kulturez, for example, it was not uncommon to see several loose ciphers of writers forming in different corners of the shop with writers circulating between them, bibles in tow. And as bibles are taken up within these spaces, as they move from one writer to the next, they are produced as traveling galleries, a term I adopt from an interview with BOWZ.

> You start like a fucking traveling gallery that you get to keep all of the dope people you met and the dope times you've had. I have a whole book from just a weekend at Scribble Jam. Some of it is sloppy as fuck. Some of it is intricate as shit. And it's just fucking dope. Like, that was that weekend. And now it's a gallery that I keep with me.

To define traveling gallery, it's useful to break it apart. In "traveling," BOWZ identifies the patently mobile nature of bibles. As compact and easily transportable venues for writing, bibles can travel with writers, basically, wherever they go. As such, a bible serves as a particularly effective and stable site for targeted circulation, a mobile writing space in tension with the divisions and boundaries of the Melting Pot and affording writers

access to their primary audience: other writers. Though a spot like the highway might get buffed or a graffiti website put under surveillance, the bible, as it is taken up and protected in these ciphers, provides a relatively secure and community-sponsored network of circulation comprised entirely of writers, with no intermediaries or auxiliary audiences.

Yet the word "gallery" is equally significant here. As the blackbook circulates among writers and as writers add their own writing to it, it is not just the texts that travel, but the produced space itself. That is, it's not traveling *writing*, but rather a traveling *gallery*, the production of a mobile writing space, an outcome of the circulatory practices of writers and their bibles.[3] It's also an important reclaiming of the term "gallery," often used in discussions of the disciplining of graffiti as it moves from the streets to more institutional settings. Several scholars have studied this movement from spots to gallery spaces, primarily understanding this institutionalization of writing as a process of displacement or disciplining, severing a text from its meaningful locatedness in urban space (e.g., Cresswell 1996; Duncan 2015). The bible, however, serves as a corrective to this street-gallery binary: it is a traveling gallery, curated, moderated, and regulated by the community of writers themselves. Writing in this gallery does not displace graffiti; it simply produces a new writing space in which to place itself.

The practice page grants a certain chronotopic freedom; outside of the vicissitudes of urban space, writers can experiment and explore new styles. The writing that produces the traveling gallery, however, is more immediately constrained by the spatial and temporal conditions in which it is taken up.[4] Within a cipher, writers are expected to hold the book for only a few moments before it is exchanged with another writer. The writing reflects that brevity and relies on gestures to the community to support its circulation. My own bible, as it circulated and became its own traveling gallery, is a good illustration of this.

3. This is similar to the argument I make in chapter 4 in relation to trains as mobile writing spaces. In that chapter, I situate this argument within "circulation studies" (Gries 2015) in rhetoric and composition more specifically.

4. For work on uptake, space, and time, see Schryer (2002).

3.4 WERD in Author's Bible. Photo by Charles Lesh.

At Kulturez during a gallery show, WERD realizes he had never hit my book. Grabbing it, he quickly does a throwup (fig. 3.4). The writing, which requires little time to compose, is highly stylized and likely illegible to non-graffiti writers. It excludes outsiders. Further, there is a prominent gesture to one of his crews, OBS, the letters cascading down the left side, reinforcing the social nature of the gallery and its primary audience: other writers.

In the event that a writer has more time in the gallery, perhaps due to a close personal relationship with the owner of the bible, or because they are hanging out in a more secure location, the resulting composition is often more elaborate.

Because of my close relationship with both writers, BEAN (fig. 3.5) and GOFIVE (fig. 3.6) took more time with my bible than a cipher would allow, GOFIVE taking it home with him for a week and BEAN sitting

3.5 BEAN in Author's Bible. Photo by Charles Lesh.

with it behind the counter at Kulturez for an hour. Both writers incorporate a range of different materials and styles, yet both remain focused on the name. GOFIVE's is heavily disguised in the face and hair of his character. Characters are one of the things he is known for; writers will know where to look. BEAN produces a much more legible text, accompanied by a sticker that would not be out of place on the side of mailbox. His text wants to be seen, to be read, to circulate more broadly. Yet its location, within the bible, orients it directly to other writers. His crew, IBK, is nodded to in initials perched on the tail of the N. The Kulturez "K" logo sits in the B, reflecting the material location of our encounter. The community is still centered, here in the traveling gallery.

Whether the quick texts of a cipher or more elaborate compositions, these texts are written to other writers. The paths they travel are populated

3.6 GOFIVE in Author's Bible. Photo by Charles Lesh.

by other writers. Handing my book to NIRO in a cipher. BEAN asking if he could sit with it for a bit behind the counter. GOFIVE taking my bible home. In these moments, writers cultivate something of a counter-circulation, an alternative channel of spatial mobility employed by writers, invisible to broader and potentially hostile publics, invisible to the Melting Pot and its spatial entrenchments. In a way, the traveling gallery is an inversion of the spot dynamic. A spot *moves* writers. The traveling gallery *moves with* writers.

If in the practice page writers learn the interrelatedness of text and location, in the traveling gallery writers learn something of circulation: how to achieve durable and community-centered networks of circulation in the bible and beyond. As the space of the traveling gallery circulates, it achieves what Jonathan Bradshaw (2018) might call "rhetorical persistence," a correction to our field's emphasis on the speed at which texts travel and the reach that they ultimately achieve (2). Bradshaw contends that rhetoricians must also be attuned to what he calls "slow circulation," or a model of

circulation that "calls us to attend to the persistence of rhetorical elements over time, arguing that this persistence is just as culturally relevant to the work of rhetors as are their transformations in greater public discourse" (3). Though Bradshaw is ultimately interested in how groups sustain circulation to eventually enact lasting change—instead of sustaining circulation intentionally invisible to broader publics, as is the case with the bible—his emphasis on community decision making around circulation is crucial. Unlike models that treat broad and fast circulation as a given, and often one that should be celebrated, community members can develop tactics to limit circulation in ways that ensure rhetorical survival: deliberate, targeted, anticipatory, cautious. Sometimes slow. Sometimes fast. This hypertargeted circulation resists notions that public writing must find a broad audience to be successful. Indeed, as Christian Weisser (2002) has noted, oftentimes public writing is successful because its circulation is limited, because "it is aimed at individuals who share common perspectives and goals" (107). The traveling gallery is a sustainable writing space *because* it starts from this place of limitation, of only circulating to like-minded writers. It thus offers us a premise on which to build alternative, local spaces of circulation.

Though I find significant promise in this idea of the production of writing spaces that circulate in community-centered ways, we should be quick not to immediately assume that these circulations or spaces of circulation are equitable. By designing patterns of circulation that lessen the risk of unintentional uptake, the traveling gallery, like all gallery spaces, contains lines of exclusion. Aside from the exclusion of nonwriters, exclusions can also be pronounced along lines of gender. While women did participate in several ciphers I was a part of for this research, a majority, including the ones described in this chapter, were comprised almost entirely of men. My own identity as a straight, cisgender man likely granted me access to these spaces with less friction than I might have experienced otherwise. Indeed, even as someone who does not consider himself a writer—which I discuss at length in this book's conclusion—my experience with writing and my community connections granted me access to these spaces with few obstacles and no elevated expectations.

This is not the case for every writer. Pabón-Colón (2018), for example, has noted that by exchanging blackbooks, writers are "not only accessing

knowledge about techniques and practical aspects of writing graffiti, but also encouraging a connection: be it a friendship, a mentorship, or crew membership." And yet, as is the case with many other graffiti events, "these spaces are not always welcoming or positive experiences for grrlz" (112). RENONE (who also participated in Pabón-Colón's study) described to me the pressures faced by women in bibles:

> I knew at the same time there was even more pressure [in writing in a bible] because I am a girl and writers are going to be like . . . You know how you flip through someone's blackbook, and you're like, 'Wack! Wack! Look at that! His E is so bad! Look at her R!' When you get up in someone's book, you gotta represent.

> For me personally, to be honest, I had a book that I never shared with anyone. Also, again, I had the whole cloud hanging over me that I was this graffiti groupie. So, I didn't really want to walk around with a book and say, "Oh, can you write in it?"

I do not want to paint with a broad brush here, and certainly exclusionary practices within the bible are situated, complex, and deserving of much more attention than I grant here. But it is important to note that, just as with spots, we should not imagine the traveling gallery as a utopian space of exclusion-free community circulation, free from the unequal treatment of identity.

Still, as was the case with spots, in the traveling gallery we have the premise on which to understand alternative circulatory spaces of writing outside of the entrenchments of the Melting Pot and similar rhetorics of division. As writers come together to write, as they share and exchange bibles, they produce a community gallery of writing, one that travels with writers wherever they might be, shielded, albeit not entirely, from potentially hostile audiences. Yet despite all the precautions, despite the ciphers and the skepticisms toward outsiders, when a bible circulates through networks of writers, when it is produced as a traveling gallery, it takes on a degree of instability. Or, as RELM puts it, "Some people start blackbooks for the sole purpose of passing them around, but sometimes they get lost in the sauce." Despite safeguards, the traveling gallery, like all public texts, can go astray, can get lost in the sauce. This tension between closed and

stable circulation, between the desire to collect writing and the knowledge that that collection can be lost to disruptive circulations, lays the groundwork and exigence for the final spatial production I explore here.

Talismanic Archive

At NIRO's apartment, I see a large stack of blackbooks beneath his desk, an unassuming stack of books that to the uninitiated would not look terribly interesting. He hands me the oldest book first. "You can tell this one is super old," he says, gesturing at the binding and cover, both of which are in tatters. The bible is falling apart, and I hold it gently as I flip through its pages.

We go through the books, page by page. A research treasure trove. As we turn each page, we trace his development as a writer. His name had gone through a series of changes, and we talk about how these letter shifts affected the style of his later pieces. "You can start to see things coming together for me here," NIRO says when he gets halfway through the second book. "My bars started to show up." I see his current style in these early pieces.

As we flip the pages, we also discuss his changing associations in the scene. Each time we arrive at a collaboratively authored page, he tells me the story of the event. This one was written in a school cafeteria. This one was from the first time he visited Kulturez. When I see a name I recognize, he explains where and when he met that writer. Every page has history, and as we flip through the collection, these stories are told. We decide to take a walk, to catch some tags and get a drink. I put the bibles back where I found them.

As NIRO and I work through his archive, we enter a produced space in which we are able to read shifting alliances, progressions, and histories, a repository of community knowledge. In this way, the bible is produced as an archival space in which writers can return and engage their personal and social histories. "Piecebooks," Ferrell (1996) writes, "serve as diaries of friendship and shared adventure" (70). I like the way that ACOMA put it to me in an interview. Bibles are "photo albums of your memories."

To this point, I've shown how bibles are spatial resources that match the needs and motivations of the graffiti community in Boston. The

practice page responds to a need for pedagogical space outside of the Athens of America: a relatively stable writing location in which writers practice and workshop their craft. The traveling gallery responds to the desire for circulation and community exposure, creating mobilities made up entirely of writers and beyond the ways text and bodies typically move within Melting Pot. Alongside development and circulation, preservation is a primary spatial need for writers: spaces in which their writing might find some longevity, durability, and lasting power. This need is created, in part, by the inherent ephemerality of graffiti, given materiality (spray paint on walls), community practice (going over other writers), and buffing (the relentless graffiti-removal efforts of urban authorities). This need for preservation manifests in several community practices, such as flick sharing, digitization of graffiti images, the creation of online archives, zine production, and others (e.g., MacDowall 2019; Snyder 2009).

And, the bible. As they are circulated and stocked by writers like NIRO, bibles are produced as talismanic archives, community-curated archival spaces in which writers preserve both individual histories and developments as well as community histories and developments.[5] As an archive, the bible provides a material context for writing to be sustained over a longer period of time than an urban surface would afford.

Back at MYND's apartment, he and SPIN reflect on this affordance.

> SPIN: The finished product in a blackbook, that shit is like its own
> thing. When you really kill a page in a blackbook, that doesn't
> really have anything to do with painting on a wall. You might try
> to paint that shit on a wall, but you're doing it for the book, for
> the book and the guy who owns the book. And for his friends and
> other people who get to see it. I think that's at least as valuable as a
> piece on a wall, and it lasts a lot longer.
> MYND: Sure does.

5. Rhetoric and composition has grown increasingly interested in the affordances of, limitations on, and potential for diverse archival practices. See, for example, Enoch and Gold 2013; Gaillet 2012; Glenn and Enoch 2009; Kirsch and Rohan 2008; McKee and Porter 2012; Monberg 2017; Ramsey et al. 2009; Rawson 2018; Wells 2002.

CHARLIE: That's crazy. I didn't even think about how long . . . I
 mean, blackbooks last as long as you know where they are.
MYND: Yeah, or as long as they fucking stay together. Falling apart
 and shit.

For writers, the bible provides the spatial stability necessary for archiving an inherently fluid, ephemeral, and risky community writing. Elsewhere from the Cradle of Liberty, bibles become their own landmarks, their own writings of history, by writers and for writers, in plain sight but also hidden from a general, unaffiliated public. Unlike the more commonly recognized monuments of the city, bibles preserve a history of revision, a history of a complex and shifting constellation of writing and writers attempting to produce, rather than foreclose, alternative spaces in the city. This is likely why, as SPIN notes, a blackbook page, as it contributes to this archive, packs a significant amount of value, even relative to a piece in a more prominent, visible, and studied urban space: not better or more significant, certainly, but different.[6]

Back at Kulturez, at the SENSE memorial show, ciphers are forming and blackbooks are being circulated. On the counter, MYND is flipping through a large, unwieldy bible that looks old. I make my way over. Another writer joins us, and we begin paging through the book together. It immediately becomes clear to me that we are looking through one of SENSE's bibles, as his style—intricate, sharp letters forming an almost circular, smooth whole—is evident on each page. The pieces show SENSE's progression through the years: from the notebook pages where he was just developing style to the blackbook pages displaying a fully realized approach to his name. MYND points this progression out to me, recognizing appearances of particular styles in the earliest pieces. It's all here, in

6. This might be a result of a particular historical moment of graffiti writing in Boston. In Craig Castleman's (1982) reference to blackbooks, there is a clear hierarchy of value between writing in the city and writing in a blackbook: "Impressive though it may be, however, style in the books does not count for much among the writers. The style that one displays on the trains means the most" (21; see also Powers 1999, 38). This hierarchization still exists, although in my research I've found it less rigid.

this book, a landmark to the late writer, a landmark of progress, revision, and the development of style.

The relative stability of the bible, which makes spaces like SENSE's archive possible, enhances its aura and creates an almost mythical, religious energy around it, evident, as noted above, in the name "bible." A well-executed bible is a sort of spot par excellence, a rare opportunity to see and read the various layers of writing often buried within an urban palimpsest. It's almost hard to explain, but the energy produced around bibles is palpable, in part due to their ability to outlast other locations of writing. In this way, the talismanic archive does more than simply archive an individual's progression or alliances in the scene; in the aggregate, they preserve urban histories that are constantly being written over or expelled from the larger production of Boston. As writers discuss bibles, they move seamlessly into discussions of the larger history of writing: what the scene was like then; what spots were most active; who was getting up the most and where. As a catalyst for this reflection, writers take pride in the writing they have in their books, the stature of the writers that populate it. They become "badges of honor," BAST tells me, testaments to the "places I've traveled, all the dudes I've met, all the people I've collaborated with . . . They are artifacts of life, really." In the course of my own research, I took pride in, and benefited from, the writers that got up in my book. TAKE once told me that a bible is a "membership card" to the whole scene, and the writing archived in your book speaks to the degree and quality of that social membership.

Yet what of the word "talismanic" affixed to the front of archive? While all archives invite questions of risks and rewards, access and ethics (e.g., McKee and Porter 2012), it is decidedly uncommon to liken an archive to a talisman, an object that at once affords and wards off, empowers and protects. I adopt the term "talismanic" from an interview I conducted with BAST:

> But [blackbooks] are also dangerous. This is something you learn quickly if you get tangled up with the police because now here is all of this fucking evidence of who you are and who you run with. And maybe [the police] are like, "You are all of these guys. You got this tag, this

tag, and this tag, and it's all you. We will pin all of this shit that we can photograph on the street and say it's you. Unless you flip or whatever." I don't know, they're like a talisman. They're like a fetish, or an idol, or an icon or something. They are critically important, a very powerful thing.

BAST articulates a duality at the core of the talismanic archive: destructive and productive, dangerous for writers and essential for their work. Talismanic in that they offer immense powers by their very possession while recognizing the intrinsic need to stave off those who would do you, and it, harm. Its talismanic qualities arise from the tremendous rhetorical affordances it activates and the immense danger of appropriation it must ward off.

To suss this out, it is important to note that bibles, though physically separated from illegal wall writing, are ultimately connected to acts deemed illicit through tag names, styles, and other identifying marks. Richard Lachmann (1988) observed this early in his work with writers in New York City:

> The police have arrested writers gathered at corners, seizing and often destroying the black books writers carry that contain photos and sketches of their murals. One policeman boasted, "We get the kids, and their books contain enough evidence to get a conviction." (243)

It's not hard to discern that this practice is ongoing in Boston. References to blackbooks pepper newspaper reports of arrests, and blackbooks are used as primary evidence linking writers to writing in undesignated areas. As just one example, a recent article on the Boston University news website titled "A Midnight Ride with BU's Graffiti Cop" recounts the tactics used by one particular police officer at BU, a well-known graffiti cop active in the Boston area for decades. One tactic is to confiscate blackbooks, which the article reports are stored in a home basement. The incriminating books are depicted in a photograph that accompanies the article, laid out on a white table in a way that conjures up images of a drug-bust press conference (Woolhouse 2018).

This strategy is well known to writers. One of the first things WERD told me was, "Never bring your bible to a spot," as a precaution in the

event that police roll up on you. The bible is a forensic goldmine for anyone attempting to research and potentially prosecute the graffiti scene in Boston. Talking to writers, I heard stories of blackbooks being used to link writers to other, illicit acts of writing (fig. 3.7).

These stories taught me that the traveling gallery, like all spaces of circulation, does, at times, move outside of its desired circulations. This ability, as Warner (2002) notes, is fundamental to a text's identity as public: "Writing to a public incorporates that tendency of writing or speech [to go astray] as a condition of possibility" (74). This intrinsic tendency of public texts to go astray, to circulate in unexpected ways—a text's "rhetorical velocity," to use a term from Jim Ridolfo and Dànielle Nicole DeVoss— renders the space of the bible precarious. That the talismanic archive butts up against dominant, antigraffiti spaces in Boston all but ensures that it will, on occasion, fall into unintended hands.

And yet the talismanic qualities of the archive seek to further attenuate these risks of unpredictable circulations. To understand these safeguards, Ellen Cushman's (2013) work on decolonial archives is useful here. To reiterate a point, I do not consider this project, or the bible specifically, to be decolonial, and the conditions of displacement and genocide that surround decolonial archives are patently different than the type of archive activated by the bible. Rather, decoloniality's emphasis on the *elsewhere*, on centering locations, knowledge-making practices, and histories not always in relation to the colonial center, but on their own terms helps to explain the production of the talismanic archive. As it produces its own elsewhere, the talismanic archive ceaselessly rejects cooption, situating itself not within, but outside. Elsewhere.

Cushman (2013) has written that decolonial archives reject imperialist tenets of collection and preservation in favor of archives that "re-place media in the languages, practices, and histories of the communities in which they are created" (116). Through her work with a group of fellow Cherokee citizens in the creation of a "Four Worlds" curriculum around knowledge found in a selection of wampum belts, Cushman stresses the importance of "perseverance rather than the imperialist agenda of preservation of cultural tradition as hermetically sealed, contained, and

3.7 SWAT in Author's Bible. Photo by Charles Lesh.

unchanging" (117). That is, the decolonial archive is one which stresses the urgency of radical emplacement: rejecting severance and preservation in order to locate objects within the epistemological and ontological conditions, and communities, of their origins.

Similarly, the talismanic archive resists, puffs up against, wards off, appropriation, approximation, displacement, and probable annihilation. It rejects the tenets of dominant space articulated earlier, and in this rejection, it constructs its own archival elsewhere, visible yet obscured from potentially destructive publics. We can read this rejection of appropriation in the very material makeup of the book itself. The book's black exterior is not merely an aesthetic preference or accident but an agential choice born of a desire for anonymity and protection from prosecution, not unlike writers selecting tag names. Unlike the spatial legibility and purported transparency of New Boston, the bible is intended to obscure

what it is, communicating only to those in the know. Whenever I took a bible with me throughout the duration of this study, and as they sit next to me as I write this chapter, individuals outside the community consistently asked, "What is that?" Its uniform, ambiguous material makeup obscures its contents. In response to a question about this ambiguity, BONES points to his own bible, exclaiming, "It's a black book. There's nothing on it. You don't know what it's about until you open it up. This book contains secrets!"

There are other explanations for the black covers. Ivor L. Miller (2002) cites iconic writer RAMMELLZEE saying that blackbook (here written as black sketch books) was "an allusion to the dark briefcases gangsters carried their pieces [guns] in" (76). While I never encountered this explanation in the field, it works similarly, as both the image of the briefcase and the reference to its exterior reflect a crucial, and legally important, resistance to an outside gaze.

Writers practice radical emplacement and spatial rejection in other material ways. Meeting GOFIVE in the subway station at the Ruggles train station to pick up my blackbook after he composed the above piece, I notice that he had affixed a thick piece of black tape to the book's binding. "Gotta keep it together," he tells me, noting that the binding had begun to crack. This desire to "keep it together" speaks, more directly, to a community hesitation toward tearing pages out or removing them in any way. Though this is not universal, many writers told me that the blackbooks should remain absolutely whole. In this sense, the bible is talismanic in another, older sense of the word. The *Oxford English Dictionary* notes that one of the possible etymological origins of the word talisman is from the Greek τελεῖν, meaning, in part, "to complete, to fulfill" ("Talisman"). Think *telos*, "end, purpose, ultimate object or aim." Within the bible, there is a compulsion for completion, for unity, for unappropriated totality. For a bible to retain its aura, it must remain intact, its contents bound between the original covers of its creation.

In rejecting page removal, writers construct that talismanic mythology. As ACOMA and I sit in his second-story art studio, before he writes in my bible, he reflects on this desire for cohesion:

ACOMA: If you have a ripped page in your book, it throws it off,
 man. You know, it just doesn't feel right no more.
CHARLIE: Say more about that?
ACOMA: There's always that one person that has a whole complete
 book with no torn pages and from my perspective, I'm always
 inspired by that, because I've never been able to complete one. So,
 when I see that shit, it gets me heated. I'm like, damn somebody
 ripped a page out. Now I can't even mess with it.
 It's not a bible no more, right? You can't rip up a bible. There's
 something missing there. It's a missing page.

This reverence for the bible, and resulting archival space, is decidedly
anticapitalist, again setting the writing spaces of the bible outside of the
neoliberal logics of New Boston. While a blackbook page can carry signifi-
cant market value due to a writer's reputation, the practice of removing,
framing, or selling the pages is decidedly uncommon. This anticommod-
ity attitude, that this writing is not for sale, goes back to the earliest days
of the culture. Miller (2002) quotes VULCAN discussing blackbooks that
have, either through sale or theft, ended up in private collections:

> The work wasn't done to be sold, it was done on a personal level as a
> gift. Pieces in black books are done out of respect for the person, out
> of respect for who you are. It is not a commodity to be sold, and that's
> what they turned it into, as if the money meant something. Money never
> meant anything, cause you can't pay me to do a piece in a black book.
> It takes too much of your soul, too much of a piece of you, it takes too
> much time to do. (156)

The talismanic archive remains intact, not because of market reasons but
for its own sake. Its perseverance relies on this expulsion of the capitalist
market economy—indeed, any economy other than writers' determina-
tions of value—from its doors.

Again, I can't help but think that the term bible seems fitting here.
"And Jesus went into the temple of God," Matthew 21:12–13 reads, "and
cast out all them that sold and bought in the temple, and overthrew the
tables of the moneychangers, and the seats of them that sold doves, And

said unto them, It is written, My house shall be called the house of prayer; but ye have made it a den of thieves."

Auburn

Like the spots explored in chapter 2, bibles—the practice page, the traveling gallery, and the talismanic archive—are core writing spaces produced by writers, dynamic venues, participants, and outcomes of writing processes. Each of these spaces, as they are produced, provides an elsewhere to the dominant rhetorical politics of Boston, to the writing spaces of the Melting Pot, the Cradle of Liberty, the Athens of America, and New Boston. In the bible, we find new pedagogical spaces where style is workshopped and rhetoricity is learned. We find new circulations, counternetworks of mobility where repositories of community writing are always on the move. We find new histories, monumental spaces to revision, annotation, and amendment. And we find new economic spaces where community determinations of value reject market principles. As these spaces constellate, as they overlap and as they withstand constant threat, bibles provide deep spatial resources for writers and expansive elsewheres in which new writing and new writing spaces are not just imagined but inhabited.

In these spaces, we might find new directions for the research and teaching of writing, new orientations to space and the communities that produce them. As I was revising this chapter, my desk was a mess of scattered books, interviews and coded data, newspaper articles. A stack of bibles in the corner. Each time I hit a writing block, I grabbed a different one, each filled with writing I had collected during my time in the field. I remember the stories behind the pages, the spaces and places in which they were written, the parties, bars, apartments, houses, kitchen tables, art galleries, paint shops. I return to and inhabit the spaces explored in this chapter.

Next to these bibles is Hannah Rule's (2018) *College Composition and Communication* article, "Writing's Rooms." Rule argues for greater attention to the spatial-material contexts in which writing occurs, a reckoning with the diverse and fluid spaces in which writers operationalize and revise their own writing processes. As she reads accounts of writers writing, she asks: "I wonder what that *looked like?*" (402). A discussion of writing is always a discussion of space, a discussion of the interplay between

text and sociomaterial context. This attention to writing's rooms, and all other contexts of writing, is crucial in understanding the dialectical and mutually constitutive relationship between writing and (social) space.

Yet it is not always enough to ask writers to draw, photograph, or record their writing spaces, however important that work is. As we've seen here, writing spaces are often emergent, messy, and ephemeral. They can be as crucial for community survival as they are dangerous to inhabit. They might be tucked away between two black covers and occluded from our disciplinary gaze, a gaze born of our relationship to institutions that have colluded in eradicating or delegitimizing particular writing or writing spaces. Writing spaces like the bible, forced to and forged on the margins of our writing landscapes, often don't resemble rooms, classrooms, or street corners at all. Sometimes they appear in the shape of a nondescript composition notebook, one slammed shut when we walk into a room.

Community Interlude 3

Blackbooking

When graffiti writers practice in or circulate bibles, the activity is often referred to as blackbooking. As in, *MYND and I were just hanging out at Kulturez, blackbooking.* Like piecing and bombing, blackbooking refers to more than just textual production. It means reading, writing, assessing, and critiquing. It means interpreting, debating, revising, and inhabiting. If the bible is comprised of writing spaces, blackbooking is the specific set of literacy practices that produce and sustain them.

Writing the last chapter, I was tempted to compare the bible to the more familiar commonplace book, those models of rhetorical education dating back centuries in which writers would transcribe snippets of texts worth remembering, possibly for later emulation. I ultimately decided that the differences were too vast and significant to warrant comparison. Yet it is interesting to note that working in commonplace books is often referred to as "commonplacing," which Tim Cresswell (2019) defines as "a way of recording the wisdom of others, and gradually drawing upon it to form a unique new assemblage—your own kind of illuminating wisdom" (11). I see blackbooking as a similar practice.

TAKE is a writer from Villa Victoria, a historic Puerto Rican enclave within Boston's South End. Along with his sharp and stylistically sophisticated pieces, TAKE is known for his blackbook skills and the serious approach he takes to bibles. As I describe in "Spot," I first met TAKE on Labor Day in 2014 at The Lab. After he read a draft of the previous chapter, I called him and we discussed his thoughts. I reproduce a portion of that conversation below.

Along with this interview, in this interlude you'll find a few images from my own research bible, some of the community voices and spaces that were the inspiration for the previous chapter. I invite you, reader, to take part in blackbooking here, if only momentarily. Read, interpret, reflect, and inhabit.

TAKE

CHARLIE: Thanks again for reading the chapter, man. There's a specific moment where I talk about you saying that your wife knows where your blackbooks are, right next to a fire escape.

TAKE: Mm-hmm. It's true.

CHARLIE: Well, bibles are obviously important to you. I wonder if, after reading the chapter, you can talk a little bit more about why they're so significant to you as a writer.

TAKE: Bibles are where it all started. It's where I built not just my own style as a writer but the sense of competitiveness between me and my friends, and my crew members.

I remember early on, we would look at each other's blackbooks. Flipping through pages, we'd be like, "That's wack." Then you would always see one of us going back to our bible, working that much harder. It created that sense of competition between us, and it pushed us as writers.

But like I say in the chapter, bibles have been with me through thick and thin. I've got all sorts of history in there.

We have a bible that we try to pass around as a crew, and the first four or five pages took almost two years to fill because every one of us had lost somebody close while we had the book. If you look through those first few pages, there are dedications and memorials. That bible had a rough start. Then I got so afraid of losing it that I ended up taking it as my own book. I still have it to this day.

Recently, ODESY and GOFIVE were talking about this one particular guy. And there was a reference to him in the bible; ODESY had it when this guy passed. Twenty years later, they're talking about this one guy, and that shows up in the bible.

That's the amazing stuff that happens in bibles. They become connectors, keeping you centered, grounded in reality. I can keep going, man. They are that important.

CHARLIE: The chapter starts with LIFE talking about the first time he encountered a bible. I'm wondering if you can remember the first time you encountered one, or started one?

TAKE: Of course I remember my first blackbook. I still have it.

CHARLIE: Really?

TAKE: Yeah. My first official bible, where I was like, "I'm doing pieces in it and I'm trying to do new stuff in here." Before that, it was always loose pieces of paper or some sort of sketchbook. But my first bible. Yeah, I got that.

I remember just going in there, doing pieces. It was one of the more oversized books. Those pieces, some of them I would never be able to paint now. I was spending hours doing pieces, hours trying to figure out my style as a writer, trying to figure out connectors and stuff like that.

CHARLIE: You're well known as someone who, when you get a bible, you tend to spend a lot of time in it. The piece you did in my book, for example. We had only met a couple of times at The Lab at that point. You got my book and you blessed it with this massive double-page production. Why do you take such pride, energy, and time when you approach a blackbook?

TAKE: It's not just blackbooks that I try to do that with. They are just more controlled spaces for me, so I'm able to execute it to a certain point. It's also a little competitive. My crew, we don't see the sense in doing anything if it's going to be halfway.

When you give me a blackbook, first and foremost, you're saying you trust me. All sorts of things happen to blackbooks. Just off of that, I'm going to show you respect. I'm going to do something dope, or something I consider dope, in your book.

I'm not going halfway in a bible. To me, that doesn't make sense. If I don't, the next man up gets it, and does something dope, then I look like a chump. There's that competition

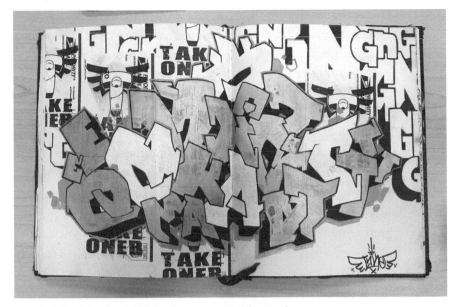

3.8 TAKE in Author's Bible. Photo by Charles Lesh.

and that respect. It's just how me and my team are built
(fig. 3.8).

CHARLIE: [laughter] Well, it's much appreciated by the people
whose books you've had.

TAKE: Actually, you quoted me in the chapter about trying to help
out younger cats in their bibles.

It got me thinking: I feel like we were the last generation
of writers truly affected by our immediate neighborhoods and
cities. Everyone has access to the internet now, which changes a
writer's relationship with a city's style.

And I think that made blackbooks even more important to
us in terms of developing a unique style within a particular city.
Especially those older bibles in Boston, from the older genera-
tions, they were just treasure troves of brand new, unique styles,
man. Now, some kids will just go to Instagram for that.

But I do think bibles will always be there. We might see a
change in the medium or whatever, but the spirit of bibles will

be there. Even me now, sometimes I don't touch my blackbook
for weeks because I'm rocking on an iPad. The actual medium,
the paper, might change, but you're always going to have that
blackbook culture that you describe in the chapter.

CHARLIE: One thing that I think bibles offer is that, unlike Insta-
gram, they're really spaces just for writers.

TAKE: I thought what was really cool about your chapter is how you
talked about the bible being private and public at the same time.
It's so true. It has that aspect in it. Since you focus on Boston,
I'm wondering how much that private side of it is more regional
for us because of how the city feels about writing. Growing up as
a graff writer, the way we moved, you just didn't talk about who
you were. People would say your writing name in public, you'd
keep it moving.

So we had to be even more private with our bibles.

CHARLIE: That's super interesting. I wondered about how much of
this chapter is specific to Boston, especially when I was writing
about the word "bible."

TAKE: Man, that section was crazy. I didn't realize it was such an
important term in Boston. I just always thought "bible" was what
writers everywhere called it.

That's another thing about graffiti losing its regional feel.
People might not say bible on graffiti websites or Instagram.
That's a part of the culture that we are losing.

But whatever it is called, there's always going to be a place
for the bible, or blackbook, whatever you want to call it.

CHARLIE: Anything else jump out to you about the chapter? Just
general thoughts, things you think I fucked up? [laughter]

TAKE: Man, overall, I like the chapter a lot. It was especially cool to
see that you had a varied group of people in there talking about
bibles. That's important. Boston graffiti culture can be pretty
segregated, as you know.

Sometimes, the conversation can really focus more on one
side of the tracks and less on the other. Even Kulturez, which

you mention in the chapter. Even there, some writers just don't go to places like that. One, they might not go to that side of the tracks, and two, they might not be into legally buying spray paint.

The fact that you got a varied group of people, it's dope to me.

A Few Pages from the Author's Bible

3.9 HATE in Author's Bible. Photo by Charles Lesh.

3.10 PROBLAK in Author's Bible. Photo by Charles Lesh.

3.11 REACT in Author's Bible. Photo by Charles Lesh.

3.12 ACOMA in Author's Bible. Photo by Charles Lesh.

4

Train

Trains arc the roots of graffiti . . . Why WOULDN'T we love paint-
ing trains? Trains are like mythical dragons. It's instinctual to slay
the dragon. Trains are graff writers' dragons. Yeah.
 RELM (Personal interview with author)

[. . .] Whatever, boxcar graffiti comes to the point faster and bet-
ter than a letter to the editor, and gets a hell of a lot better circula-
tion. [. . .]
 Bud Collins (1972)

Introduction

In *The History of American Graffiti*, Roger Gastman and Caleb Neelon
(2010) situate the emergence of graffiti writing in Boston within the city's
divisive spatial history. The earliest writers were

> raised amid years of forced integrative busing between Boston Public
> Schools and in the nearly all-white neighborhoods of Charlestown, half
> of Dorchester, and South Boston (Southie), and schools in black and
> Latino neighborhoods of the South End, Roxbury, Jamaica Plain, Mat-
> tapan, and the other half of Dorchester. (152)

For writers, this divisiveness was most pronounced along the Orange and
Red subway lines of the Massachusetts Bay Transportation Authority
(MBTA). The lines themselves served as connective tissue for the Black
and Latinx neighborhoods that produced a number of the city's writers. But
these trains also served as daily reminders of racism and segregation, often
in the form of racist graffiti that would seemingly never get buffed (Gast-
man and Neelon 2010, 152–53). From the start, it seems, graffiti here grew
up in direct relation to the mobility and immobility of people and texts.

This entwinement between mobility, urban history, and writing is perhaps unsurprising in Boston. The city's history reflects an early commitment to public transportation, with its first iteration in 1631, when "a colonial charter authorized a ferry service to transport residents to the various peninsulas" (O'Connor 2000, 313). On September 1, 1897, 266 years later, Boston's subway opened as "the first of its kind in North America" (O'Connor 2000, 314). Despite some initial public misgivings and protest, Boston's urban history would be forever rooted in mobility.

This relationship can be a point of pride, but it can also speak to urban trauma. For this, we need look no further than the "busing" that Gastman and Neelon reference. Broadly, busing is shorthand for a series of school desegregation policies, set in motion by a June 1974 ruling by Federal Judge W. Arthur Garrity Jr., and the subsequent unrest and racial violence that followed this challenge to unequal resource distribution. In his decision, Garrity ruled that the Boston School Committee had "knowingly carried out a systematic program of segregation" that created a "dual system" of education based on race (quoted in O'Connor 2000, 73). To address this, "Garrity ordered a program to take effect the coming September that would bus some 18,000 schoolchildren in order to achieve a balanced mixture of white and black students in the public schools" (O'Connor 2000, 73).

That *busing* became shorthand for the episode is telling of two things. First, it signals an eagerness to recast the events to make them more palatable to a positive urban identity. As Matthew Delmont and Jeanne Theoharis (2017) have written, busing as a rhetorical construct

> serves to reduce Boston's racism to working-class ethnic parochialism, privileges the prerogatives of those who thought desegregation of Boston's schools was unnecessary or unfair, and obfuscates the long history of systematic racial inequality in the Cradle of Liberty that led to a decades-long protest movement in the city and Judge Garrity's finding that Boston's schools were intentionally segregated. (193)

In addition to this revisionism, busing also speaks, I think, to the contested role that mobility plays in the story of Boston. It reveals an anxiety that arises around spaces of circulation when, as in spots and bibles, they are

used in ways that threaten entrenched demographic landscapes. In this way, the *bus* in busing is not just *taken* by students, but *made,* rhetorically, to represent both a threat to entrenched spatial politics *and* the promise for a different circulatory future.[1]

It is against this backdrop of movement, racism, and space that graffiti writing initially emerged in Boston. Tellingly, right as the first mentions of graffiti *writing* started showing up in the *Boston Globe*, there was a simultaneous uptick in references to racist graffiti, mostly in reference to busing or public transportation.

- They have heard about the graffiti painted in bold black letters on the rear wall of South Boston High. It reads: "Kill N[. . .]ERS." (Hutson 1974)
- When South Boston High let out last Friday, 150 State Police were on guard as the whites trooped out, the buses pulled to the curb and the blacks came out and into the buses. Graffiti scrawled on walls a block away smelled like Selma, Ala., in another era: "This is Klan country," "N[. . .]ers drop dead." (Evans and Novak 1974)
- The favorite words of graffiti specialists in Charlestown are: Never, Stop Forced Busing and Resist (Buchanan 1976).
- The removal of racist graffiti should be an unquestioned priority for the management of the MBTA. Those of us who ride the MBTA are all too aware of the overt and somewhat covert (e.g., "West Roxbury No. 1") antiblack graffiti on public vehicles and stations—much of which seems to remain untouched for months. (Carter 1978)[2]

1. The Union of Minority Neighborhoods' "Boston Busing/Desegregation Project" (2021) is an excellent resource for various perspectives on school desegregation in Boston. In graduate school, I was lucky to assist in a few of the oral histories archived as part of the project. See the website for the Union of Minority Neighborhoods.

2. "West Roxbury No. 1" is, as far as I can tell, a reference to the relative white racial homogeneity of the neighborhood at the time. Ronald P. Formisano writes that in the decades surrounding busing, West Roxbury "was far from uniformly middle class, but of a population of over thirty-one thousand, only seventy-seven were black. In a 1975 poll the neighborhood ranked high in 'outrage' over busing, and close to 80 percent agreed

As I've noted, I am no historian of Boston graffiti. Still, these larger representations and histories of mobility are important context for the work of this chapter: to develop and model a framework for unpacking the complex and patently spatial relationships that communities of writers develop with circulation and mobility.

In *Taking the Train: How Graffiti Art Became an Urban Crisis in New York City,* Joe Austin (2001) tells the story of early New York writers seizing the circulatory affordances of the subway to send messages across the city and how that process was met with significant and multifaceted resistance. This tension coalesces in Austin's overarching framework: *taking the train.* Graffiti, Austin writes, "made a place for itself in New York City by selectively appropriating institutional spaces created by other organizational entities and re-forming these into its own physical and cultural networks" (66). As writers leveraged resources available to them, they reclaimed public spaces as sites for community building, including the trains and their surrounding infrastructures. Writers took the train, harnessing and repurposing its circulatory affordances, while urban authorities worked to take it back. This is the story of writing.

While this certainly maps onto Boston graffiti's relationship with trains, the specific connections between mobility, identity, and writing sketched above tell a slightly different story. Working with writers, I've found that train writing means much more than just taking an existing space of circulation for different ends. Rather, I've found it more precise to think of the train as produced by writing itself, a real and imagined community writing space onto which writers write their names, yes, but also their aspirations, identities, and visions of an alternative Boston. In this way, trains come to represent not just a method of writing circulation but a community's relationship with circulation: its values, ideals, hopes, and struggles. Don't get me wrong: writers have and continue to take the train. But, just as the "bus" was made rhetorically to stand in for an upending of spatial arrangements, the train is also made rhetorically as an aspirational,

with the statement that forced busing violated constitutional rights (just 6 percent behind Southie)" (2004, 131).

if contested, space of mobility outside of the entrenched urban politics of the Melting Pot.

My focus here is on the process of making and remaking the train—both subway and freight, real and imagined—as a writing space, one that affords and represents a vast array of mobilities connected to, but often outside of, the literal movement of cars on rails.[3] Train writing is an irreducibly complex rhetorical act, and in writing this chapter, I was reminded of something Foucault (1986) once (parenthetically) wrote: a "train is an extraordinary bundle of relations because it is something through which one goes, it is also something by means of which one can go from one point to another, and then it is also something that goes by" (23–24). To get at the complex relationship writers have with trains and, in turn, the relationships they develop with circulation, we have to understand the entire bundle: the ways trains move texts, move readers, and create spaces and publics along the way; the ways writers produce and sustain trains by tapping into a set of representational values; and the ways that trains are embodied and experienced by writers. My hope is that this bundle might help other scholars of community and public writing make sense of the relationships that writers develop with circulation, not just as means to move texts but as important sites of community building.

Circulation, Mobility, and Writing

To understand trains in Boston, we need to understand something about the circulation and mobility embedded in them. We need to add a more explicitly mobile vocabulary to our framework of the *writing of where*. We need, in other words, to know something about the story of trains and graffiti.

3. Scholars such as Jeff Ferrell (1998b) and Robert Donald Weide (2016) have articulated the cultural and geographic connections and disconnections between freight writing and other street forms of writing, with Weide compellingly calling freight writing a "subculture within a subculture" (36). Despite these core differences, I find that both subway and freight trains are produced as writing spaces in similar ways and that those similarities are largely rhetorical. Henry Chalfant, an important photographer and documentarian of graffiti, has called freight writing "the heir to writing on the subway," done with the same "ethos" (2006, 0021).

Ivor L. Miller (2002) tells the story of early writers using "spray paint and markers to resurface trains," and as they collectively developed an aesthetic, effectively "remapped the city" (3–4). Recognizing the various racial and class-based divisions in New York, these early writers "targeted specific trains they knew would circulate their paintings throughout the city, a concept they accurately called 'goin' all city'" (4). This recognition of movement and exposure—and the train's ability to forge "multi-ethnic groups of painters from different classes and neighborhoods" (4)—made trains, and continues to make them, almost paradigmatic locations for effective public writing. Simply put, trains *move*. And, as longtime Boston-based journalist Bud Collins writes in this chapter's epigraph, trains have a greater reach than many other seemingly stable venues for public writing, including one that us teachers of writing are quite familiar with: the letter to the editor.

Trains give writers a stable infrastructure for circulation to audiences near and far, affiliated and unaffiliated, interested and hostile. This is no small thing. In their work on community publishing, Mathieu, Parks, and Rousculp (2012) have noted that access to circulation is a primary challenge for writers excluded from mainstream presses and writing spaces (5). How do writers with limited resources distribute their writing widely, reaching audiences of various degrees of interest and awareness? Trains have historically and contemporarily answered this question for graffiti writers. They have granted writers with limited resources and access to infrastructures of circulation a steady, reliable, and punctual means to move their writing to the various, often segregated, audiences in the city.

In this sense, I'm tempted to situate train writing as a classic example of rhetorical circulation: a group of writers adopting and adapting infrastructures of movement to circulate and recirculate texts in rhetorically significant ways. Laurie Gries's work especially has centered discussions of circulation in public rhetoric, particularly visual rhetorics. Gries (2015) dubs this conversation "circulation studies," a capacious and constantly expanding interdisciplinary set of theoretical and methodological resources for "studying rhetoric and writing in motion" (xix; see also Gries 2018). "Things," Gries (2015) writes, "do not just move inconsequentially and unchanged through space and time; they are both impacted by and

impact that which they encounter" (37). As texts on trains move, as they impact and are impacted by, we might be reminded of Collin Brooke's (2009) oft-cited articulation of circulation: that it might be more productive to attend to train writing "as circulating rather than some*thing* that we circulate" (192). Once affixed to a train, writing moves, it circulates, on its own, often far beyond the control or environments of the initial composition.

But there is something else at work here, something I hope my above discussion of *making the train* might help elucidate. What train writing in Boston adds to discussions of circulation in public and community writing is a sense of how community approaches to circulation, over time, become imbued with their own histories, values, politics, and experiences. These relationships to circulation become meaningful spaces for community writing and building: from the trains that graffiti writers make to the corners where street papers are sold (Mathieu and George 2009); to the listservs that become spaces of resistance and counterstories for Black women within exclusionary academic spaces (Kynard 2010); to the ways that busses and cars become important sites of mobility for literacy work and research (Nordquist 2017). Trains might have started as a practical and consequential means to move writing, but during my time in the field, I found that they carried significance to writers in ways that often escaped the movement of writing on steel. Rather, writers talk about trains like they talk about spots and bibles: as material venues of writing, participants in writing, and outcomes of writing, as ideal writing spaces that *mean* something beyond just the rhetorical dimensions they afford. They are themselves the goal, not just the methods to move writing from here to there. They are their own *here* and *there*.

We need a framework to capture these spatial-circulatory qualities of trains, a framework for understanding the relationships that communities develop over time with particular circulations. Deviating slightly from circulation studies, here I propose a framework of mobility, one I first encountered in Tim Cresswell's (2010b) "Towards a Politics of Mobility": an entanglement of movement, representation, and practice. Cresswell's work participates in a broader intellectual turn, what Mimi Sheller and John Urry (2006) call "a new mobilities paradigm," a transdisciplinary

conversation—out of which Rhetoric and Composition's work on circulation emerges, at least in part (Gries 2015, xix)—that foregrounds the discourses that surround the mobilities of subjects, ideas, and things.[4] *Movement* is the literal motion of people, objects, or ideas through space. A train moves a tag around the city. A train moves readers by walls covered in writing. *Representation* includes the discourses that surround mobilities, the cultural politics, meanings, values, and significance we assign to particular movements. Finally, mobilities are always experienced in and with bodies, what Cresswell calls *practice*. Together—and these really do need to be considered together, as overlapping and mutually constitutive—this "constellation of mobility" affords us a "way of accounting for historical senses of movement that is attentive to movement, represented meaning, and practice and the ways in which these are interrelated" (26). In what follows, I disentangle this entanglement, unpacking the ways that trains in Boston at this current historical juncture, and other methods of circulation, accrue spatial significance through consistent community uptake.[5]

Movement

HATE once described to me the appeal of trains: "Trains, yeah. A train was our outlet to move your tag around, move your tag around *and* have it be seen by the public and other writers. And it would go everywhere. It would be in different places. That was the beauty of the train." If movement is

4. It is beyond the scope of this chapter to survey all of the work being done within mobility studies. The journal *Progress in Human Geography* publishes excellent reports that overview work on mobility within particular time frames. See Cresswell (2010a, 2012, 2014) and Merriman (2015, 2016, 2017). For more direct theorization of mobility studies and its implications for studies of literacy, see Nordquist (2017).

5. Considerations of mobility are never far from studies of graffiti. Early subcultural accounts consistently centered the act of locating spaces for the circulation of texts and, in turn, the various patterns of (sub)cultural mobility that arose around them (Ferrell 1998b, 594). This is perhaps why Cameron McAuliffe (2013) notes that it just "makes sense to approach the study of graffiti from a mobilities perspective" (521). Studies of train graffiti have similarly attended directly to mobility, recognizing the multiple and emergent mobilities activated when writers write on trains and when that writing confronts readers (e.g., Fraser and Spalding 2012; Karlander 2018).

the "raw material for the production of mobility" (Cresswell 2010b, 19), then trains offer a lot of rhetorically attractive material. As "getting up" has always been an animating ethos for writers (e.g., Edbauer 2005a), the train, with movement through different places and diverse audiences, seems an almost perfect space in which to realize this mass circulation.

While writing in Boston has a unique relationship with trains—lacking the concentration that made New York graffiti so prolific, vilified, and eventually documented—writers remain acutely aware of the train's potential for matching texts to readers in spaces that would be otherwise inaccessible to them.

> RYZE: People get into writing on trains because trains travel. So, you have a billboard that advertises how awesome you are, and it travels. That's why graffiti works so well on trains. Its best incarnation is on trains.

Trains find readers, and as they do, they—borrowing language from Casey Boyle and Nathaniel Rivers (2018)—augment landscapes and activate particular forms of publicity (84). Herein lies the distilled, circulatory attraction of all trains as writing spaces: as they move, they augment landscapes and activate public relationships, both with other writers but also with an unknown and more ambiguous "public" sure to encounter trains in contexts other than that of the writer's (Ferrell 1998b, 603). Trains expand the reach of graffiti's public and spatial potential.

Writers are acutely aware of this expansionary public potential of train writing, particularly with freight trains that move writing outside of the geographic boundaries and constraints of the city (see Ferrell and Weide 2010, 57–59). When NIRO and I first met, he was regularly hitting freights, and we'd talk extensively about it. I asked him once to reflect on why he was so attracted to them as venues for his writing.

> NIRO: But to go to a train, it takes your work out of the environment where you live. You know that train is going somewhere else. It's not going to stay there forever. It's going to travel way more than you ever could have thought it would. If you hit a tag on a train, it could be across the country in the next week, and some writers in Cali are like, "Who is this NIRO guy? He's not from around here,

but that's cool." And so it's like that other aspect of travel and taking the writing out of its environment to bring it a whole 'nother social level.

> You put your work out there and then you just let it go. It may be judged, it may be appreciated, but you're just letting the work speak for itself. That's literally it. Your work is then in place, representing you. Your work is directly yourself. I mean, you're not going to be in Cali in a week. Your tag is going to be. That really reflects who you are.

As scholars have noted, this engagement with strangers is a primary orientation of public writing (Warner 2002). As scholars in rhetoric and composition have noted, the "rhetorical velocity" of public texts on the move always contain elements of precarity, unknowability, and potential recomposition (DeVoss and Ridolfo 2009).

Yet what sets freight train writing apart from some other digital and nondigital methods of circulation studied in our field is that through this expansion of audience and landscape, through this rhetorical velocity, freight trains *increase* their spatial sustainability and prospects for textual survival. Henry Chalfant recognizes that while freight train writing distinguishes itself from subway writing through its sheer "scale," it is also distinct in terms of pace, "attenuated" by delayed gratification, as opposed to the intensity—and precarity—of "compact urban systems" (2006, 0021). As I discuss below, subway graffiti in Boston gets removed before the train runs. But freights, by moving writing outside the city in a form of "slow circulation" (Bradshaw 2018), promise writers the potential for a longer shelf life for their work. The freight takes the writing outside of Boston, away from the narratives of place explored earlier. Because of this, every time a freight rolls past, it's a history lesson to a writer.

> BOWZ: Freights are always fucking mesmerizing. When you bench them shits, man, and there are freight pieces that have been up— and they are like full murals—for like twenty years. Let me not exaggerate, because I haven't actually seen those. But, big KEM5 shits that I've benched are like ten years old, bro.

RYZE: When you paint a freight, you go back and get photos of it
 hopefully. Then it's gone, so you never fucking see it again. It's
 just out in the ether somewhere. It's out traveling. MELT, another
 Boston writer from the 1990s recently posted a flick of a freight
 I painted in 1995 that was running through North Carolina. So
 that's, I don't know, like twenty years ago or something?

Freights become durable and sustainable writing spaces through a slow-but-persistent circulation outside of Boston. If you love something, set it free; if you want your writing to keep circulating to readers, put it on a freight.

So, trains find readers and provide the infrastructure for movement. But trains also carry readers; recall Foucault's (1986) remark that a train "is also something that goes by" (3). In their movement, trains produce gone-by spaces, spots in which writers have steady access to a broad and constantly changing audience. As the train moves, these gone-by spots take on significant contemporary and historical value for writers. Contemporarily, these gone-by spaces afford writers access to a diverse and constantly changing set of readers mobilized by the trains, audiences that might only experience a neighborhood through a window. This is why, in cities everywhere, tracksides serve as spatial anchors for writing. Trust me: if you want to find writing where you are, find train tracks.

Historically: As writers continually travel to and write these gone-by spaces, these spots develop histories, residues of community writing that survive long after texts are buffed or painted over. In Boston, this is most pronounced on the rooftops that surrounded the old elevated Orange Line. Along with the Red Line, the Orange Line drew the focus of most early Boston writers, a formerly elevated train line that "wove through the black and Latino neighborhoods of the South End and Jamaica Plain, ending at Forest Hills" (Gastman and Neelon 2010, 154). It would be difficult to overstate the significance of the elevated line—or the "el" to locals, originally opened in 1901. It was, simply, where "graffiti in Boston found its first true home" (Gastman and Neelon 2010, 154). TAKE tells me how the el concentrated graffiti in his neighborhood, particularly on the rooftops by which the train rolled.

> The el ran straight through the South End. So, on Washington Street,
> all of those rooftops were hit. All of those buildings used to have graff
> on them.

Because the rooftops were "sometimes only visible from the elevated train
level and not the street itself, and since Boston's trains stop for the night
after 1:00 a.m., relaxed rooftop painting could take place during the wee
hours if the spots were right" (Gastman and Neelon 2010, 155). These
spots were well known to writers, or aspiring writers, and as the el ran, it
produced patently mobile literacy practices.

> REACT: The whole time, as soon as you got outside, which was just
> past Chinatown, until you got to Forest Hills, your eyes would be
> glued to try and see what was new and who was up on the rooftops.

The el produced the rooftops as writing spaces. It was a "bloodline," as
HATE calls it, for movement.

The el came down in May 1987—after its final ride on April 30 (Bar-
nicle 1987)—and was moved underground and slightly rerouted along the
Southwest Corridor of the city, part of a larger process of change that
would have demographic effects on the graffiti community. On May 13 of
that year, the *Globe* ran an article titled "3 Youths Held for Orange Line
Vandalism."

> Three juveniles pleaded innocent yesterday and were ordered held
> on $10,000 bail after they allegedly painted graffiti on the Southwest
> Corridor Orange Line, a Massachusetts Bay Transportation Authority
> spokesman said . . . The spray painting, which occurred Monday night
> between the Green and Forest Hills stations, was the first since the line
> opened May 4, Dimond said. ("3 Youths" 1987)

This moment represents an early salvo in the city's larger war on graffiti,
a signal that the Orange Line was no longer for writing. Still, the el's
rooftops remain an important imagined geography on which the graffiti
community builds its identity.

The el came up in almost every discussion I had with writers, both
new and old. TEMP, who would take the el to see writing when visiting
Boston from nearby Lynn, theorizes this historical legacy:

I know people talk about the el a lot. When things aren't here anymore, they kind of develop a reverence. But really, what made it a good place to go was that you could see all the rooftops along the route of the train. You had a great vantage point.

VISE tells me that every city's graffiti scene develops its own reverence for a particular writing space: "In New York, it was the trains. Philadelphia, it was handball courts and walls. Florida was the penits."[6] After thinking on it for a bit, he circles back to Boston, where, "honestly, it might be the rooftops." Every city has rooftops, of course, but to Boston writers, they connect to this specific (counter)public history.

Physically, then, trains are the ideal material support for the production of a range of contemporary and historical writing spaces. In a way, this is the sense that trains match up most neatly with circulation studies. Trains find readers, readers ride trains, and in the process, particular forms of public arrangements are activated, particular writing spaces are produced. The literal movement of trains establishes the conditions for writing's spatial productiveness. But there is more to this story than just movement.

REACT was one of the first writers I met in this study, and the first one I talked with about trains. The way he framed the relationship between trains and graffiti stuck with me throughout and clearly influenced the approach I take in this chapter.

> The basic idea of train writing was just to spread. But, the kind of weird chicken and egg thing, and this is a rabbit hole that I can go down for a while, is that graffiti was in English languages, which are horizontal, right? So, if you're going to write an English-language word, you're going to go horizontal. Trains are horizontal. Most people's tag names were like 3 to 8 letters. Those actually fit pretty well on half of a subway car at relatively standard letter spacing and kerning. All of these things conspired to create an aesthetic . . .

6. I asked MISS REDS, a writer I met during this study who has spent a lot of time in Miami, for a definition of *penit*. Her response: "Penit is what we call an abandoned building where ppl paint. 'Let's go paint the penit on 79th.' 'Wanna go paint the Bank of America penit?'"

People were drawn to trains because they offered a delivery mechanism for their names. Then, trains influence the aesthetic. The aesthetic escapes trains but then people realize that this aesthetically looks good on trains, even freight trains. So, it's kind of this weird, symbiotic relationship between sending your name out into the wild and the aesthetic having been honed on trains, wanting it to find its home on trains. It's almost incomplete, the thoughts I have on it. You start in this one place, you end up here, but you go back there because the thing that you started with transformed the writing and it needs to go back to where you started but for a different reason than why you started writing there.

Writing started on trains. It started in a place of circulatory ambition. Yet as graffiti moved into other spaces, as it escaped the train, it carried with it an aesthetic residue from trains, a continuity constantly in search of a homecoming.

The relationship between trains and graffiti is more than just the crude movement of (re)painted steel on rails. Rather, it is embedded in a particular history, tradition, a bond between graffiti and trains that escapes its initial channels of circulation and its promise of readership. Movement is essential to theories of mobility, but as Cresswell (2010b) notes, it "says next to nothing about what these mobilities are made to mean or how they are practised" (19). For community and public writing, we need to understand that meaning, that representational quality.

Representation

The train *means* something to writers in Boston. As a writing space, it has symbolic, representational qualities that transcend its initial affordance of movement. The train symbolizes access to circulation, access to a publishing infrastructure that does not exclude graffiti. It means inventing community-sponsored patterns of mobility not dictated exclusively by entrenched patterns of racial or class-based segregation. It means circulating identities and new writing histories of Boston, beyond the plaques, monuments, and memories of the Cradle of Liberty. Trains are one of the primary writing spaces where writers hang hopes for a different sort of New Boston, a city with a different relationship to writing and mobility. It represents not just circulation, but the community's relationship with, and hopes for, mobility.

To consider the representational qualities of trains, we have to unpack the ways that, in the face of significant social and legal consequences and constraints, writers innovate new community practices to make the train, to produce it as an iconic writing space that promotes spatial reorganization and a remapping of the city. These emergent community practices tap into the metaphorical qualities of the relationship between graffiti and trains.

> Just as a metaphor has two parts, the tenor (the thing meant) and the vehicle (what embodies it), trains have been literal vehicles for metaphors since their invention in England in the early 1800s. But when the artists of New York City began bombing them in 1969 and 1970, the iron horses became the rare metaphor that is not only written *about*, but written *on*. (Miller 2002, 89)

Writers employ the train not just as a rhetorical means-to-a-circulatory-end but also produce it as a sustainable geography affording mobilities that transcend the literal application of aerosol to steel. In this way, graffiti writers in Boston not only write on or about trains, as Miller suggests, but also *with trains*, alongside them in the coconstruction of writing space.

As writing spaces, trains are important points of connection for Boston writers, particularly to graffiti history. Writers are aware of the rhetorical tradition of train writing, that however temporarily or anachronistically, they can tap into the long and rich subcultural traditions associated with graffiti and trains.

> LIFE: There is a dope association with trains and graffiti that I really cherish.

> MYND: Writing on trains is also reliving a piece of nostalgic graffiti history, when dudes in New York would hit the layups, ya know? You actually get to experience a small piece of what they did every day.

When the earliest writers took the train in New York, they simultaneously made the train into a symbol for a different and defiant circulatory future, one unencumbered by the persistent segregation that limited their ability to forge community through writing. This promise, of a newly written city,

stuck with trains, and as writers in Boston write the train, they tap into that promise of an alternative, and mobile, urban experience.

Yet before we get to those community practices of making the train, it's important to first understand the rhetorical and legal constraints on train writing, the ways that trains become contested spaces on which to write the city's relationship with writing and mobility. In "Boston(s)," I argued that New York City appears in mainstream texts on graffiti often as a sort of warning if Boston does not remain fortified in its quest to erase writing. Perhaps predictably, then, as trains become spaces where writers in Boston develop connections to early New York writers, they likewise become battlegrounds for the larger war on graffiti.

> MYND: The number one rule [in Boston] is that you don't hit [subway] trains. If you know anything about Boston graffiti, you know not to touch the trains because the police will hunt you down like a pack of rabid dogs. That's not really an exaggeration. That's basically true. It is very frowned upon here.

Simply: if trains mean something to writers, they also mean something to urban authorities.

As part of the archival research for "Boston(s)," I uncovered countless examples of New York being invoked to justify harsher crackdowns on train writing. In these representations, we can see a crackdown not just on the movement of writing on trains but also a crackdown on what trains mean for writers: the promise of a different urban experience and mobile future. As just one example, in 1980, the *Globe* ran an article describing a New Yorker living in Boston who returns home to find "graffiti that covers almost every inch of every [subway] car." When he asks a fellow rider why the city allows this, the following instructive conversation ensues:

> "It's a problem all cities have," he said.
> "I haven't seen it in Chicago, Boston or Montreal," I said.
> "Where are you from," he asked.
> "Boston," I said. "We have graffiti here and there, but nothing as insane as this."
> "Oh, that's because of the Puritan ethic there," he said. (Bray 1980)

In this and other forays into New York, the threat of losing control of the train signals a larger breakdown, a loss of entrenched urban identity. If the train is (re)made into a writing space, with all of its implied revisions to urban mobility, then Boston loses a piece of itself, its relationship with public transportation, its Puritan ethic. Trains are *of* Boston, historically, but the written train is foreign, from New York.

These references to trains recur, each differently signaling the threat of train writing. Sometimes train writing foretells murder (James 1977). Other times, it worries riders about the threat of terrorism (Saltzman 2003). Regardless of the way the specific threat is articulated, this constellation of trains, Boston, writing, and New York comes together in real and tangible constraints on train writing as a community writing practice. In 1985, the *Globe* ran an article titled "Painting Boston: Surge in N.Y.-style Graffiti Prompts City, T Officials to Say Enough Is Enough." In it, the MBTA is described as having the belief that "defacing of its property fosters the perception that things are getting out of control and reduces the public's sense of security in riding the T." In order to "counter that perception—and to avoid reinforcing the authors of graffiti by displaying their works—the authority refuses to run graffiti-covered trains as a matter of policy" (Kindleberger 1985).

Along with these policies of not allowing trains with graffiti to run, which continue today, the MBTA also houses a "Graffiti Police" unit dedicated to preventing graffiti and catching writers. In a thesis titled "Subway Spaces as Public Places: Politics and Perceptions on Boston's T," Holly Bellocchio Durso (2011) notes that "while the MBTA has embraced grassroots community art . . . it has characterized unauthorized individual or gang-related etchings or paintings as criminal vandalism" (62–63). Durso notes that no matter if graffiti is seen as a "meaningful message or not, Boston's subway authorities historically held the bright-line policy that any graffiti was bad graffiti" (64). The trains, in other words, are not for writing, and writers know that by hitting a subway train, they take on a considerable amount of risk.

At this point, it's useful to recall the above articulation of the representational value of trains as writing spaces and what they mean for writers in

Boston. Severing access to trains means more than just a lack of access to circulation; rather, it is removing access to the idea and promise of circulation itself: the ability to move writing, to remap. It's not a leap, then, to connect this commitment to preventing train writing to persistent segregation. PROBLAK, for example, explains to me how trains are a primary way that individuals situate themselves in Boston.

> We were Orange Line, all day. That was our line. The trains are very, very important to the region and the neighborhoods. That iron worm, that was your horse.

This imagery of the iron worm and horse has a long-standing cultural history; one of the cultural traditions that Miller (2002) identifies in early New York train writing is that of "Ògún, Yorùbá divinity of iron and patron of blacksmiths," who "came to the Caribbean with West African slaves" and "became associated with modern tools, like the machinery of sugar mills and the trains" (92). While Miller's work provides the full scope of this connection, it is worth noting the racial and class-based significance underpinning this relationship between graffiti, trains, and neighborhoods. PROBLAK notes that trains are rooted in neighborhoods, both metaphorically and physically, but they also move through them, enabling interneighborhood mobilities for writers and writing. As Maggie Dickinson (2008) has written on antigraffiti efforts in New York, this use of trains by writers to reject segregation through circulation posed challenges for a business class dedicated to "transforming the city as much as possible into an infrastructure to support corporations" (32). In the service of this neoliberal project, and "in order to justify the expensive and ineffective wars on graffiti the practice had to be linked to a racial discourse of criminality" (42). The appropriate use of trains—for capital, not writing, to move—becomes a catalyst for questions of race, class, segregation, and mobility.

When transgressed, these expectations of appropriate use lead to spontaneous outbursts of vitriol, evident in the above discussion of busing but also viscerally evident in a 1981 *Globe* letter lamenting the lack of cleanliness on the MBTA.

> For the moment, I'm not expecting the T to do much about the litter, graffiti and slashed seats. As long as a portion of the ridership is

composed of human rodents, that sort of despoilment if probably inevitable. (Nelligan 1981)

Likening graffiti writers to "human rodents" participates in a long history of animalistic racist discourse of invasion and infestation, situating the writers again as unwelcome and out of place on the trains or in the areas they access. For anyone who has ever dealt with an actual infestation, you know the first step is to stop its spread. The train in Boston becomes a focal point in a larger debate of access to public space, who the city's infrastructure serves, and the maintenance of a status quo that corresponds to entrenched and persistent segregation.

There is no question that these legal policies and rhetorical representations have been successful in constraining (but not eliminating) subway bombing in Boston. Subways or commuter trains are seldom bombed, and when they are, the writing is quickly removed. Yet, none of this has been successful in severing trains from their larger representational value. Despite these hurdles, these constraints, this policing—in fact, perhaps because of it all—trains still represent to writers a promise of mobility, a point of connection to history, a direct and highly visible way to (re)write the city in their image. This value to writers means they continually find new ways to center the train in community practices, even in the face of tremendous opposition. An obvious example of this innovation is freight writing: in the absence of opportunities within the city, writers look to freights to carry on the tradition of train writing, tapping into a range of (counter)cultural associations (Chalfant 2006; Cresswell 2006; Ferrell 1998b, 2018; Lennon 2016; Weide 2016). Yet, here, I am more interested in other, less visible ways that writers in Boston continually make the train as a writing space in the face of significant limitations. Graffiti writers need trains, and in this need, develop ways to tap into their representational value beyond and outside of the literal, movement-based circulation that trains afford.

A few examples of these community practices should help here. One way that writers make the train is through what BAST calls, albeit dismissively, a "meta up."

Kids were always hitting trains, and trying to do end-to-ends, but that shit almost never ran. That's because the city is very aggressive in

buffing. I think that it's almost like a matter of personal preference. Do you love the thrill so much and are you connected to the historical arc of graffiti that painting on trains is important to you because that's where New York blew up? And if so, then maybe you want to go paint in the fucking Red Line at Ashmont and take a flick and be happy that you can say that you did it. But in general, I mean, it was never something that appealed to me, because like, why do it if it is never going to run? To flick it? I guess that's interesting or something. That kind of "meta up" was not that interesting to me, though.

A writer writes on a train, and knowing that the writing will be removed before the train leaves the station, takes and circulates an image, either to crew members or in a more widespread, social-media way. In this meta-up, the writer recognizes that circulation will not be achieved through the literal movement of the train but, rather, through the (re)circulation of the image. The value of the train, as a representation of mobility, stands, while escaping its routinized circulation.

> CHARLIE: So, there hasn't really been a tradition of train graffiti here in Boston, as far as hitting the subways?
> MYND: People have tried. A lot have been caught.
> SPIN: People paint 'em, definitely. They don't ride. It's not like people are painting them all the time. It's like here and there.
> MYND: Writers are painting trains for the picture, more or less.
> SPIN: Yeah, definitely. Painting for the picture . . .
> MYND: And the obvious props that come with it.
> SPIN: They are pretty much doing it for the props. Anybody that does it is just doing it to do it. It's fucking crazy to paint a bus or a train in Boston. It's so hot.

Painting for the picture. Meta-up. Writers participate in the tradition of train writing, even if the writing circulates in a new way. It is metacirculation: the writing circulates, and in doing so, comments on the history and legacy of a form of community circulation itself.

Recall for a moment REACT's discussion of the train, that it speaks to a constant search for graffiti to finds its true home. In a city hell-bent

4.1 BEAN, Train Bible. Photo by Charles Lesh.

on preventing this journey home, writers adopt new ways to homestead. During my time in the field, several writers carried bibles with outlines of various subways and freight trains from around the world. One of these train bibles lived behind the counter at Kulturez (fig. 4.1). A long, yellow book with no exterior markings, the "train book," as it was called, always reminded me of a children's book missing its dust jacket. Inside, each page is filled with an outline of a Union Pacific boxcar, offering writers to get up, indirectly, in an iconic writing space. In this bible, and in bibles like it, writing finds its home.

One afternoon I am flipping through MYND's bible, and I come across a page I haven't seen before: a black-and-white pencil drawing in which the letters of MYND's name compose the metallic exterior of what I can only call a tank-train. The imagined vehicle traverses a desert, frontier landscape with wheels that combine the traction for off-roading and the smooth exterior for rails. The tank-train is futuristic looking, to be sure, with antennas, laser rockets, and satellites dotting the exterior. Yet the scene has a distinctly vintage feel to it. The land is only disrupted by this new technology. To the right is a prisoner, long in beard and tooth, rope tied to a stake, a scene of discipline that temporally contrasts with the rivets and technologies of the approaching vehicle. When I ask MYND

4.2 MYND Bible. Photo by Charles Lesh.

about the page—"So, obviously, this piece has wheels. Train graffiti, what's the appeal? What is it with trains?"—he ignores the page and starts his answer elsewhere. We never return to the page, except for me to take a photo of it before I leave (fig. 4.2).

On the ride back to campus—Red Line extension from Mattapan to Ashmont, Red Line from Ashmont to Park Street, Green Line E from Park Street to Northeastern—I set the image as the background on my phone, kicking myself for not returning to it. I'm struck by how different the scene is than the one I'm witnessing on my train ride to campus: people crammed into seats, the train rolling through neighborhoods in predictable and strategic ways. The image on my phone begins to feel almost like writing fantasy, a dream in which you not only write on the trains but write the trains themselves. The obscure geography and temporal

indeterminacy represent a place and time far from this one, with a different, less rigid relationship to mobility. It's train circulation beyond the geographies of rail travel. It cites the history of train writing, honors it, and imagines a future for it beyond the anxieties of mobility in Boston.

Encounters such as these motivated me to seek out other examples of train writing that escapes movement on rails. In July 2015, I was invited to "Under the Bridge," an event hosted jointly by Kulturez and Uniun, a warehouse gallery space in Somerville, Massachusetts. Writers from across the city and surrounding areas submitted model trains on which they had written. At first, this event seemed like an ideal ethnographic event. I participated in blackbook ciphers, met writers and connected with friends, and viewed the trains with a certain distant interest. After composing the first half of this chapter, though, and texting some thoughts to BOWZ, he reminded me of this event as an example of the representational value I attempt to capture here.

All three writers transform trains from representations of movement to representations of writing circulation. LIFE (fig. 4.3) and MYND (fig. 4.4) create replicas of Red Line trains (the line they both grew up on), participating, tangentially, in the cultural meanings and representations of Boston subway writing. SWIL (fig. 4.5) opts to leave the locatedness of

4.3 LIFE Model Train. Photo by Charles Lesh.

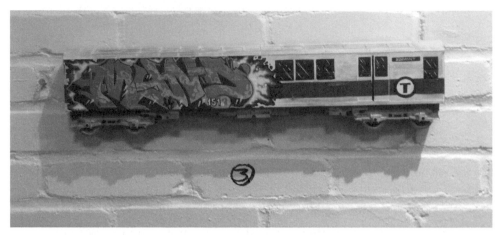

4.4 MYND Model Train. Photo by Charles Lesh.

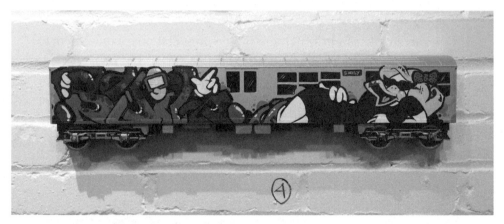

4.5 SWIL Model Train. Photo by Charles Lesh.

his train ambiguous, signaling perhaps the fluidity of the relationship between trains and place or perhaps the idea of trains as places themselves. In these moments, we see the train being made and sustained as a writing space, the distant participation in the cultural meanings assigned to this particular venue of mobility.

These are just a few examples of the ways writers sustain the meaning of trains beyond literal movement. Whether writing on long-abandoned, out-of-service train cars, repurposing old railroad tunnels or trestles as

chill spots, or incorporating trains into wall pieces, writers are continually innovating, writing the train. In each of these examples, the promise of train writing rings out, the promise of writing defying the ways that people and texts circulate or fail to circulate in Boston. In his work on digital circulation, Dustin W. Edwards (2018) calls for us to attend to "circulation gatekeepers—people, institutions, technologies, and/or other infrastructures that control and direct the flow of how, or if, content moves in particular rhetorical ecologies" (62). What seems especially important is how communities respond to these limitations on circulation, how inventive writing practices arise not only as responses to these constraints, but as means to defy them directly, to tap into and articulate what circulation means to community writers.

Practice

I quietly turn right to the commuter-line track, past the sign that instructs me that this area is off limits to pedestrians. The ground is cluttered with empty beer bottles, cigarette butts, and spent paint cans. The walls are alive with writing. Layers upon layers of writing, and as I walk along, I take pictures of the palimpsest.

Walking along the right side of the tracks, on the rail, I'm focused on the walls. Suddenly, I feel my Air Max 1s shaking. I jump off, realizing that a commuter train is approaching. I remember seeing a video that instructs bombers to act as though they are lost in the event that a train appears; too much purpose can lead the conductor to call the police. I run up to the nearest wall and start scurrying about, as though I had dropped something. The train passes, blowing its horn. I lean against the wall. My heart is racing, ears ringing. Still, I feel relieved. I step back on the rail and keep it moving.

To this point, we've seen how trains afford both literal and representational mobility. Trains move writing, and that movement means something to the community. Yet, as writing spaces, trains are also inhabited by bodies, experienced in corporal ways. "Only bodies can make places meaningful," Reynolds (2004) writes, "and the bodies that occupy a place give it meaning" (144). The train is inhabited and experienced, by writers, by readers; it is a space of "practiced mobility that is enacted and

experienced through the body" (Cresswell 2010b, 20). To fully account for the train as a writing space, then, we need to say something of *how it feels*.

From their invention, trains introduced new ways of seeing and reading, new orientations of the body and/in space. Cresswell (2006) notes that as trains became embedded in the regular practices of everyday life and "as more and more people traveled at new speeds in trains, a new panoramic perception of space (as seen from the train window) emerged. For the first time it was possible to see the world as a continuous blur" (5). Writers understand this blur. Anyone who has ever written graffiti or appreciated graffiti has more than one "blurry photograph" saved on their phone.

At a textual level, writers attend to this emergent blurriness through stylistic adjustments. Assessing the physical movement of trains, writers often make compositional choices with an eye toward this train-riding or train-viewing public. Circulation is thus baked into the writing itself (see Trimbur 2000). Whether through the production of what Boston writers call "dead letters" or through the placement of the writing itself, writers attend to this intersection of space, movement, and body. But practiced mobility extends far beyond compositional choices. In talking to writers about their own relationship to train writing, many spoke about the movement-based rhetorical affordances and cultural significance of the practice. Undergirding these discussions—sometimes implicitly, sometimes explicitly—was a distinctly personal, embodied relationship with trains. On the phone one day, TENSE untangles the entanglement of the physical, cultural, and embodied mobilities at the core of train writing.

> TENSE: Graffiti writing and trains. There's a big relationship. Graffiti writers, we love trains. The thing about it is, if you really love trains, you love the art of trains, too. I love trains. I love to write on trains. I used to scratch train windows with sandpaper, and walk around with etch materials in my pocket. I'd write on the windows.
>
> But I also love the train itself. I love the smell of the brake dust when the train is coming into the station. Or just the rumble, the noise. It just has a really urban, city-like appeal to someone like me from the city. It makes you feel good. Those same sounds, you hear in the interludes of your favorite rap songs. When you

hear the introduction on that song Talib Kweli and Mos Def are on . . .

CHARLIE: The sample from *Style Wars*, right?

TENSE: Yeah. "Blasting holes in the night till she bled sunshine."

CHARLIE: Yeah, Black Star.[7]

TENSE: The intro to that pretty much captures it. The train was the moving vehicle or museum for graffiti, you know what I'm saying? Your name could be seen. Boston had the first transportation system. Period. A lot of people don't know that history. We were called the MTA before New York came along and bought the name and then we added the B for the Bay. That's why we have the MBTA.

 When you look at the history of the train, they were rickety, they were old. They were ugly. They were a hunk of metal on tracks to get people to and fro'. And when graffiti started getting painted on trains, in the '60s or '70s, it was like a barrage of both negative and positive emotions.

TENSE sees the material and representational affordances of trains. But he also loves the smell of trains. He loves the surfaces of trains, the glass and the friction it creates against the sandpaper. He loves the rumble, the noise. PROBLAK, too, hears the noise, specifically the el.

 The elevated train was the biggest thing, but I was a baby. When the train was coming from Egelston to Dudley, this corner that it would turn, it would make this loud screeching noise. I would see how long I could scream with it. But it would sound like the train was about to fall off the top.

In May 1987, after the el came down and the new underground Orange Line had opened, the *Globe* commemorated the event by running a front-page article titled "A Gift of Silence After El, Many Relish the Quiet on Washington St." According to the article, residents enjoyed the newly created silence of an el-less cityscape: from Cardinal Bernard F. Law rejoicing

7. The song "Respiration" by Black Star (1998) starts with a sample from the documentary *Style Wars*, in which SKEME discusses a recent subway piece he did with DEZ and MEAN 3 that reads, "All you see is . . . crime in the city."

over a mass at the Cathedral of the Holy Cross uninterrupted by the rat-
tling of the old train to a resident finally able to hear her favorite soap opera
without cranking up the volume. Though some residents claim to have
gotten used to the noise, others celebrated the urban mute. "At the end, it
seemed the noise was worse than ever," one store manager explained, as
if "the train knew it was leaving" (English 1987). The elegiac noise of the
dying train might signal freedom to some, but it signals an absence to oth-
ers, a lack of rhetorical situation, the death of a writing space.[8]

For many writers, this embodied relationship with trains shows up
in the ways they describe their first encounters with writing. Numerous
writers pointed directly to public transportation as both the origin of their
interest in writing and the location that afforded them the ability to read
writing, to develop their own writing, and to identify potential venues for
their writing.

> BAST: As a kid, I really traveled all over the city. I walked a ton. And
> so that urban exploration aspect of my life exposed me to tons and
> tons of graffiti and all the hidden nooks and crannies all over the
> place, all the train lines I didn't live on, and so forth.

These movements center the body's role in the production of writing space:
how these experiences of mobility lead to more intimate understandings
of the city, the ways it is carved up, and the ways in which to traverse/trans-
gress those boundaries through physical and/or textual mobility.

In these movements, writers are exposed to, and play a role in produc-
ing, the sacred cartographies of the Boston graffiti writing scene. Writers
rode and continue to ride trains in an attempt to learn the city's writing
spaces, to become familiar with the names that show up most, and to
learn the geographical reach that particular writers have.

> LIFE: How did I get into graff? I used to always see it on the Red Line
> train. I lived in Fields Corner in Dorchester. I would see it around
> me . . . I would be on the train a lot and see it.

8. For a fuller theorization on the relationship between hip-hop culture and "black
noise," see Rose (1994).

So, trains, Blue Line, Red Line, loving the way that I can see graffiti going by me. The colors and the motion, the way people are tilting their letters, the way they would space them. Big, big life-size dead letters. How I can read them. Others I can't, but I know, they were down in that bridge making some wildstyle or some intricate character. I want to go down there. Trains would be a way to know locations and kind of know where I could go to do it myself.

It would be like graffiti monuments, I guess. I would go on tour. When I was riding on the trains it would be like going on a tour of the city. That's what the trains would be. They would be these nuggets of inspiration, these nuggets of how to do it, where to do it, and who is doing it.

LIFE's reflection on trains signals just how central the practice of riding trains is to understanding the relationship that the community has to circulation. As it moves LIFE past the monuments of graffiti, it becomes its own monument. It becomes its own symbol of revision and remapping, experienced with and through the body.

Conclusion

One of the first things I read when I started researching this book was Nathan Glazer's (1979) "On Subway Graffiti in New York," an oft-cited early account of graffiti and potential solutions for urban authorities. Graffiti is an urban problem that leads to the "inescapable" conclusion "that the subway is a dangerous place—a mode of transportation to be used only when one has no alternative" (4). The article focuses on New York, though Boston does get a shout out, perhaps because of Glazer's Harvard affiliation: "The more serious problem here is the fact that once graffiti gets on a car, it must be taken off immediately so as not to encourage other graffitists. This is the practice in Boston where, as in other cities, the mass-transit system does not have graffiti" (7). Glazer is half right. As noted above, this policy does exist. But the mass-transit does have graffiti and always has had it. If it didn't, there would be no need for such a policy.

What this and other antigraffiti rhetorics miss, and what I've attempted to model here, is the role that trains play not just as vehicles for

circulation but as writing spaces that embody the community's larger attitudes toward, relationships with, and aspirations for mobility. I've argued here that as writers excluded from mainstream networks of circulation innovate, these spaces of innovation become consequential not just to the spread of writing but in the production of community identity. This is true of a vast range of spaces, from street corners to social media, from zines to geocaches. In the case of graffiti writers, as they are met with gatekeepers and gates, with graffiti-proof paint and other security technologies, they adapt, inventing new ways to make the train, to retain that which it promises. Sometimes this means writing on trains. Sometimes this means writing about trains. Often it means writing with the train, producing new venues of writing divorced from but indebted to the steel, rumble, and dust of the tracks. Writers will continue to innovate, continue to sustain the train, long after this book gathers dust. In that spirit, I want to close with one more innovation, one more story about making the train in which, I hope, the reader might find many of the themes of mobility explored above.

SYNAPSE is a street artist in Boston. A research scientist by day—hence the alias—he became intrigued by graffiti while photographing urban landscapes in New York City in 2012. Street art provided the opportunity to meld his lifelong interest in drawing with his larger commitments concerning public space. I met SYNAPSE at a graffiti show in Somerville. Though his work is decidedly street art, I had encountered it in many of the writing spaces that this book has considered. When we met, we chatted while exchanging blackbooks, and after hearing about my project, he wrote his email address on a United States Postal Service (USPS) sticker he had retrieved from his bag.

It might be accurate to say that SYNAPSE's work is born on the train. He observes and draws the faces of people he encounters on the subway, fellow riders he calls "strangers," bound together by this shared-but-fleeting practice of mobility. Sometimes, he creates these images for wheat pasting but, more often, he produces them on USPS stickers, a popular technique, as we've seen, across graffiti and street art.

SYNAPSE's work is about mobility, evident in both the subjects and the circulation. Bodies moving on the train are captured. These arrested

likenesses are transferred to stickers, which invoke another circulatory channel, the USPS. SYNAPSE then (re)circulates these stickers throughout the city, moving these likenesses into new spaces: back alleys, mailboxes, electrical boxes, dumpsters. Along with his own tag, each sticker is labeled with the train line the person was riding. The "To" field on the sticker often tattoos the face, an unintentional reminder that this figure is in motion, in *a place* and going *someplace* (fig. 4.6).

On a cool May night, I meet SYNAPSE at the Squealing Pig, a bar near the Harvard Medical Campus. The bar is dark, and while my eyes adjust, I scan for SYNAPSE. As I sit next to him toward the right corner of the bar, I set up my audio recorder.

> CHARLIE: Why faces? What's your goal for this work?
> SYNAPSE: I'll tell you why it's people on the subway that I draw. Not necessarily just faces, but why are they the focus? There's something very communal about being on the train all together. We're, for all intents and purposes, strangers, yet we're sharing a common experience. It's usually a very mundane and frustrating experience that we're all doing at the same time. I feel like that shared experience with strangers, and particularly people from various backgrounds, different ethnicities and colors and beliefs, there's something really appealing to me about that.
>
> We just hang on. We'll get to our common goal, whether it be work or home or whatever. I find that people who experience that, being on a train or a bus with other people, tend to be, I would say, a bit more sensitive to what other people believe and what they think, and maybe a bit more accepting.
>
> I guess focusing on them is just my way of helping me, and maybe everyone else, understand that everyone has their story. I wonder whether or not that may help people stop and think, and realize that they themselves are not the center of the universe.
> CHARLIE: What are your thoughts on Boston's relationship with trains?
> SYNAPSE: It has a lot to do with the geographic size of the city that these systems cover. If you're taking a train from one end of New York to the other, it does feel like you're traveling to another country. You are in a vastly different place from when you started, if

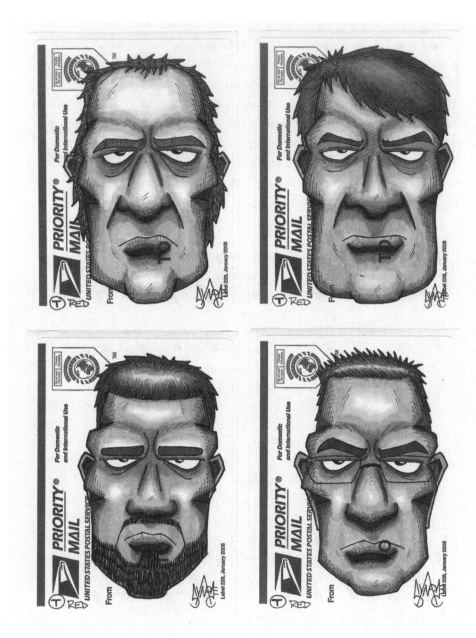

4.6 SYNAPSE Faces. Photo by SYNAPSE.

you take it from one end of the line to the other, from Manhattan all the way to the reaches of the Bronx.

In Boston, it's not so much that. I don't feel like it's treated like this way of covering vast expanses of space. It is really more like a trolley-type idea, that it is just moving you from one location to where you need to go and back. It's not used as a way of exploring new areas.

CHARLIE: Why a USPS sticker?

SYNAPSE: Practically, it is free. It's adhesive. You can stick it places. They have some broad white space. Every few years, as you know, they'll update the model. The current, in my opinion and for what I do, is the best.

They also mean something though. If you are doing street art or graffiti, it's a very DIY, very maker-type endeavor. Over time, as people started using postal stickers as just a surface on which to draw and stick things, they've become synonymous with it. Actually, I'm certain that's why a lot of people do it.

By no means are people limited to it, but it speaks to where they're coming from and what they're trying to do. This is someone drawing something on a sticker. This is obviously some sort of a graffiti or street art thing. It's not an advertisement, not some little grade-school kid trying to vandalize something. It has meaning behind it.

CHARLIE: Why stamp each sticker with the train line?

SYNAPSE: The line you live on is supposed to speak a lot about the person. If you live on the Blue Line, you're Eastie. If you're on the Red Line north of the Charles, you're in posh Cambridge with its ivy-covered brick. Or you're hipster Somerville. Whereas, if you live south of the Charles, Red Line, you're Southie, you're Dorchester.

I feel like putting the subway line on there is almost like a timestamp, or some sort of placement to where these people are and where they're coming from. From a practical standpoint, it just helps people understand that this is what they're seeing. It has something to do with the subway.

I think people piece it together pretty quickly that these are portraits of people on the subway.

> And I think the subway is something worth celebrating
> because I feel like we are becoming more and more isolated just
> by virtue of where society goes, how we're designing our cities
> these days, how often we're in cars.
> . . . One way to combat that is to bring everyone together.
> That's why I think being on a train or being on a bus or anywhere
> in these communal spaces is wonderful. It's a fantastic thing. I
> can't say enough how much I think it positively shapes how people
> think and interact with others.
> CHARLIE: What's our plan for the night?
> SYNAPSE: I'm going to wait until it gets a little darker and then get
> some stuff up.

I stop the tape and we continue to talk. SYNAPSE pulls a black portfolio from his backpack. We discuss plans for the night as we flip through pages of faces. Once it's dark enough, we head out of the bar. On a deserted side street, SYNAPSE wastes no time, rubbing his hands along surfaces, checking for spots that would hold wheat paste. Settling on a backdoor, he asks me to look out. I light a cigarette and my eyes dart around the corner, the familiar adrenaline welling up. It takes about a minute for him to apply the face. When I hear the zipper of his backpack, I turn and start walking. He catches up half a block later.

As we walk, I ask him about his wheat paste recipe. He explains that it is really just varying amounts of wheat, sugar, and water. He's been experimenting with adding small amounts of Elmer's glue. We walk past Northeastern, looking for spots. This one is too well lit. This one isn't visible enough. Each time he finds a spot he likes, SYNAPSE looks around, rubs the surface, and then quickly applies a Postal sticker. I look out. We fall into a rhythm.

As we make our way through the alleyways behind Massachusetts Avenue, we hit about seven spots. I begin tagging dumpsters. A rat darts between us. "Fucking Boston," SYNAPSE laughs.

Occasionally, drivers or walkers move through the alleys, eyeing us cautiously. SYNAPSE tells me that he is going to do his first "big one" of the night: a face that covers four separate sheets of paper. As he painstakingly connects the sheets to create a coherent facial image, a car turns,

approaches slowly, its headlights illuminating the entire alleyway. As it turns away down an adjoining alleyway, SYNAPSE calls me over. "If I get stopped by a cop or a pedestrian, just walk away and keep walking. Don't stop."

We emerge from the alleyway and stand on the busy corner Massachusetts Avenue and Newbury, watching the foot and car traffic over the overpass. It's a perfect spot: above the Hynes Convention Center train station, full of people walking, cyclists riding, cars honking. Mobilities abound. We spot an electrical box on the corner, slightly boxed in by another, larger one, offering just a touch of cover from the street. Enough, we decide. "Man, this is risky . . ." he says nervously, gathering his materials. I turn around, using my body to give him a bit more cover.

A cop pulls up to the adjacent intersection. I whistle. A family with a stroller approaches and starts watching SYNAPSE. While I'm eyeing the family, the light turns green and the cop makes a left turn toward us. I shift my body to cover SYNAPSE, but there is no need: the cop is fidgeting with a cellphone, looking down. I hear the bag zip and we both walk away. "Damn, that was close," SYNAPSE says, "but I figured you had it under control." I laugh anxiously.

We hit a few more spots in the alleyways, at one point hiding behind a fire escape from a "rent-a-cop." We decide to call it a night, stopping quickly to buy burritos.

I descend the stairs toward the Green Line, thinking about the walk I'll take tomorrow to flick tonight's work. I ride the train to my apartment. Surrounded by faces, I read writing through the windows.

Community Interlude 4

Benching

Benching is the act of posting up along trains tracks to read and take pictures of writing on freights. It's a democratic and accessible reading practice: anyone who can find a decent view of freight tracks can bench. I've benched freights from cars, sidewalks, atop embankments, and as we'll see in this book's final chapter, from actual benches. The term *benching* calls back to early New York City graffiti when writers would congregate on benches in subway stations—most famously the Grand Concourse, 149th Street Station, which TEMP mentions below—to watch subway trains roll by (Gastman, Rowland, and Sattler 2006, 0212). Today, benching is a core literacy practice for graffiti writers.

In benching, readers find writing and writing finds readers. As trains pass, writers engage in a process of reading, interpretation, and recirculation, capturing the trains in images and carrying them off through different channels of mobility. Like piecing, bombing, and blackbooking, benching is a spatially productive community practice. It is one of the ways that trains are sustained as mobile spaces of community writing.

In this last Community Interlude, TEMP and BEAN offer insights into the train, picking up and extending many of the themes from the previous chapter. They theorize the movement, the meaning, and the practice of this core writing space. Take a seat on the bench, or wherever you find yourself reading, and check out the writing as it rolls by.

TEMP

CHARLIE: I write a bit about trains as connections between New York and graffiti communities elsewhere. I'm curious about your own thoughts on trains and graffiti, that appeal.

TEMP: Well, it started on the trains. I actually don't think the connection is entirely geographic, between Boston, Lynn, and New York. I think those early trains, they influenced people all over the world, not just in Boston.

While we're talking about trains. I had a friend of mine, not a graffiti writer, in the 1980s, during the early years of graffiti for me. He was a neighbor, lived right across from me in the projects in Lynn. Every summer, he would go stay with his aunt in New York. One year he comes back and says, "There's graffiti all over my aunt's area, on the trains. You would love it there."

So, the following three summers, I spent two weeks in New York with him. I believe that was a huge influence on my style development.

CHARLIE: How so?

TEMP: Man, that's all I did when I went there. My friend got bored with me. I just wanted to absorb style. I went to the Grand Concourse station and sat on those benches. That is where you could go see style. That was like a museum for graffiti style, on and around those trains.

A couple of years before this, *Style Wars* had come out. It was on PBS, and in our group of writers in Lynn, somebody had the luxury of having a VHS player in their house. So they recorded it. That got passed around our group. That was an eye into graffiti. You were able to absorb the same thing as a kid growing up in New York.

So I knew Grand Concourse was my destination. I sat there for hours taking pictures the next time I was in New York.

But those trips out there, it definitely raised my quality of painting. It raised the bar. I wanted to paint cleaner, and I

definitely think that I would see a boost in the quality of my painting, just from being exposed to better quality work.

I didn't view the trains differently because of New York, though. Coming back to Massachusetts, at that time, it was nothing like it. It was night and day, man. I knew it was a New York thing, and I never gave it much thought when we came back here.

We didn't have subways in Lynn. So to us, locally, it didn't matter whether we were painting on walls or trains or whatever surfaces. In downtown Lynn, the rooftops were a big thing for me, because it was better exposure. I would go out and do big, multicolor pieces on billboard rooftops.

CHARLIE: Why were those spots attractive to you?

TEMP: Just being a kid, looking up and seeing my work. I put a lot of effort into the details and that, and I did it when it was dark out. Now it's daytime, and I can see it from right here, on the ground.

To go back to trains, we painted along the tracks, too. That was a main gallery for graffiti in Lynn. The walls were huge and concrete, they were smooth, and they faced the tracks. It just seemed right. Trains were the birth of graffiti.

Along the tracks back then, you'd have SEIZE, DIZMO (first-generation), AVOID, NEONE, and RIVAL. There were other people, but this was the main cast. There was a point where you could go to the Lynn tracks, and you could see every one of our pieces on a primed surface. Nobody had a throwup down there.

That's one thing the Boston writers used to say when they came to Lynn. There was a strong Boston to Lynn connection, and I think they enjoyed coming to Lynn and experiencing our little island of graffiti as much as we enjoyed going to Boston. If you went down to the tracks in Lynn in 1987, you would have seen a gallery of burners.

CHARLIE: One of the things I write about in the chapter is these model trains that writers have been doing recently. The show I write about, you did a train for it, and I think you were a judge

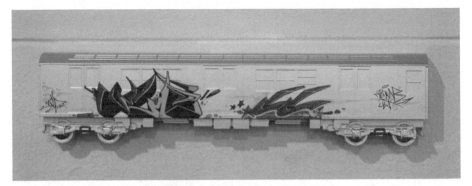

4.7 TEMP Model Train. Photo by Charles Lesh.

for the event (fig. 4.7). So, I'm wondering if you could talk a bit about these model trains.

TEMP: I definitely feel like there is a connection between graffiti writing and trains. There is something that ties it to the roots of graffiti. Like I said, it is how it began.

I actually enjoy doing those model trains. They take time, though, and I've been so busy with life stuff lately that I haven't done a ton of them.

But as far as the attraction, I just think they bring people back. It gives you, it's just a little imaginative journey into those train yards or those benches, but from your desk. It's obviously different, but it's just something that brings you back to those roots.

BEAN: I was actually painting for a while before I started getting into trains. I painted mostly to see my name when I traveled around the city. So at the time trains didn't really appeal to me much. It also didn't help that the closest yard to me was almost an hour away. A few years ago, I had a couple friends who were making the trip and painting trains pretty consistently. They started to drag me to go out to the yard every once in a while.

I instantly fell in love with it. The smells, the steel, the atmosphere, the bugs, the bulls, the panel chase . . . all of it. I started

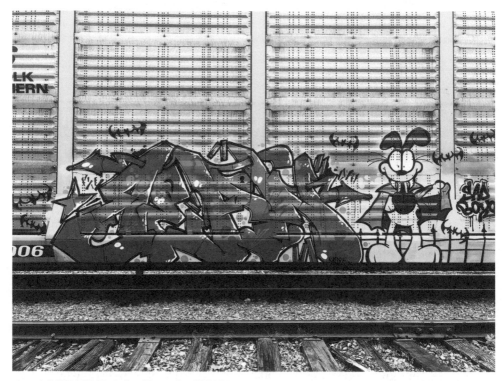

4.8 BEAN Freight. Photo by BEAN.

going to the yard almost every night after that. Three of us even split a beater car that we'd all make the trip in. It has been like that since.

It's kind of funny. I avoided trains because of never seeing it, and now it's my favorite part of the game. I don't take pics of a lot of my panels (fig. 4.8). I love the idea of painting and never seeing it again, which kind of screwed me when Charlie asked for flicks, ha ha. I hate when my trains get spotted locally. I want my writing out there traveling the world, seeing all types of rad shit I never will.

For me, nowadays, trains are my escape. I don't drink or do any drugs, so painting is my way to avoid reality for a few minutes. It's about the experience now more than the piece. The drive up, the bullshitting, the shit talking. It all means way more

to me than the piece I do. The memories I have from the yard will be with me forever.

One time we got spotted by workers. I usually just take my time and get out. But this worker yelled about calling the cops, so we all started running. We had a photographer with us doing a shoot for a magazine, actually.

I take three steps running and I trip on a rail tie and fall straight on my face. My paint goes everywhere. My step ladder goes flying. I get up and I'm bleeding everywhere. Everyone is trying to pick my paint up, and I can't stop laughing.

We get back to the car finally and I realize my brand-new glasses went flying when I fell. I go back to sneak into the yard, and there are cops and workers everywhere. I had to hide out for half an hour and army crawl to find them.

Everyone got a good kick out of that.

5

Warehouse

Where from here?

In conclusion, I'm compelled to ask this question, to offer insights into how I hope this book is taken up, and where I hope it takes us in rhetoric and composition. My answer to this question of where might seem unlikely: to a warehouse in Quincy, Massachusetts, and a bench in Opelika, Alabama. But it is in these two spaces where I find similar hope for writing's ability to make new spaces across vast expanses and boundaries, new *wheres* for writing and new *wheres* for writing studies. At this juncture, I want to think through how the warehouse and the bench help articulate this hope in concrete ways, how these spaces can help project what a spatially productive view of writing might mean for research, teaching, and community work. In this warehouse in Quincy, I find hope for new methodological futures for writing studies, new forms of ethical and tactical community partnerships founded on the coproduction of reciprocal spaces. At the bench, I find hope for our theories and teaching of writing, a glimpse into a different orientation to who writers are and what writing does.

What does it mean to find hope in a warehouse and on a bench? It means something like what Paula Mathieu (2005) describes as a critical and reflexive rendering of hope that "requires the ability to recognize the radical insufficiency of any actions, be honest in assessing their limitations, imagine better ways to act and learn, and despite the real limitations, engage creative acts of work and play with an eye toward a better not-yet future" (134). I hope that this book, the answers it provides, and more so, the questions it asks, are read through this hope: radically insufficient, limited, and partial but providing momentary glimpses of alternative

writing landscapes, however fleeting and ephemeral they may be. The spots on the sides of highways where writers write together. The bibles that are written, shared, and archived. The trains that circulate through space and become spaces themselves. And now, an abandoned warehouse in an industrial area and a bench on a quiet downtown street. My hope is that each of these spaces provides a glimpse into how writers make and sustain spaces for writing and, through this, generate hope for a different writing future, one that is always in process, never fully arrived at or realized.

Warehouse

During this study, I spent a lot of time in an abandoned warehouse in Quincy, Massachusetts. Quincy is just south of Boston, and if you have ever met someone from there, you've learned that it is pronounced *Quin-zee*. I learned this early on.

From the street, the warehouse was entirely unassuming: a mass of gray and white, it seemed to almost naturally emerge from the concrete. When I first encountered the warehouse, it had been abandoned for decades. With its precarious floors, creaky staircases, and suspicious odors, it stood as a monument to an industrial past. Most recently it had been a uniform factory. I learned this by digging through two large trunks I found upstairs in a room with a low ceiling, little ventilation or light, and a hole in the floor so big that, if you weren't careful, would send you down twenty feet to the concrete floor below. Digging through these trunks, I found order forms, notes on uniform design for military and civilian occupations, and other manufacturing and corporate detritus, including a blue-and-gold felt banner. EST. 1898 BOSTON UNIFORM COMPANY: BOSTON, MASSACHUSETTS.

I first learned of the warehouse through a graduate student named Jimmy. As part of a rent reduction agreement with the property owner, Jimmy was tasked with keeping an eye on the building. The warehouse, and the plot it sat on, was unused because of a disagreement with the city over land use. Knowing my fondness for abandoned spaces, Jimmy suggested that we explore one night. As we walked through the warehouse, our steps illuminated by cell-phone flashlights, I caught a few tags and took quiet stock of the massive amounts of clean wall space. Visible from

the Red Line trains and from a nearby overpass, but isolated and feature-less enough to warrant little attention, it was a perfect chill spot for writing.

Later, hanging out on the roof, I asked Jimmy if I might use the ware-house for my research. After some negotiations with the property owner, I was given a four-number code that unlocked a hidden key box. Groups of writers and I were able to go the warehouse to paint any time we liked, as long as we only wrote on things that "can't be sold." This arrangement lasted for about three years.

At this point in the book, you've already visited the warehouse. In chapter 2, it was where I met BEAN on that cold December day. But, to give you a better sense of it as a writing space, here is a quick excerpt from a fieldnote I took during a painting session with MYND and BOWZ.

> I have a head rush. The ventilation in this warehouse is nonexistent, and the fumes and smoke (from various points of origin) are enough to choke someone.
>
> MYND is painting in one of the back rooms, a massive teal and black piece that requires him to stand on a concrete shelf on the wall. Not sure how stable it is. BOWZ has picked one of the long walls in the main room, and I circulate between the two writers, asking questions about their process, occasionally helping to fill in letters. BOWZ is free-styling his piece. MYND is working off a sketch.
>
> When I'm not watching them write, I'm in the back room, practic-ing throwups and tags. Other times, I'm sitting at an old paint covered desk, coding data for a chapter I am working on.
>
> MYND yells to me. "Yo! Open the door. Are you trying to kill us?" Even though we are allowed to be here, we'd still prefer not to deal with any nosey neighbors or inquiring police. I crack the main warehouse door anyways, and find two old fans in the back room.
>
> One, the knob has broken off. Useless. The other works, so I set it up to blow fumes out. MYND ties his T-shirt around his face and pours water on it, crafting a makeshift gas mask.
>
> The writing continues.

For years, writers and I would visit the warehouse. We would write graf-fiti, and occasionally, I would work on my academic writing. We would

talk about graffiti, either in interviews or more informally, about who was up, what spots were active, who had beef with who. We'd theorize graffiti, its place in Boston or elsewhere. We'd also listen to music and smoke cigarettes. But mostly, we'd write and talk about writing. The warehouse no longer stands. The owner eventually secured permission to sell the property to a developer. It was torn down to make way for apartments, I think. *New Boston*. I never went back to check. All of the writing in that spot, like so many of the spaces examined in this book, is gone, preserved only in photographs and stories. It is also preserved in this book in two central ways: as an ethnographic space and as a model for partnership and writing.

Warehouse as Ethnographic Space

The warehouse was an ethnographic space, but I mean this not only in the sense that it was one of the spaces where ethnography happened. Rather, the warehouse was a (writing) space *because* ethnography happened.[1] As all of the writing and methods for data gathering circulated here, they contributed to the larger production of this project and also to the warehouse as a writing space, a venue, participant, and outcome of writing. Here I conducted some of the interviews for this book and collected fieldnotes.[2] I was an active participant-observer here, watching writing, assisting writers, and writing myself. I gathered images of graffiti for analysis, and I shared those images with writers, either directly via text message or indirectly via Instagram. And I exchanged blackbooks with writers to gather data

1. For more on ethnographies of space and place, see Low (2016).

2. I didn't know it at the time, but this attempt to interview writers in the spaces and places of writing is similar to what Bloch (2018) usefully calls "place-based elicitation," an emplaced and multisited approach to interviewing that yields richer, more nuanced data, discursively and extradiscursively. Though not all of the interviews I conducted happened this way—some were conducted via phone and email, others in spaces on campus I secured—many of them were deeply embedded in spaces of writing. For this project, I conducted semistructured qualitative interviews with thirty writers, as well as countless other informal interviews in the process of fieldwork.

and to write myself.[3] While conducting this study, I frequently thought of Mary Sheridan's (2012) call to rhetoric and composition to make "ethnography our own," to think of methods not as "rigid things written about in books but flexible practices meant to be understood and adapted for present needs . . ." (82). As they were enacted within this warehouse, and in many spaces like it, these methods were constantly revised to reflect present needs: they became ways to learn about how graffiti writers make space and also to participate, in some small way, in the production of those community spaces.

In adopting and enacting these methods and leveraging them in the production of writing spaces, I worked within a rich ethnographic tradition, primarily in rhetoric and composition, but also in studies of graffiti in other fields. In rhetoric and composition, ethnography has established itself as a core methodology in the study of writing, literacy, and rhetoric as situated and complex social acts (e.g., Heath 1983; Kirklighter, Vincent, and Moxley 1997; Lindquist 2002; Moss 2003). We've developed a critical ethnographic orientation, a tradition of research that has shifted goals away from just the acquisition of knowledge and toward a more integrated participation and engagement with the writing work under investigation, often to the end of some social critique or transformation (e.g., Brooke and Hogg 2004; Brown and Dobrin 2004; Cushman 1998; Horner 2002; Lu and Horner 1998; Stinnett 2012). I was drawn to an ethnographic approach to this research for this very reason: it allowed me to not only examine the writing spaces of graffiti, but by the practices of my research, participate in their production and their critique of the ways that dominant writing spaces are organized in the city.

Because of this, it should be no surprise that researchers of graffiti have long used ethnographic perspectives to develop detailed portraits of the subculture. Long before I ever laid eyes on the warehouse, or any of the writing spaces in this book, two books in particular—Jeff Ferrell's (1996) *Crimes of Style: Urban Graffiti and the Politics of Criminality* and

3. I adapted this idea from Gregory Snyder (2009), who uses a blackbook as an "interactive research tool" that offered a community-sponsored venue to observe and discuss writing (13–15; 196–98).

Gregory Snyder's (2009) *Graffiti Lives: Beyond the Tag in New York's Urban Underground*—provided me with a methodological roadmap, a sensibility I would take into all of the scenes of research represented here. This work taught me that graffiti required methodological flexibility, and indeed, innovative research on graffiti has continued since, evident in recent groundbreaking autoethnographic (Bloch 2019) and digital-ethnographic work (Pabón-Colón 2018).

Thinking about the warehouse in this vein, it's primary affordance was the ability to directly observe and participate in the writing processes of graffiti writers in a relatively stable and technically legal location. Because this legality no doubt impacted the types of writing that occurred there, I was careful to situate the warehouse as just one of many interconnected-but-distinct writing spaces in the city. Still, the warehouse provided a space in which to write and have sustained discussions of writing.[4] From my earliest encounters with writers in Boston, I was continually told of the necessity to experience writing firsthand, not mediated by internet technologies. While places like the warehouse would circulate digitally on social media, writers told me that to understand how such places are made required spending time in them, inhabiting them.[5] The warehouse afforded that dwelling.

This necessity for dwelling presented more substantial challenges when the writing spaces were not sanctioned. Early on in this research, I was especially inspired by Jeff Ferrell's and Mark S. Hamm's (1998) edited collection *Ethnography at the Edge: Crime, Deviance, and Field Research*, particularly Ferrell's contribution. In it, Ferrell (1998a) defines what he calls "criminological *Verstehen*" as a "researcher's subjective understanding of crime's situational meanings and emotions—its moments of pleasure

4. In this sense, the warehouse was similar to Snyder's (2009) use of the blackbook as a "controlled and safe environment" to observe writing (13).

5. This necessity to study graffiti in the places of its production—in the warehouse and in many places just like it—aligns with critical rhetorical studies that seek to research rhetorical production *in situ*, leading researchers into diverse and often multisited field sites (e.g., Britt 2001; Cintron 1997; Endres et. al 2016; Hess 2011; McCracken 2013; McHendry et al. 2014; Pezzullo 2009; Rai 2016; Rai and Druschke 2018).

and pain, its emergent logic and excitement—within the larger process of research." Ferrell contends that "through attentiveness and participation," a researcher "can at least begin to apprehend and appreciate the specific roles and experiences of criminals, crime victims, crime control agents, and others caught up in the day-to-day reality of crime" (27). This need to inhabit, however temporarily, the position of writer made being present in spaces like those presented in this book crucial to understanding not only the logics and codes of graffiti writing but also the ways that it works rhetorically to invent locations of writing.

As has no doubt been clear throughout this book, I am by no means a criminologist, and this book has decidedly not been about legal versus illegal debates regarding graffiti or the ethics of working with communities who engage in acts deemed illicit. As I've noted, centering the (production of) writing spaces of graffiti means engaging with them on their own terms, not only on the legal categories imposed on them. Yet, recognizing graffiti's illegality through Ferrell's rendering of *Verstehen* poses obvious possibilities for rhetoric and composition. Indeed, just inserting "writing" in place of "crime" in Ferrell's definition shows the synergy between his work and community-engaged work in writing studies. We are constantly striving to study writing with "attentiveness and participation," constantly trying to gain insider, participatory perspectives on rhetorical production.

This also poses challenges. If writing is crime, or is written out of a city's rhetorical landscapes, how do we, as researchers, come to understand "its moments of pleasure and pain, its emergent logic and excitement?" Here, graffiti pushes at a boundary of rhetoric and composition where it is not just the content of writing that is risky but the literal act of inscription itself. How can we learn from these writers? One way is spending a lot of time in places like the warehouse, and in that dwelling, help participate in the cultivation of spaces where this writing might find a home. I believe that the writing spaces produced by graffiti make Boston a more dynamic and equitable city, one where more voices are present and different orientations to city life are announced. This was, to borrow a term explored by Jeffrey Grabill (2012), my "research stance," the essential position I carried with me as a guide to the way I conducted research. That stance led

me to places like the warehouse, places that, when built and constellated together, increase the opportunities for rhetorical work in the city.

Warehouse as Model for Partnership and Writing

As the warehouse was made, it came to represent my attempt to build productive and reciprocal community partnerships. Reciprocity—the dialogic negotiation between researcher and participant in forming ethical and mutually beneficial projects—has long been a primary concern of critical ethnographic work in rhetoric and composition (e.g., Cushman 1998). In my project, from the warehouse to the blackbook, this creation of mutually beneficial partnership took on a decidedly spatial flair as a process of spatial production, a leveraging of research to contribute to the coproductions of writing spaces. Thinking of reciprocity as an act of spatial production involves us in seeking out, inhabiting, and potentially producing writing spaces that can help facilitate the rhetorical aims of the communities we partner with. If, as I've argued in this book, we need to invent the spaces of (community, public, academic) writing we want to inhabit, then we also need to invent the spaces of partnership that reflect our critical, ethical, and reciprocal approaches to community engagement. These spaces can resemble a lot of things, from writing classrooms and writing groups to blackbooks and warehouses. But in their invention, we open up possibilities for more equitable research practices and engagements.

The warehouse is exemplary of this notion of partnership as spatial coproduction. As writers and I continually returned to the place, we produced a space that benefited us in different but interrelated ways. For writers, it was a consistent spot, a relatively stable space to write. For me, it was a productive research site where I could observe writing and talk to writers openly. Yet spatial reciprocity took other forms beyond pronounced examples like the warehouse. My academic literacies—"Your type of writing," as writers would often call it—could at times help secure space for writing elsewhere. I have composed countless genres of writing for a variety of purposes, something I continue to do today. I write letters of inquiry to local art festivals hoping to secure space to paint. I edit applications for graduate school. I help write grant applications for organizations. I write copy for websites so that writers can sell graffiti-related goods. I edit

answers for interviews. Each of these instances of reciprocity funnel into that larger goal of producing spaces for community writing.[6]

The warehouse, as a space of reciprocity, also inspired the production of this book and the ways it is composed. In "Bible," I mention leaving the cipher at the gallery show to meet LIFE outside. When I got outside, the writer pulled me aside to discuss my project. Here is an excerpt from a fieldnote from that evening.

> I go outside the gallery show to join a group of writers smoking ciga-rettes. I pull out my "research pack," a pack of cigarettes I carry during fieldwork to justify my presence within outdoor conversations. And, if I'm being honest, to kill time at spots while others are writing. LIFE calls me over toward the center of the parking lot, where he and his wife are sharing a cigarette, passing it back and forth. He introduces me as a graduate student from Northeastern who is writing a dissertation on Boston graffiti. "This is the cat who interviewed me," he tells her. "This is going to be cool, man. We need more people like you."

When LIFE tells me that there is a need for more people like me, it has little to do with me personally, of course. What he is articulating here is a hope that a book about graffiti in Boston might promote a more nuanced understanding of the community and its writing. For that hope to be real-ized, the book would have to, in some ways, look like the warehouse and writing spaces like it: multivocal, a little messy, containing diverse stories, histories, experiences, and theories of writing.

Other than the multivocality of each chapter, I sought to make this book reflective of other writing spaces through the Community Inter-ludes. While the inclusion of these chapter breaks might strike a reader as

6. Reciprocity took other, subtler, forms as well. As part of IRB compliance (IRB: Northeastern University IRB 14-09-27), I did not pay any writers for participation. When possible, I tried to compensate writers in other ways, such as by facilitating the sale of art or purchasing pieces myself. On a smaller scale, I bought lunches, drinks, and other low-cost items consumed during interviews, painting sessions, or nights out. Though incom-mensurate with what I received, these local gestures were appreciated and perhaps best summed up by MYND who, when describing introducing me to so many writers, said, "You keep bringing me burgers, I'll keep feeding you writers."

an example of "collaborative ethnography" (Lassiter 2005), for me, I saw it as a way of crafting a book that takes very literally Thomas Deans's (2000) call for community partnerships to "write *with* the community" (18–19). I always viewed Deans's call as a spatial one that involves us in attempting to leverage partnerships in the production of more dynamic and equitable writing spaces, whether it's in the midst of community work or in the academic products that result from it. While critical ethnographic work in rhetoric and composition has long privileged multivocality, my goal here was to not only include the voices and perspectives of participants but to literally write along with them however they chose: through essays, images, interviews, or stories. In this writing, the book is produced as a particular type of writing space not entirely dissimilar to the warehouse. It is a coproduction of a space where multiple voices and perspectives are shared, a space constantly being produced, debated, revised, and sustained.[7] That is, I hope this book is received as *a writing space*, one production of space afforded by this partnership.

Like any writing space, this book is far from comprehensive and has obvious and substantial limitations and oversights. As I've noted throughout, I'm hardly the perfect person to do the work presented here. The writers in this book—just a very small sample of the writers the city has produced—are from Boston or the surrounding areas, with a few transplants living in Boston. All of them are writers. Many of them are people of color. A significant majority of them are men. While women writers have played, and continue to play, a central role in the community, my interactions with writers skewed heavily toward men, likely the result of my own gender identity. As a white man from out of town—and a self-labeled

7. In modeling this type of ethnographic partnership for rhetoric and composition, I follow, and am directly indebted to, important feminist research in graffiti studies. Macdonald (2001) shared her work on masculinity and subculture with writers and printed their responses at the end of her book in an afterword titled "Writers Talk Back." More recently, Pabón-Colón (2018) included direct quotes from writers to aspiring graffiti grrlz in a section of her conclusion titled "Passing the Mic," a reference to the hip-hop act of passing the microphone to another MC. Both of these works taught me the value of direct community participation in authorship.

"nonwriter," which I explain below—my choice to study and write about Boston graffiti was always a fraught and limiting one that no doubt shaped the perspectives of this book.

Still, as the reader likely noticed, I eschewed the typical ethnographic convention of articulating my own identities in a discrete moment in the beginning stages of this book and instead situated these discussions in action as they were performed within, and influenced my reading of, specific writing spaces. I wanted to show identity not as something supplemental but, rather, as something that impacted the very real day-to-day, space-to-space of community partnership. I consider my identity in relation to these writing spaces not just to signal my commitment to any critical-methodological tradition but also to signal the interested and mediated nature of the data emerging from my inhabiting these spaces. This goal was made more complicated by graffiti's emphasis on anonymity, with the presence of the writer in urban space being attached solely to the name. I've tried to honor this community preference for name-based publicity by divulging identity categories or personal details only in instances where the writers themselves discuss them. Because of all of this, like any graffiti space, this book is only partial and representative of only one constellation of writing decisions among many others.

To tie together some threads here: this framing of community partnerships as spatial coproductions helps frame our methodological work toward the situated needs of particular communities of writers. This linking of methodology and partnership became clear to me during a conversation I had with Caleb Neelon. Caleb is an artist and writer who lives in Cambridge. Along with an amazing array of artistic production, his decades-long career writing about graffiti has produced foundational texts about the subculture. Notably, he, along with Roger Gastman, is the author of *The History of American Graffiti*, a book that provides an unprecedented and detailed historical-cultural framework for understanding the emergence and evolution of graffiti writing in the United States. The book itself is organized around different geographical contexts, and Boston is the focus of two chapters.

I didn't meet Caleb until late in my research, when GOFIVE, at my urging, put the two of us in touch. In the midst of a phone interview, we

talked about writing, graffiti, academia, and methodology. What was striking to me was his rejection of the label of "methodology" to describe his own research practices and how in that rejection, an equitable, reciprocal, and ethical model of partnership was articulated. I'll recreate that part of the interview here.

CHARLIE: I have to say, as I was writing my first seminar paper on graffiti writing, my first time trying to wrap my head around Boston graffiti, *The History of American Graffiti* was so important to me.

CALEB: [laughter] All right, well, I'm glad it was useful.

CHARLIE: I can't even imagine what that was like, putting together.

CALEB: It ate a good five years of our lives. It was something that had to be done and we had the chance to do it, basically.

CHARLIE: Before we even get started, because I'm curious as a researcher, how did you go about, like methodologically, compiling that many writers to talk to?

CALEB: Well, not methodology. Mind you, we aren't academics. Once you get into citations and all that, you get into ripping apart other people's methodologies. We sidestepped a lot of that. We were not going for that, because honestly, we didn't care. [laughter] That was not the prize, for us.

But, the way to get the 500th graffiti writer you need to talk to you to talk to you is to do a good job with the first 499, basically.

It's still a culture which is all about your rep. If you have a good track record with doing what you say you are going to do and treating people fairly and respectfully, then everything builds on itself.

[*later in the interview*]

CALEB: Honestly, I have opinions about academia and the limitations of academia, even though I live in Cambridge. I'm from here and I love it here, but there are a lot of limitations.

I definitely teased out the idea of trying to do more graffiti-related studying with my various professors. I got answers that ranged from fucking stupid to innocent misdirections. Innocent misdirections in the context of what I knew and what people I cared about knew versus the direction I was getting [from

professors]. I knew that I wasn't going to find the guidance I
needed there.

This was just one of those times when popular interest and
money was way ahead of the academics in terms of being able to
establish a dialogue with writers. We were getting book offers. The
book offers, the magazine offers and things like that, they were
always at a higher level. The editors were asking me way, way bet-
ter questions than the academics were.

I still have yet to hear really good academic anything about
graffiti.

Academics not asking me anything close to the right ques-
tions, that was one of the things that took me away from that as a
possible path.

Thankfully, in the end. I would hate to sit in an office and all
that stuff. I would much rather swing around on a boom lift in a
cloud of fumes. It's a lot more fun, to actually write stuff normal
people can find.

CHARLIE: And with academic books, at least for me, there's always
 that question of tenure, citations, getting it assigned, whatever.

CALEB: Right, right, that whole aspect of things. Growing up, I was
 an MIT brat, with my stepmom. That whole process is miserable.
 I'm sure I'm preaching to the choir here.

The process of peer review and all that has nothing to do with
your content. It only has to do with your research methods. People
who are just as miserable as you for the same reasons that you're
miserable. That is really the only thing everybody has in common.
What a dreadful process.

Not to bring it all down. But, feel free to quote that. [laughter]

The guy who has published more on graffiti than he can lift
on why he never went into academia. I actually want that to get
out there.

This suspicion of methodology signals to my mind a generative gap, a
place where we might more directly unite doing the work of community
partnerships and describing an "underlying theory and analysis of how
research does or should proceed" (Kirsch and Sullivan 1992, 2). This inter-
section between methodology and partnership can be messy and difficult

to describe in any macro sense. As Rebecca Rickly (2012) might put it, this project required me to "become a little more comfortable with what [John] Law refers to as the 'messiness' of research," the ways that the study of writing is, like writing itself, often "tangential, muddled, recursive, and takes us in directions we had no idea we were going to end up in" (266; see also Fleckenstein et al. 2008). Embracing this mess in writing research might take us into different spaces, spaces like the warehouse and this book, spaces not only where a partnership happens, but because partnership happens, partnership as coproductive spatial practice.

Thinking of the warehouse as the materialization of a particular critical orientation to partnership and methodology seems to me close to what Susan Naomi Nordstrom (2018) has called an "antimethodology," a radically situated, ongoing practice of generative research occurrences so embedded and continued that it happens to us as much as we do it (222–24).[8] Antimethodology does not abandon traditions of qualitative research, but it does ask us to locate our work in the lived experiences of research with fidelity to the communities we partner with. It rarely happens in an office. Rather, it is something that is negotiated, unceasingly, in places like the warehouse. It locates the study of writing not just in scholarly literature but also in the actual writing spaces we study and potentially take part in building. To borrow a visual from Caleb, it often happens in a cloud of fumes.

Bench

There is a bench in Opelika, Alabama. The bench is made of steel, coated in black, and on a September day in 2019, it's hot to the touch. September in Alabama: it is ninety-seven degrees with only a scattering of clouds. I moved here in 2016 for a job at Auburn University, about ten miles from this bench. Sitting here, I slide all the way down to the right armrest, taking advantage of the little shade provided by a nearby tree.

8. See also Jessica Restaino's (2019) work on the limitations of methodological work in writing studies, particularly as it relates to the personal.

Behind the bench is a blue-and-gold sign—the same colors as the felt banner in the warehouse—erected in 2010 by the Alabama Tourist Department and the City of Opelika. "Opelika: A Railroad Town," the sign reads, going on to tell the history of this small city (pop. 30,555). Opelika, I read, was founded in the 1830s. In the middle the nineteenth century, the Montgomery and West Point Railroad Company extended its Montgomery-Opelika line to West Point, Georgia, an infrastructural change that led to the rapid growth and development of the city, largely revolving around a series of warehouses storing cotton and other manu-facturing goods. The origins of this cotton and these other goods, in nine-teenth-century Alabama, the sign leaves unsaid. During the Civil War, the warehouses once used to store the plunders of slavery became Con-federate storage facilities, storing goods in the fight for the preservation of slavery. Most of the warehouses were eventually destroyed by Union troops, who also tore up the railroads.

The bench faces northwest, away from downtown and toward a set of freight tracks operated currently by the Norfolk Southern Corporation and Georgia Southwestern Railroad. Next to the tracks is a small sign: "Train Yourself Not To Litter."

Behind the bench, behind the sign, is a monument. The gray stone is an equilateral triangle, three dimensions and pushed on its side. Etched in two of the sides: "ALABAMA: WE DARE DEFEND OUR RIGHTS." On the third side, the provenance of the monument: "Presented to the city of Opelika by the Opelika Exchange Club: May 28, 1979." Left unsaid are what rights are being defended, by and for whom. The tree and the sign behind the bench don't obscure this monument.

Two blocks away from the bench is a cenotaph, a Confederate monu-ment to soldiers buried elsewhere.[9] The monument is adorned with two crossing Confederate battle flags, couched with the dates of the war, 1861–65. The monument was dedicated not immediately after the war,

9. For work on the rhetoricity of Confederate monuments and (aerosol) resistance to them, see Sanchez and Moore (2015).

but in 1911, by the United Daughters of the Confederacy. This is not uncommon. In the *New York Times*, historian Karen L. Cox (2017) writes:

> The heyday of monument building, between 1890 and 1920, was also a time of extreme racial violence, as Southern whites pushed back against what little progress had been made by African-Americans in the decades after the Civil War. As monuments went up, so did the bodies of black men, women, and children during a long rash of lynching.

A Confederate soldier stands atop the monument, facing the bench from two blocks away. Along with other marks and memorials to the Confederacy, one side of the monument reads, "Defeated, Yet Without A Stain."

I frequent this bench, and I'm usually alone. A passerby will occasionally look at me, and then look around, presumably wondering what would compel a person to sit on a bench facing away from the sidewalk and the well-manicured shops, restaurants, cafes, and bars that line the downtown streets.

Sitting on the bench on this day in September, I flip through Instagram, scrolling through the flicks of graffiti that dominate my feed. Today, this is one of the ways I keep up with my friends, research participants, and the work they are putting in. MYND texts me. He is temporarily staying in Panama City, Florida. Four hours from this bench. "Want to hit some freights? There are freights fucking everywhere down here." I'm down, I tell him. "Keep me posted on your moves." My shorts feel hot between my body and the bench.

In the distance, a blaring horn, followed immediately by bells. I jump off the bench to look at the nearby street crossing. The red and white gates drop, illuminated by flashing red lights. I walk past a "Dog Waste Station," scrambling to open the camera on my phone. In the distance, I see a metal speck, slowly growing as it approaches.

As the train roars past, it blows its horn. The boxcars start appearing, sequenced one after another, moving in steady and comforting intervals. Almost every car is smashed, covered with bright, bold, big graffiti writing from across the country. I see throwups from writers back in the northeast, pieces from writers I don't recognize, and massive rollers that cover entire

cars. A few weeks prior, I saw a BEAN piece roll by. Boston writers a thousand miles from this bench coming to visit. As each car passes, my head turns, straining to read the writing, to take an occasional flick, to interact with the texts.

I stay for about two more hours, catching a few different trains. I begin my walk home, three-fourths of a mile from this bench. There is an overpass that runs over a section of the tracks. As I walk under it, tracks to my right, I look over my shoulder. No one. I scale the ramp up to the top and grab a black paint marker from my bag.

This bench is 1,198 miles from the counter at Kulturez, from the place this book started. An unlikely place to end, maybe. But in some ways, it's not all that different from the writing spaces we've visited. There are the monuments, strategic texts looming over and dictating the writing spaces of the city. Like the monuments in Boston, these tell a version of Opelika's history, with consequences for future attempts at revision. And there is the bench. Like so many benches before it in the history of graffiti writing, it is made, in part, by writing, not unlike the highway spots, the bibles, the trains, the alleyways, and the other writing spaces this book has moved through. In those moments when the trains rush by, daring a reader to keep up, this is not just a bench in east-central Alabama. It's a writing space, a space for writing to find readers, a space because writing finds readers.

The work of this book continues to lead me to places like this bench, these spaces between worlds, boundaries between established and emergent writing spaces. Ferrell (1998b) has written of the potential for freight writing to find places like Opelika, to move through spaces unaccustomed to graffiti writing. Exploring the multiple intertextual dynamics at play on freights, Ferrell contends that "similar intertextual effects are created as tagged or pieced trains pass through the countryside, small towns, urban neighborhoods, and railyards, creating momentary ironies and juxtapositions with local imagery" (597). It is precisely in these disjunctions with the landscape, its pristine landscaping and storefronts, its Confederate monuments, its nineteenth-century red-brick courthouse, that new writing spaces are being made here in Opelika. As writing goes by, a reader from this part of this state interacts with it: frustrated that the train has

stopped a commute home, perplexed by the illegible writing, or moved to wonder what is being communicated here. Whatever the case, this reader is taken up into new writing spaces, rhetorical interactions of a different sort than others downtown and with a writer often far away.

When I moved to Opelika, I was told that, other than freights, I'd have to drive to nearby Atlanta for any graffiti writing. Save for the occasional tag, this has largely proven true. Yet it is this very absence of writing that makes the trains and the bench so revealing in terms of the larger arguments of this book: that writing produces spaces, often in ways that don't adhere to more strategic, formalized boundaries of writing. Sitting on this bench, benching freights a thousand miles from Boston, from the warehouse in Quincy, I'm wondering what I'd want to communicate about this book to a distant reader who might only catch a glimpse of it as it whirls by, who might only temporarily inhabit the writing space it produces. It might look something like this.

(X) Writing Produces (X) Spaces

Like graffiti writers sending their names and messages across the country on trains, I can't anticipate how any of the work presented here will be used, how any of it will be read. Such is the nature of writing on the move. But I can hope that wherever it is read, this formula and its parentheses—echoing Lefebvre's (1991) foundational "(social) space is a (social) product" (26)—is read both skeptically and suggestively. Let me explain.

I hope that this book conjures some skepticism. Disciplinary skepticism can be productive, I think, in that it generally leads to more conversation, more writing, and thus more spaces. And skepticism toward spatial work is well established. Lefebvre (1991), for example, anticipated wholesale objection to his project in *The Production of Space*. Noting an absence of space in larger theoretical discussions, Lefebvre writes, "To speak of 'producing space' sounds bizarre, so great is the sway still held by the idea that empty space is prior to whatever ends up filling it" (15). The idea of writing producing writing spaces similarly might seem, at first glance, bizarre. At second glance, it might seem backward. We've spent a lot of time unpacking the rhetorical dimensions of space in which writing occurs, of space as an active participant in writing processes. This work

has been crucial, and continues to be so, because of its important and powerful explanatory potential.

Take the above scene, of a reader on a bench in downtown Opelika. The train writing moves through the real and imagined spaces of Opelika, material spaces and metaphorical ones. The bench itself is suspended in a web of material and metaphorical significance. It is physical, surely, hot to the touch, but it is also shot through with metaphorical qualities: from the lasting impact and visibility of slavery and white-supremacist violence to the economic development and changing makeup of the downtown area, spatial reorganizations and gentrifications not entirely unrelated to the bench's proximity to the university that brought me here. The writing interacts with these spaces in rhetorically meaningful ways. The interactions a reader has with the texts, and in turn the forms of publicity the texts generate, are surely influenced by this emplacement. Understanding this context, this rhetorical space, is urgent in our analyses.

But so too, as I've tried to argue in this book, are the new writing spaces that graffiti writing makes for itself as it sweeps through these quiet downtown streets, the ones alongside, within-but-decidedly-distinct-from Opelika. These *wheres of writing* are fleeting, difficult to capture, and often frustratingly inconsistent. But they are here, and while they might not offer us a certain or concrete vision for a different writing future, they do offer us the chance to temporarily inhabit one.

(X) Writing Produces (X) Spaces

I also hope this formula, this book, is read suggestively. I hope it inspires some action, some work, and that readers will fill in their own Xs, plug in the types of writing they are studying, assigning, and encountering, and contend with the spaces they are producing. I hope they will approach those spaces on the terms dictated by the writing itself and not always in relation to the hopes for spaces we bring to them. To understand writing and rhetoric is to understand the spaces it produces, not just as venues and participants but also as outcomes.

Of course, there is work to be done beyond fill-in-the-blank writing theory. To understand these spaces requires us to spend time with them, to experience them, to get to know them, as well as the people and texts

that create them. In other words, we have to sit on the bench. We have to visit the warehouse. Rhetoric and composition seems poised to do this dwelling, inhabiting texts and spaces in instructive and meaningful ways (Reynolds 2004, 140). In rhetoric and composition, we spend a lot of time within texts, from student writing to journal articles, from essays in writing centers to research on writing centers. Understanding that the production of texts and the production of space are not just similar but constitutively dependent on each other opens up conversation on a vast range of spatial productions in the field.

Of interest to me is how community-engaged work in rhetoric and composition, particularly, seems poised to push the boundaries of the spaces and texts in which we dwell. Community-engaged work, as I note earlier in this book, has always seemed to me the camp of our field most explicitly dedicated to rhetorical spaciousness, to cultivating robust rhetorical landscapes within and beyond the academy, and to pushing the boundaries of where writing (studies) is and what writing (studies) can do. Mathieu (2005) describes this quite well as "a significant redrawing of geographic boundaries that define sites for composition teaching and research" (14). Recent work has only continued this tradition, exploding the where of the larger discipline in transformative and provocative ways.

From my perspective, today, the where of our field might increasingly feel like the spaces explored in this book: public and community spaces betwixt and between, sometimes tactically hidden from the mainstream, and often from our own discipline, though no less rhetorically or politically meaningful. Spaces that jump out at you while you're sitting on a bench, unexpecting, and seem to disappear as quickly as they came. My hope is that we continue to chase these spatial experiences, to work where the work takes us. Starting from this place of willingness, we might continue to expand our understandings, theories, and pedagogies of writing, specifically the diverse ways that communities, faced with a dearth of adequate space, use writing both to confront these spatial-political realities and to make new spatialities, new relationships and experiences with texts.

This book has not been about pedagogy. In the Introduction, I compared Kulturez to a writing seminar, an experiential pedagogical environment where I learned of alternative cartographies of writing. Those

rhetorical landscapes were different than the ones I encountered in rhetoric and composition and remain so. So too was the pedagogy I experienced. This despite the fact that some writers represented are working teachers, as we've seen. Some of them are students. Most of them consider themselves students and teachers of graffiti and that the work they do as writers is educating readers in myriad ways. Yet the locations of teaching and learning present on every page of this book are decidedly not another iteration of the Athens of America narrative. Nor are they parts of Composition—not even of our "extracurriculum," to borrow a term from Anne Ruggles Gere (1994). Often, I found the spaces and places of this research to be not only distinct from disciplinary locations, but in tension with them, and my movement between institutional locations and community spaces only heightened my awareness of these contradictions. Where did the spaces I was inhabiting, the rhetorical work I was doing, fit into our theories of space, place, and writing? I don't think I've found an answer.

Because of this, I have no hope or desire for a *Graffiti Composition*. I cringe even at the sight of that phrase, though I do recognize my impulse, especially in a conclusion, to appropriate what is productive in the communities I work with and inject it back into rhetoric and composition, repackaging and remixing, reducing and rebuffing. Still, the work that graffiti writers do—*their* theories of space, place, writing, and publicity—have implications for the teaching of writing, ones that readers of this book have no doubt already identified.[10] Fundamentally, graffiti teaches us that when we introduce public writing assignments, or any writing assignments, the spaces that texts produce should be a, if not the, primary concern, a topic to be discussed at every stage of production and circulation. Students should not only be tasked with inventing publics but also, when necessary, tasked with imagining how they might invent new spaces where these publics and counterpublics might write, where they might continue the conversation.

10. Across disciplines there is quite a bit of work on the pedagogical implications of graffiti writing and street art. See, for example, Christen 2003; Cozza 2015; Ross and Lennon 2018.

Sometimes, I've learned, they'll be bathroom walls. A former student in a class I taught on public writing was motivated by (graffiti) writing's ability to make spaces connected to, but meaningfully distinct from, more dominant rhetorical spaces. What new writing spaces did Auburn need, she asked? And where? As an answer, she produced a series of posters that contained a crowdsourced list of different words and phrases that all mean "No." Hanging these multivocal posters in the men's bathrooms at a bar that she and others associated with rape culture and sexual assault, the student hoped to create, even temporarily, a new writing space, one where consent is centered. Where an unexpected text on consent confronts you in a place you might not expect to see it and takes you up into its space on its terms and with its terms. What is crucial here is that she not only imagined the spaces and places of public writing, the rhetorical spaces of her work, but also the possibility of new spaces and places because of her work. This bathroom wall, and a bench eight miles away from it, are where I find hope.

Warehouses

I feel comfortable in warehouses like the one in Quincy. This is probably because warehouses have been part of my life since I was a child. I like to tell people that I grew up in a bar in Buffalo, New York. What is more accurate is that I grew up in an Italian-American bar-owning family, and I spent a lot of my time in bars. The bar business can be inconsistent and precarious, and warehouses tend to pop up during the more difficult financial times.

During these periods, my family—six children, my mom, my dad— would experience intermittent housing precarity. We'd move our stuff into rented warehouses while we moved between living with relatives, friends, or in rental homes. When it was time to get our stuff out of a warehouse, either because we found a new place to live or because we couldn't afford to pay the storage fees, we would head to the warehouse, often in the middle of the night before the locks could be changed, pack up, and leave.

My interest in graffiti writing dates back to one of those periods, in early high school. A landlord had discovered my brothers and me living in a spare room in my grandma's apartment and threatened eviction. A few

days later, my dad would park around the corner late at night so we could sneak in the back door undetected. Until then, I'd stay with a friend. Sitting at his kitchen table, my friend pulled out his blackbook and explained graffiti writing to me. I became enamored. I selected my first name that night, one I've long since abandoned.

The first tag I ever did was soon after, at night on a stop sign in North Buffalo. I can still replicate the curvatures of that first tag, so many times I practiced it in my school notebooks. By the next morning, when I went to look at it, it was covered with the word TOY. Whoever wrote that was right. I was, undoubtedly, a toy, a name writers use to refer to someone with subpar talents and a lack of community knowledge. I slowly got better. All of my notebooks and textbooks from high school and college were filled with tags and throwups. I still have some of them. Friends' bedrooms were covered with our writing, composed during late night talks about graffiti. I would walk around and look for the writers most up. I would scour the message boards on 12ozProphet (a graffiti website) for pictures and discussions about writing. To this day, the first thing I do when visiting a city is walk around and look for graffiti.

Despite all of this, I never became a *writer*. Maybe it was the disappointment in that first attempt, but I never wrote my name in the city with any regularity. To this day, despite my having written graffiti, I do not consider myself a graffiti writer. I have far too much respect for the term and for the people who put in the work to earn it. Still, this enduring passion toward writing, this familiarity with its histories, traditions, and rules, no doubt opened up spaces like the warehouse to me, opened up conversations with writers and afforded me the research ethos to engage with writers in the manner presented in this book. When SENSE used to introduce me to other writers, he'd often say, "Oh this is just Charlie. He's good people." Much more than being a decent person, being *good people* meant that familiarity with writing, that proven respect for its culture. Without it, this book would not have been possible.

Though my interest in graffiti dates back to that friend's kitchen table, I can trace the academic work of this book to one specific moment: my first encounter with the work of Nedra Reynolds. Researching my first seminar paper in graduate school, I was guided by my professor (Chris

Gallagher) and a classmate to think about graffiti within the larger tradition of critical spatial theory and rhetoric and composition's uptake of it. To that end, the first thing I read was Nedra Reynolds's (1998) article, "Composition's Imagined Geographies: The Politics of Space in the Frontier, City, and Cyberspace." Sitting at my desk, in my cramped and shared office that was surely once a closet, I read Reynolds describe with such clarity and energy graduate office spaces at her own university, contending that "a qualitative study of this space would have to account, in the fullest possible ways, for the material conditions of this office which have everything to do with the work that gets done there" (30–31). Suddenly, my office seemed much more to me than where I did work; it seemed to me a space that was participating in the work itself. As any reader of this book now surely knows, Reynolds's introduction of an explicit spatial imagination to rhetoric and composition had a profound impact on my intellectual life. It shaped and refined my initially nebulous interest in graffiti as an academic pursuit.

During that initial read, a few moments jumped out to me. The word "graffiti" appears twice in this essay. As I argued in "Boston(s)," when graffiti appears in strategic texts, it can often teach us something beyond just an attitude toward graffiti, something about larger attitudes toward writing in a city, or, here, in an academic discipline.

> I began to think more about the politics of space after Jane Marcus visited Miami University and, struck by its wealth and privilege, spoke about the material conditions at her institution, City College, where instructors were lucky to have an office with a desk at all; forget about photocopying, a phone, chalk, or paper. If your walls weren't covered with graffiti and you had a chair, you were truly lucky. (Reynolds 1998, 20)

> The material spaces of campuses, schoolyards, and classrooms across the country—especially those in economically devastated areas—are marked by ceiling tiles falling onto unswept floors, in rooms with graffiti, trash, and no chalk, or no chalkboard. Classrooms are crowded and too hot or too cold, or with badly filtered air. (Reynolds 1998, 30)

Reynolds's larger point is crucial and well taken, of course. The material context of instruction does directly influence writing, and "to neglect

these realities" would be "to ignore the politics of space, the ways in which our surroundings or location affect the work that is done there" (30).

I remember being struck by these passages, this grouping of graffiti with other symbols of deprivation, with other spatial characteristics that shrink productive writing spaces. I no longer have my first copy of that article. It was likely one I printed off using my allotted number of pages-per-month from our department printer. But I can guess what it looked like. It likely looked like all of my notebooks and books since high school, the margins of each page covered with tags and throwups. Even as I write this, my office walls are covered with graffiti, some my own, some the names of writers whose paths have crossed mine.

These passages got me thinking about the walls of rhetoric and composition: where we build them, what we want them to look like, which walls we feel are most conducive to the work of writing and studies of writing. Building these walls, or identifying desirable walls, we've inevitably privileged certain types of writing and certain types of writing spaces, often at the expense of others, others like the warehouse and the bench. I immediately knew I wanted to reread these scenes, and scenes like them, not just as scenes lacking educational resources, which they might be, but also as writing scenes, writers attempting to make a particular type of space in tension with our own. What is the relationship between the spaces being produced by that graffiti and the spaces that we, in the field, are producing? What was being expressed on those walls that wasn't, or couldn't, be expressed in our disciplinary spaces? When we talk about walls, we too reveal our own thoughts on the appropriate places of writing. We, too, construct a rhetorical and disciplinary space, one that locates writing, tells it where it should and shouldn't be. This is likely, and perhaps joyously, futile. Cresswell (1996) notes that the unintended consequence of disciplining space is that you invariably open up the potential for transgression (163). When we build walls around our field and determine what they should look like, we create more opportunities for transgressive writing. We create more walls for graffiti.

In his work on this relationship between walls and graffiti, Brighenti (2010) notes that despite all of the changes in contemporary urban governance and control, walls remain "among the primary boundary-creating

objects" (322). Graffiti writers have a distinct way of looking at walls, one that I think rhetoric and composition might learn from. "The wall" for a graffiti writer, Brighenti notes, "not so much separates a 'within' from a 'beyond,' as it joins a 'here' to a 'there'" (329). In this sense, walls are subject to their strategic function of social (and disciplinary, in the academic sense) control but also to tactical uses, to prompting conversations on that very nature of control and division, and practiced alternatives (329). Indeed, the widespread strategic use of walls, and the tactical rhetorical work it invites, centers the wall as a primary geography of graffiti writing, in Boston and elsewhere.

They too have been a primary geography in rhetoric and composition. Gere's (1994) oft-cited "Kitchen Tables and Rented Rooms," for example, concludes with a meditation on walls. Gere wrestles with the ways that Composition has used its walls, our walls, as a means to establish itself disciplinarily—what Sidney Dobrin (2007) would later call our "occupation"—and, relatedly, to keep out other histories and practices of writing. As Gere works to both model and advocate for a broader notion of Composition, including its extracurriculum, she keeps coming back to walls and our future with them. The last sentence of the article is: "The question remains whether we will use classroom walls as instruments of separation or communication" (91).

Do we cow to the strategic function of these divisions? Do we navigate and write within them in hopes of eventual reform? Or do we radically break from them, diverting our disciplinary emphasis toward the creation of new, unfamiliar writing spaces? I think all of rhetoric and composition's public turn has been, in one way or another, an attempt at answering these questions and figuring out what our relationship with walls is or should be: talking through them, climbing over them, preserving them, or tearing them down. And now, I hope, writing on them.

These seem appropriate questions to close on, but not because I think I've provided adequate answers. Nor do I think adequate answers are possible or desirable. These questions should recur. We should be continually interrogating our relationship with walls and the spaces they either separate or join. It is, perhaps counterintuitively, in the very unanswerability of these questions that I find hope for more work. As we

encounter walls—from the writing centers to the hot spots, the workshops to the warehouses, the classrooms to the freight yards—I hope we view them not as boundaries but as opportunities to take part in making new spaces, new *wheres*, that reflect, enact, and sustain our goals as teachers and researchers of writing. And when we see a tag on a wall, wherever it might be, we might think of the spaces it is producing and imagine what we might learn there.

Works Cited

Index

Works Cited

"3 Youths Held for Orange Line Vandalism." 1987. *Boston Globe*, May 13, 1987.

Ackerman, John. 2003. "The Space for Rhetoric in Everyday Life." In *Towards a Rhetoric of Everyday Life: New Directions in Research on Writing, Text, and Discourse*, edited by Martin Nystrand and John Duffy, 84–117. Madison: Univ. of Wisconsin Press.

Ackerman, John M., and David J. Coogan, eds. 2010. *The Public Work of Rhetoric: Citizen-Scholars and Civic Engagement*. Columbia: Univ. of South Carolina Press.

"Acts That Vanish." 1980. *Boston Globe*, Nov. 3, 1980.

Alaoui, Fatima Zahrae Chrifi. 2019. "Arabizing Vernacular Discourse: A Rhetorical Analysis of Tunisian Revolutionary Graffiti." In García and Baca 2019, 112–40.

Alexander, Jonathan, Susan C. Jarratt, and Nancy Welch, eds. 2018. *Unruly Rhetorics: Protest, Persuasion, and Publics*. Pittsburgh: Univ. of Pittsburgh Press.

Andron, Sabina. 2017. "Interviewing Walls: Towards a Method of Reading Hybrid Surface Inscriptions." In Avramidis and Tsilimpounidi, *Graffiti and Street Art* (2017): 71–88.

Asen, Robert. 2000. "Seeking the 'Counter' in Counterpublics." *Communication Theory* 10 (4): 424–46.

Augé, Marc. 2008. *Non-Places: An Introduction to Supermodernity*. Translated by John Howe. London: Verso.

Austin, Joe. 2001. *Taking the Train: How Graffiti Art Became an Urban Crisis in New York City*. New York: Columbia Univ. Press.

———. 2013. "Academics Don't *Write*: A Few Brief Scribblings and Some Questions." *Rhizomes* 25. http://rhizomes.net/issue25/austin.html.

Autrey, Ken. 1991. "Toward a Rhetoric of Journal Writing." *Rhetoric Review* 10, no. 1 (Fall): 74–90.

Avramidis, Konstantinos, and Myrto Tsilimpounidi, eds. 2017. *Graffiti and Street Art: Reading, Writing, and Representing the City.* New York: Routledge.

Ball, Kevin. 2009. "Prairies and Potential Spaces: Placing Experience Within Rural Landscapes." In Powell and Tassoni 2009, 17–35.

Ballou, Brian R. 2007. "Mission Hill Man Held in Weeks-Old Vandalism Case." *Boston Globe,* Jan. 8, 2007.

Barnicle, Mike. 1987. "Making History." *Boston Globe,* May 12, 1987.

Berry, Colin. 2001. "Black Magic." *Print* 55, no. 3 (May): 41–49.

Black Star. 1998. "Respiration." *Mos Def & Talib Kweli Are Black Star.* New York: Rawkus Records.

Blair, Carole. 1999. "Contemporary U.S. Memorial Sites as Exemplars of Rhetoric's Materiality." In *Rhetorical Bodies,* edited by Jack Selzer and Sharon Crowley, 16–57. Madison: Univ. of Wisconsin Press.

Bloch, Stefano. 2012. "The Illegal Face of Wall Space: Graffiti-Murals on the Sunset Boulevard Retaining Walls." *Radical History Review* 113 (2012): 111–26.

———. 2016a. "Challenging the Defense of Graffiti, In Defense of Graffiti." In Ross 2016, 440–51.

———. 2016b. "Why Do Graffiti Writers Write on Murals? The Birth, Life, and Slow Death of Freeway Murals in Los Angeles." *International Journal of Urban and Regional Research* 40 (2): 451–71.

———. 2018. "Place-Based Elicitation: Interviewing Graffiti Writers at the Scene of the Crime." *Journal of Contemporary Ethnography* 47 (2): 171–98.

———. 2019. *Going All City: Struggle and Survival in LA's Graffiti Subculture.* Chicago: Univ. of Chicago Press.

———. 2020. "Broken Windows Ideology and the (Mis)Reading of Graffiti." *Cultural Criminology* 28: 703–20.

Boston Planning & Development Agency. n.d. "Urban Design." Accessed July 20, 2021. http://www.bostonplans.org/planning/urban-design/storefront-signage.

Boston Planning & Development Agency, Research Division. 2020. "Boston by the Numbers 2020." Accessed Apr. 8, 2021. www.bostonplans.org/getattachment /51f1c894-4e5f-45e4-aca2-0ec3d0be80d6.

Boston Redevelopment Authority. 2011. "Downtown Crossing: Signage Guidelines." Accessed July 1, 2021. www.bostonplans.org/getattachment/3c271a37 -9b58-464f-98ff-bb71cf4845f5.

Botticelli, Jim. 2014. *Dirty Old Boston: Four Decades of a City in Transition.* Wellesley Hills: Union Park Press.

Boyle, Casey, and Nathaniel A. Rivers. 2018. "Augmented Publics." In Gries and Brooke 2018, 83–101.

Bradshaw, Jonathan. 2018. "Slow Circulation: The Ethics of Speed and Rhetorical Persistence." *Rhetoric Society Quarterly* 48 (5): 479–98.

Bray, Richard T. 1980. "The Big Apple Has Worms, Says Transplanted New Yorker." *Boston Globe*. Nov. 29, 1980.

Brenner, Neil, Peter Marcuse, and Margit Mayer, eds. 2012. *Cities for People, Not for Profit: Critical Urban Theory and the Right to the City*. New York: Routledge.

Brighenti, Andrea Mubi. 2010. "At the Wall: Graffiti Writers, Urban Territoriality, and the Public Domain." *Space and Culture* 13 (3): 315–32.

Britt, Elizabeth C. 2001. *Conceiving Normalcy: Rhetoric, Law, and the Double Binds of Infertility*. Tuscaloosa: Univ. of Alabama Press.

Brodkey, Linda. 1996. *Writing Permitted in Designated Areas Only*. Minneapolis: Univ. of Minnesota Press.

Brook, Daniel. 2006. "The Cracks in 'Broken Windows.'" *Boston Globe*, Feb. 19, 2006.

Brooke, Collin Gifford. 2009. *Lingua Fracta: Toward a Rhetoric of New Media*. New York: Hampton Press.

Brooke, Robert E., ed. 2003. *Rural Voices: Place-Conscious Education and the Teaching of Writing*. New York: Teachers College Press.

———, ed. 2015. *Writing Suburban Citizenship: Place-Conscious Education and the Conundrum of Suburbia*. Syracuse: Syracuse Univ. Press.

Brooke, Robert, and Charlotte Hogg. 2004. "Open to Change: Ethos, Identification, and Critical Ethnography in Composition Studies." In Brown and Dobrin 2004, 115–30.

Brown, Stephen Gilbert, and Sidney I. Dobrin, eds. 2004. *Ethnography Unbound: From Theory Shock to Critical Praxis*. Albany: SUNY Press.

Bruce, Caitlin Frances. 2019. *Painting Publics: Transnational Legal Graffiti Scenes as Space for Encounter*. Philadelphia: Temple Univ. Press.

Bruch, Patrick, and Richard Marback. 1996. "From Athens to Detroit: Civic Space and Learning Writing." *Rhetoric Review* 15 (1): 156–73.

Buchanan, William. 1976. "Charlestown . . . A Bicentennial Walk." *Boston Globe*, July 2, 1976.

Budden, Joe. 2015. "Love, I'm Good." *All Love Lost*. New York: eOne Music.

Burns, William. 2009. "*PublicandPrivate*: The Trialectics of Public Writing on the Street, on Campus, and in Third Space." *Composition Studies* 37 (1): 29–47.

Cardona, Rebio Diaz. 2016. "Ambient Text and the Becoming Space of Writing." *Environment and Planning D: Society and Space* 34 (4): 637–54.

Carlo, Roseanne. 2016. "Keyword Essay: Place-Based Literacies." *Community Literacy Journal* 10 (2): 59–70.

Carter, Clare. 1978. "Racist Graffiti." *Boston Globe*, Sept. 2, 1978.

Castleman, Craig. 1982. *Getting Up: Subway Graffiti in New York*. Cambridge: MIT Press.

Chalfant, Henry. 2006. "Foreword." In *Freight Train Graffiti*, edited by Roger Gastman, Darin Rowland, and Ian Sattler, 0021. New York: Abrams.

Chmielewska, Ella. 2007. "Framing [Con]text: Graffiti and Place." *Space and Culture* 10 (2): 145–69.

Christen, Richard S. 2003. "Hip Hop Learning: Graffiti as an Educator of Urban Teenagers." *Educational Foundations* 17 (4): 57–82.

Cintron, Ralph. 1997. *Angels' Town: Chero Ways, Gang Life, and Rhetorics of the Everyday*. Boston: Beacon Press, 1997.

City. 2010. 14, nos. 1–2.

City of Boston. 2019. "Cleaning Up Graffiti in the City of Boston." Accessed Nov. 19, 2019. www.boston.gov/departments/property-management/cleaning-graffit -city-boston.

———. 2021. "Removal of Graffiti Agreement and Release of Liability." Accessed July 1, 2021. https://www.boston.gov/sites/default/files/file/2021/04 /graffiti-form-updated-2021.pdf.

Clifford, James. 1986. "Introduction: Partial Truths." In *Writing Culture: The Poetics and Politics of Ethnography*, edited by James Clifford and George E. Marcus, 1–26. Berkeley: Univ. of California Press.

Cloutier, Catherine. 2015. "Study Questions 'Broken Windows' Theory of Policing." *Boston Globe*, Sept. 11, 2015.

College Composition and Communication. 2014. 66, no. 1 (Sept.) and no. 2 (Dec.).

Collins, Bud. 1972. "'The Words of Prophets Are Written on Boxcar Walls.'" *Boston Globe*, May 11, 1972.

Cooper, Marilyn M. 1986. "The Ecology of Writing." *College English* 48 (4): 364–75.

Cox, Karen L. 2017. "Why Confederate Monuments Must Fall." *New York Times*, Aug. 15, 2017.

Cozza, Vanessa M. 2015. "'Getting the Word Out!': Public Street Art for Rhetorical Study." *enculturation* 20. Accessed Oct. 28, 2019. https://www.enculturation .net/getting-the-word-out

Cramer, Maria. 2006. "Back Bay Neighbors Draw a Line on Graffiti." *Boston Globe*, Aug. 21, 2006.

Cramer, Maria, and John R. Ellement. 2009. "Cultural Acclaim, Residents' Anger, Artist's Arrest Points to a Boston Divide." *Boston Globe*, Feb. 10, 2009.

Cresswell, Tim. 1996. *In Place/Out of Place: Geography, Ideology, and Transgression.* Minneapolis: Univ. of Minnesota Press.

———. 2004. *Place: A Short Introduction.* Malden: Blackwell.

———. 2006. *On the Move: Mobility in the Modern Western World.* New York: Routledge.

———. 2010a. "Mobilities I: Catching Up." *Progress in Human Geography* 35 (4): 550–58.

———. 2010b. "Towards a Politics of Mobility." *Environment and Planning D: Society and Space* 28: 17–31.

———. 2012. "Mobilities II: Still" *Progress in Human Geography* 36 (5): 645–53.

———. 2014. "Mobilities III: Moving On." *Progress in Human Geography* 38 (5): 712–21.

———. 2019. *Maxwell Street: Writing and Thinking Place.* Chicago: Univ. of Chicago Press.

Crimaldi, Laura. 2011. "Pike Tagged for Trouble." *Boston Herald*, Jan. 15, 2011.

Cushman, Ellen. 1998. *The Struggle and the Tools: Oral and Literate Strategies in an Inner City Community.* Albany: SUNY Press.

———. 2013. "Wampum, Sequoyan, and Story: Decolonizing the Digital Archive." *College English* 76 (2): 115–35.

D'Angelo, Frank. J. 1974. "Sacred Cows Make Great Hamburgers: The Rhetoric of Graffiti." *College Composition and Communication* 25 (2): 173–80.

———. 1975. "Oscar Mayer Ads Are Pure Baloney: The Graffitist as Critic of Advertising." *College Composition and Communication* 26, no. 3 (October): 263–68.

———. 1976a. "Fools' Names and Fool's Faces Are Always Seen in Public Places: A Study of Graffiti." *Journal of Popular Culture* 10, no. 1 (Summer): 102–9.

———. 1976b. "Up Against The Wall, Mother! The Rhetoric of Slogans, Catch-phrases, and Graffiti." In *A Symposium in Rhetoric*, 41–50.

Daly, Ned. 2007. "Graffiti in the Eye of the Beholder." *Boston Globe*, Jan. 10, 2007.

Daniel, Seth. 2017. "Graffiti Brought Many South End Young People into the Arts." *Boston Sun*, Feb. 28, 2017.

Deans, Thomas. 2000. *Writing Partnerships: Service-Learning in Composition.* Urbana: NCTE.

Deans, Thomas, Barbara Roswell, and Adrian J. Wurr, eds. 2010. *Writing and Community Engagement: A Critical Sourcebook.* Boston: Bedford/St. Martin's.

de Certeau, Michel. 1988. *The Practice of Everyday Life.* Translated by Steven F. Rendall. Berkeley: Univ. of California Press.

Delmont, Matthew, and Jeanne Theoharis. 2017. "Rethinking the Boston 'Busing Crisis.'" *Journal of Urban History* 43 (2): 191–203.

DeVoss, Dànielle Nicole, and Jim Ridolfo. 2009. "Composing for Recomposition: Rhetorical Velocity and Delivery." *Kairos* 12 (2): webtext at https://kairos .technorhetoric.net/13.2/topoi/ridolfo_devoss/intro.html.

Dickens, Charles. *American Notes.* (1842) 2004. New York: Penguin Books.

Dickinson, Greg, Carole Blair, and Brian L. Ott, eds. 2010. *Places of Public Memory: The Rhetoric of Museums and Memorials.* Tuscaloosa: Univ. of Alabama Press.

Dickinson, Maggie. 2008. "The Making of Space, Race and Place: New York City's War of Graffiti, 1970–Present." *Critique of Anthropology* 28 (1): 27–45.

Dobrin, Sidney I. 2001. "Writing Takes Place." In Weisser and Dobrin 2001, 11–25.

———. 2007. "The Occupation of Composition." In Keller and Weisser 2007, 15–35.

———. 2011. *Postcomposition.* Carbondale: Southern Illinois Univ. Press.

Dobrin, Sidney I., and Christian R. Weisser. 2002. *Natural Discourse: Toward Ecocomposition.* Albany: SUNY Press.

Donlan, Ann E. 1997. "Graffiti Gangsters City Battles Army of Spray-Can Artists." *Boston Herald,* Aug. 13, 1997.

Doran, Meghan V. 2015. "Narratives of the Past in Contemporary Urban Politics: The Case of the Boston Desegregation Crisis." PhD diss., Northeastern University.

Dovey, Kim, Simon Wollan, and Ian Woodcock. 2012. "Placing Graffiti: Creating and Contesting Character in Inner-city Melbourne." *Journal of Urban Design* 17 (1): 21–41.

Drew, Julie. 2001. "The Politics of Place: Student Travelers and Pedagogical Maps." In Weisser and Dobrin 2001, 57–68.

Dryer, Dylan B. 2008. "Taking Up Space: On Genre Systems as Geographies of the Possible." *JAC* 28 (3–4): 503–34.

Duncan, Alexandra K. 2015. "From the Street to the Gallery: A Critical Analysis of the Inseparable Nature of Graffiti and Context." In Lovata and Olton 2015, 129–38.

Durso, Holly Bellocchio. 2011. "Subway Spaces as Public Places: Politics and Perceptions of Boston's T." Master's thesis, Massachusetts Institute of Technology.

Eberly, Rosa A. 1999. "From Writers, Audiences, and Communities to Publics: Writing Classrooms as Protopublic Spaces." *Rhetoric Review* 18 (1): 165–78.

———. 2000. *Citizen Critics: Literary Public Spheres*. Champaign: Univ. of Illinois Press.

Edbauer, Jennifer H. 2005a. "(Meta)Physical Graffiti: 'Getting Up' as Affective Writing Model." *JAC* 25 (1): 131–59.

———. 2005b. "Unframing Models of Public Distribution: From Rhetorical Situation to Rhetorical Ecologies." *Rhetoric Society Quarterly* 35 (4): 5–24.

Edwards, Dustin W. 2018. "Circulation Gatekeepers: Unbundling the Platform Politics of YouTube's Content ID." *Computers and Composition* 47 (March): 61–74.

Ellement, John R., and Andrew Ryan. 2009. "Fairey Pleads Guilty to Vandalism Charges." *Boston Globe*, July 11, 2009.

Endres, Danielle, Aaron Hess, Samantha Senda-Cook, and Michael K. Middleton. 2016. "*In Situ* Rhetoric: Intersections Between Qualitative Inquiry, Fieldwork, and Rhetoric." *Cultural Studies—Critical Methodologies* 16 (6): 511–24.

Endres, Danielle, and Samantha Senda-Cook. 2011. "Location Matters: The Rhetoric of Place in Protest." *Quarterly Journal of Speech* 97 (3): 257–82.

English, Bella. 1987. "A Gift of Silence After El, Many Relish the Quiet on Washington St." *Boston Globe*, May 4, 1987.

Enoch, Jessica, and David Gold. 2013. "Seizing the Methodological Moments: The Digital Humanities and Historiography in Rhetoric and Composition." *College English* 76 (2): 105–14.

Evans, Rowland, and Robert Novak. 1974. "Boston, Busing and Leadership." *Boston Globe*, Oct. 23, 1974.

Farmer, Frank. 2013. *After the Public Turn: Composition, Counterpublics, and the Citizen Bricoleur*. Logan: Utah State Univ. Press.

Ferrell, Jeff. 1996. *Crimes of Style: Urban Graffiti and the Politics of Criminality*. Boston: Northeastern Univ. Press.

———. 1998a. "Criminological *Verstehen*: Inside the Immediacy of Crime." In Ferrell and Hamm 1998, 20–42.

————. 1998b. "Freight Train Graffiti: Subculture, Crime, Dislocation." *Justice Quarterly* 15 (4): 587–608.

————. 2017. "Graffiti, Street Art and the Dialectics of the City." In Avramidis and Tsilimpounidi 2017, 27–38.

————. 2018. *Drift: Illicit Mobility and Uncertain Knowledge.* Berkeley; Univ. of California Press.

Ferrell, Jeff, and Mark S. Hamm, eds. 1998. *Ethnography at the Edge.* Boston: Northeastern Univ. Press.

Ferrell, Jeff, and Robert D. Weide. 2010. "Spot Theory." City 14 (1–2): 48–62.

Fiorentino, Anna. 2007. "Peters Park Street Artists Decry the Loss of Their Wall." *Boston Herald*, Sept. 23, 2007.

Fleckenstein, Kristie S., Clay Spinuzzi, Rebecca J. Rickly, and Carole Clark Papper. 2008. "The Importance of Harmony: An Ecological Metaphor for Writing Research." *College Composition and Communication* 60 (2): 388–419.

Fleming, David. 2008. *City of Rhetoric: Revitalizing the Public Sphere in Metropolitan America.* Albany: SUNY Press.

Flower, Linda. 2008. *Community Literacy and the Rhetoric of Public Engagement.* Carbondale: Southern Illinois Univ. Press.

Formisano, Ronald P. 2004. *Boston Against Busing: Race, Class, and Ethnicity in the 1960s and 1970s.* 1991. Chapel Hill: Univ. of North Carolina Press.

Förster, Larissa, and Eva Youkhana, eds. 2015. *Grafficity: Visual Practices and Contestations in Urban Space.* Paderborn: Wilhelm Fink.

Foucault, Michel. 1986. "Of Other Spaces." Translated by Jay Miskowiec. *Diacritics* 16 (1): 22–27.

Fraser, Benjamin, and Steven D. Spalding. 2012. "The Speed of Signs: Train Graffiti, Cultural Production, and the Mobility of the Urban in France and Spain." In *Trains, Culture, and Mobility: Riding the Rails*, edited by Benjamin Fraser and Steven D. Spalding, 27–57. Lanham: Lexington Books.

Fraser, Nancy. 1999. "Rethinking the Public Sphere: A Contribution to the Critique of Actually Existing Democracy." In *Habermas and the Public Sphere*, edited by Craig Calhoun, 109–42. Cambridge: MIT Press.

Gaillet, Lynée Lewis. 2012. "(Per)Forming Archival Research Methodologies." *College Composition and Communication* 64 (1): 35–58.

García, Romeo, and Damián Baca, eds. 2019. *Rhetorics Elsewhere and Otherwise: Contested Modernities, Decolonial Visions.* Champaign, IL: NCTE.

Gastman, Roger, and Caleb Neelon. 2010. *The History of American Graffiti.* New York: Harper Design.

Gastman, Roger, Darin Rowland, and Ian Sattler. 2006. *Freight Train Graffiti*. New York: Abrams.

Geertz, Clifford. 1973. *The Interpretation of Cultures: Selected Essays*. New York: Basic Books.

George, Diana. 2002. "The Word on the Street: Public Discourse in a Culture of Disconnect." *Reflections* 2 (2): 5–18.

Gere, Anne Ruggles. 1994. "Kitchen Tables and Rented Rooms: The Extracurriculum of Composition." *College Composition and Communication* 45 (1): 75–92.

Glazer, Nathan. 1979. "On Subway Graffiti in New York." *Public Interest* 54 (Winter): 3–12.

Glenn, Cheryl, and Jessica Enoch. 2009. "Drama in the Archives: Rereading Methods, Rewriting History." *College Composition and Communication* 61 (2): 321–42.

Goldblatt, Eli. 2007. *Because We Live Here: Sponsoring Literacy beyond the College Curriculum*. New York: Hampton Press.

Goldscheider, Eric. 2000. "In Writing, 'Make a Mess' Professor's Method Helps Students Lose Inhibitions." *Boston Globe*, March 26, 2000.

Gopinath, Gabrielle. 2015. "Ornament as Armament: Playing Defense in Wildstyle Graffiti." In Lovata and Olton 2015, 117–28.

Grabill, Jeffrey. 2012. "Community Based Research and the Importance of a Research Stance." In Nickoson and Sheridan 2012, 210–19.

Graham, Stephen. 2011. *Cities Under Siege: The New Military Urbanism*. London: Verso.

Gray, Arielle. 2019. "Graffiti or Street Art? The False Dichotomy." *Boston Art Review* 4 (Fall): 40–45.

Grego, Rhonda C., and Nancy C. Thompson. 2008. *Teaching/Writing in Thirdspaces: The Studio Approach*. Carbondale: Southern Illinois Univ. Press.

Gries, Laurie. 2015. *Still Life with Rhetoric: A New Materialist Approach for Visual Rhetorics*. Logan: Utah State Univ. Press.

———. 2018. "Circulation as an Emergent Threshold Concept." In Gries and Brooke 2018, 3–24.

———. 2019. "Writing to Assemble Publics: Making Writing Activate, Making Writing Matter." *College Composition and Communication* 70 (3): 327–55.

Gries, Laurie, and Collin Gifford Brooke, eds. 2018. *Circulation, Writing & Rhetoric*. Logan: Utah State Univ. Press.

Halsey, Mark, and Alison Young. 2006. "'Our Desires Are Ungovernable': Writing Graffiti in Urban Space." *Theoretical Criminology* (10) 3: 275–306.

Hammond, Kenneth. 2000. "Boston Needs a Policy on Graffiti." *Boston Globe*, Oct. 8, 2000.

Harcourt, Bernard E. 2001. *Illusion of Order: The False Promise of Broken Windows Policing*. Cambridge: Harvard Univ. Press.

Hauser, Gerard A. 1999. *Vernacular Voices: The Rhetoric of Publics and Public Spheres*. Columbia: Univ. of South Carolina Press.

Haynes-Burton, Cynthia. 1994. "'Hanging Your Alias on Their Scene': Writing Centers, Graffiti, and Style." *The Writing Center Journal* 14 (2): 112–24.

Heath, Shirley Brice. 1983. *Ways with Words: Language, Life, and Work in Communities and Classrooms*. Cambridge: Cambridge Univ. Press.

Herndon, Astead W. 2015. "Walsh Launches New 311 Hotline." *Boston Globe*, Aug. 12, 2015.

Hess, Aaron. 2011. "Critical-Rhetorical Ethnography: Rethinking the Place and Process of Rhetoric." *Communication Studies* 62 (2): 127–52.

Holmes, Ashley J. 2016. *Public Pedagogy in Composition Studies*. Urbana, IL: CCCC/NCTE.

hooks, bell. 1990. *Yearning: Race, Gender, and Cultural Politics*. Boston: South End Press.

Horner, Bruce. 2002. "Critical Ethnography, Ethics, and Work: Rearticulating Labor." *JAC* 22 (3): 561–84.

Hutson, Ron. 1974. "Common Fear, Safety for Students, Ripples Through North Dorchester, Roxbury as Busing Becomes Real." *Boston Globe*, June 27, 1974.

Iveson, Kurt. 2007. *Publics and the City*. Malden: Blackwell.

———. 2010a. "Introduction: Graffiti, Street Art, and the City." *City* 14 (1–2): 25–32.

———. 2010b. "The Wars on Graffiti and New Military Urbanism." *City* 14 (1–2): 115–34.

———. 2017. "Graffiti, Street Art, and the Democratic City." In Avramidis and Tsilimpounidi 2017, 95–104.

Jacobi, Tobi. 2011. "Speaking Out for Social Justice: The Problems and Possibilities of US Women's Prison and Jail Writing Workshops." *Critical Survey* 23 (3): 40–54.

Jacobs, Sally. 1993. "Suburban Kids 'Bomb' City Graffiti Scene." *Boston Globe*, Dec. 5, 1993.

James, Clive. 1977. "An Outsider in New York." *Boston Globe*, Sept. 4, 1977.

Jenkins, Sacha, and David Villorente. 2008. *Piecebook: The Secret Drawings of Graffiti Writers*. New York: Prestel.

————. 2009. *Piecebook Reloaded: Rare Graffiti Drawings 1985–2005*. New York: Prestel.

————. 2011. *World Piecebook: Global Graffiti Drawings*. New York: Prestel.

Johnson, Akilah. 2017. "Boston. Racism. Image. Reality. The Spotlight Team Takes On Our Hardest Question." *Boston Globe*, Dec. 10, 2017.

Jolliffe, David A., Christian Z. Goering, James A. Anderson, and Krista Jones Oldham. 2016. *The Arkansas Delta Oral History Project: Culture, Place, and Authenticity*. Syracuse: Syracuse Univ. Press.

"Justin Freed's Passion for Film Played a Lead Role in Local Screen History, Particularly at the Coolidge." 2009. *Boston Globe*, Aug. 23, 2009.

Kairos. 2012. 16, no. 3 (Summer).

Kaplan, Fred. 1997. "Looks Count When It Comes to Fighting Crime, Cleaning Up the Urban Landscape May Be the Most Cost Effective Strategy." *Boston Globe*, June 19, 1997.

Karlander, David. 2018. "Backjumps: Writing, Watching, Erasing Train Graffiti." *Social Semiotics* 28 (1): 41–59.

Keith, Michael. 2005. *After the Cosmopolitan? Multicultural Cities and the Future of Racism*. New York: Routledge.

Keller, Christopher J., and Christian R. Weisser, eds. 2007. *The Locations of Composition*. Albany: SUNY Press.

Kenny, Herbert. 1971. "Graffiti Last and Lasts." 1971. *Boston Globe*, June 16, 1971.

Kindleberger, R. S. 1985. "Painting Boston: Surge in N.Y.-Style Graffiti Prompts City, T Officials to Say Enough Is Enough." *Boston Globe*, Apr. 24, 1985.

Kindynis, Theo. 2019. "Excavating Ghosts: Urban Exploration as Graffiti Archaeology." *Crime Media Culture* 15 (1): 24–45.

Kinloch, Valerie. 2010. *Harlem on Our Minds: Place, Race, and the Literacies of Urban Youth*. New York: Teachers College Press.

Kirklighter, Cristina, Cloe Vincent, and Joseph Michael Moxley, eds. 1997. *Voices & Visions: Refiguring Ethnography in Composition*. Portsmouth: Boynton/Cook.

Kirsch, Gesa, and Liz Rohan. 2008. *Beyond the Archives: Research as a Lived Process*. Carbondale: Southern Illinois Univ. Press.

Kirsch, Gesa, and Patricia A. Sullivan, eds. 1992. *Methods and Methodology in Composition Research*. Carbondale: Southern Illinois Univ. Press.

Kramer, Ronald. 2010. "Moral Panics and Urban Growth Machines: Official Reactions to Graffiti in New York City, 1990–2005." *Qualitative Sociology* 33 (3): 297–311.

Kuebrich, Ben. 2015. "'White Guys Who Send My Uncle to Prison': Going Public within Asymmetrical Power." *College Composition and Communication* 66 (4): 566–90.

Kynard, Carmen. 2010. "From Candy Girls to Cyber Sista-Cipher: Narrating Black Females' Color-Consciousness and Counterstories in and out of School." *Harvard Educational Review* 80 (1): 30–52.

———. 2014. *Vernacular Insurrections: Race, Black Protest, and the New Century in Composition-Literacies Studies.* Albany: SUNY Press.

Lachmann, Richard. 1988. "Graffiti as Career and Ideology." *American Journal of Sociology* 94 (2): 229–50.

Landers, Ann. 1978. "The Writing on the Wall and the Street and . . ." *Boston Globe,* Aug. 4, 1978.

Lassiter, Luke Eric. 2005. *The Chicago Guide to Collaborative Ethnography.* Chicago: Univ. of Chicago Press.

Lauzon, Robb Conrad, and Laquana Cooke. 2017. "Counter-Buffing: A Visual Criticism of Guerilla Advertising." *Changing English: Studies in Culture and Education* 24 (2): 162–74.

Lefebvre, Henri. 1991. *The Production of Space.* Translated by Donald Nicholson-Smith. Malden: Blackwell Publishing. Originally published as *La production de l'espace* (Paris: Editions Anthropos, 1974).

Lennon, John. 2016. "Trains, Railroad Workers and Illegal Riders: The Subcultural World of Hobo Graffiti." In Ross 2016, 27–36.

Lindquist, Julie. 2002. *A Place to Stand: Politics and Persuasion in a Working-Class Bar.* Oxford: Oxford Univ. Press.

Lovata, Troy, and Elizabeth Olton, eds. 2015. *Understanding Graffiti: Multidisciplinary Studies from Prehistory to the Present.* Walnut Creek, CA: Left Coast Press.

Low, Setha. 2016. *Spatializing Culture: The Ethnography of Space and Place.* New York: Routledge.

Lu, Min-Zhan, and Bruce Horner. 1998. "The Problematic of Experience: Redefining Critical Work in Ethnography and Pedagogy." *College English* 60 (3): 257–77.

Lunsford, Scott. 2018. "Public Marginalia: (Re)Markable Conversations (Re)Surfacing and(Re)Buffed." *Present Tense: A Journal of Rhetoric in Society* 7 (2): 1–9.

Macdonald, Nancy. 2001. *The Graffiti Subculture: Youth, Masculinity, and Identity in London and New York.* London: Palgrave.

———. 2016. "Something for the Boys? Exploring the Changing Gender Dynamics of the Graffiti Subculture." In Ross 2016, 183–93.

MacDowall, Lachlan. 2019. *Instafame: Graffiti and Street Art in the Instagram Era*. Bristol: Intellect.

MacQuarrie, Brian. 2017. "The Next Longfellow Bridge Problem Has Nothing to Do With Construction." *Boston Globe*, May 20, 2017.

Marback, Richard. 2001. "Learning to Inhabit Writing." *Composition Studies* 29 (1): 51–62.

———. 2003. "Speaking of the City and Literacies of Place Making in Composition Studies." In *City Comp: Identities, Spaces, Practices*, edited by Bruce McComiskey and Cynthia Ryan, 141–55. Albany: SUNY Press.

———. 2004. "The Rhetorical Space of Robben Island." *Rhetoric Society Quarterly* 34 (2): 7–27

Massey, Doreen. 1994. *Space, Place, and Gender*. Minneapolis: Univ. of Minnesota Press.

Mathieu, Paula. 2005. *Tactics of Hope: The Public Turn in English Composition*. Portsmouth: Boynton/Cook.

Mathieu, Paula, and Diana George. 2009. "Not Going It Alone: Public Writing, Independent Media, and the Circulation of Homeless Advocacy." *College Composition and Communication* 61 (1): 130–49.

Mathieu, Paula, Steve Parks, and Tiffany Rousculp, eds. 2012. *Circulating Communities: The Tactics and Strategies of Community Publishing*. Lanham: Lexington Books.

Mauk, Johnathon. 2003. "Location, Location, Location: The "Real" (E)states of Being, Writing, and Thinking in Composition." *College English* 65 (4): 368–88.

McAuliffe, Cameron. 2013. "Legal Walls and Professional Paths: The Mobilities of Graffiti Writers in Sydney." *Urban Studies* 50 (3): 518–37.

McCain, Nina. 1983. "Undoing Vandals' Work." *Boston Globe*, Apr. 14, 1983.

McCarthy, John E. 1979. " . . . in the Hub." *Boston Globe*, Aug. 5, 1979

McComiskey, Bruce, and Cynthia Ryan, eds. 2003. *City Comp: Identities, Spaces, Practices*. Albany: SUNY Press.

McCracken, Jill. 2013. *Street Sex Workers' Discourse: Realizing Material Change through Agential Choice*. New York: Routledge.

McHendry Jr., George F., Michael K. Middleton, Danielle Endres, Samantha Senda-Cook, and Megan O'Byrne. 2014. "Rhetorical Critic(ism)'s Body: Affect and Fieldwork on a Plane of Immanence." *Southern Communication Journal* 79 (4): 293–310.

McKee, Heidi A., and James E. Porter. 2012. "The Ethics of Archival Research." *College Composition and Communication* 64 (1): 59–81.

Meckfessel, Shon. 2015. "Making Space, Not Demands: Literacies of Autonomy and Dissensus." *Literacy in Composition Studies* 3 (1): 188–200.

Medway, Peter. 2002. "Fuzzy Genres and Community Identities: The Case of Architecture Students' Sketchbooks." In *The Rhetoric and Ideology of Genre: Strategies for Stability and Change,* edited by Richard Coe, Lorelei Lingard and Tatiana Teslenko, 123–53. Cresskill: Hampton Press.

Megler, Veronika, David Banis, and Heejun Chang. 2014. "Spatial Analysis of Graffiti in San Francisco." *Applied Geography* 54: 63–73.

Merriman, Peter. 2015. "Mobilities I: Departures. *Progress in Human Geography* 39 (1): 87–95.

———. 2016. "Mobilities II: Cruising. *Progress in Human Geography* 40 (4): 555–64.

———. 2017. "Mobilities III: Arrivals." *Progress in Human Geography* 41 (3): 375–81.

Micciche, Laura R. 2014. "Girls Writing in Spirals." *College Composition and Communication* 66 (1): 15–18.

Miller, Ivor L. 2002. *Aerosol Kingdom: Subway Painters of New York City.* Jackson: Univ. Press of Mississippi.

Mitchell, Don. 2003. *The Right to the City: Social Justice and the Right for Public Space.* New York: The Guilford Press.

Mitman, Tyson. 2018. *The Art of Defiance: Graffiti, Politics, and the Reimagined City in Philadelphia.* Bristol: Intellect.

Monberg, Terese Guinsatao. 2017. "Ownership, Access, and Authority: Publishing and Circulating Histories to (Re)Member Community." *Community Literacy Journal* 12 (1): 30–47.

Mooney, Brian C., Tina Cassidy, and Frank Phillips. 1999. "Dukakis Paints the Town Blue." *Boston Globe,* Oct. 24, 1999.

Moss, Beverly J. 2003. *A Community Text Arises: A Literate Text and a Literacy Tradition in African-American Churches.* New York: Hampton Press.

———. 2010. "'Phenomenal Women,' Collaborative Literacies, and Community Texts in Alternative 'Sista' Spaces." *Community Literacy Journal* 5 (1): 1–24.

Moss, Beverly J., Nels P. Highberg, and Melissa Nicolas, eds. 2004. *Writing Groups Inside and Outside the Classroom.* New York: Routledge.

Mountford, Roxanne. 2001. "On Gender and Rhetorical Space." *Rhetoric Society Quarterly* 31 (1): 41–71.

Negt, Oskar, and Alexander Kluge. 1993. *Public Sphere and Experience: Toward an Analysis of the Bourgeois and Proletarian Public Sphere.* Translated by Peter Labanyi, Jamie Owen Daniel, and Assenka Oksiloff. Minneapolis: Univ. of Minnesota Press. Originally published as *Öffentlichkeit und Erfahrung: Zur Organisationsanalyse von bürgerlicher und proletarischer Öffentlichkeit* (Frankfurt: Suhrkamp, 1972).

Nelligan, Tom. 1981. "Diesel Pollution Rides the T." *Boston Globe*, Aug. 24, 1981.

Nickoson, Lee, and Mary P. Sheridan, eds. 2012. *Writing Studies Research in Practice.* Carbondale: Southern Illinois Univ. Press.

Nordstrom, Susan Naomi. 2018. "Antimethodology: Postqualitative Generative Conventions." *Qualitative Inquiry* 24 (3): 215–26.

Nordquist, Brice. 2017. *Literacy and Mobility: Complexity, Uncertainty, and Agency at the Nexus of High School and College.* New York: Routledge.

Nunley, Vorris. 2011. *Keepin' It Hushed: The Barbershop and African American Hush Harbor Rhetorics.* Detroit: Wayne State Univ. Press.

O'Brien, Daniel T., Chelsea Farrell, and Brandon C. Welsh. 2019. "Looking through Broken Windows: The Impact of Neighborhood Disorder on Aggression and Fear of Crime Is an Artifact of Research Design." *Annual Review of Criminology* 2 (Jan.): 53–71.

O'Brien, Daniel T., and Robert J. Sampson. 2015. "Public and Private Spheres of Neighborhood Disorder: Assessing Pathways to Violence Using Large-scale Digital Records." *Journal of Research in Crime and Delinquency* 52 (4): 486–510.

O'Connor, Thomas H. 1991. *Bibles, Brahmins, and Bosses: A Short History of Boston.* 3rd ed., rev. Boston: Trustees of the Public Library of the City of Boston.

———. 2000. *Boston A to Z.* Cambridge: Harvard Univ. Press.

———. 2001. *The Hub: Boston Past and Present.* Boston: Northeastern Univ. Press.

Oliver, Veronica. 2014. "Civic Disobedience: Anti-SB 1070 Graffiti, Marginalized Voices, and Citizenship in a Politically Privatized Public Sphere." *Community Literacy Journal* 9 (1): 62–76.

Owens, Derek. 2001. *Composition and Sustainability: Teaching for a Threatened Generation.* Urbana, IL: NCTE.

Oxford English Dictionary, s.v. "Bible (*n.*)," "Melting Pot (*n.*)," "Spot (*n.*)," "Talisman (*n.*)." Accessed Nov. 12, 2019. www.oed.com/.

Pabón-Colón, Jessica Nydia. 2018. *Graffiti Grrlz: Performing Feminism in the Hip Hop Diaspora.* New York: NYU Press.

Parks, Stephen. 2010. *Gravyland: Writing Beyond the Curriculum in the City of Brotherly Love*. Syracuse: Syracuse Univ. Press.

Pennycook, Alastair. 2010. *Language as Local Practice*. New York: Routledge.

Pezzullo, Phaedra Carmen. 2009. *Toxic Tourism: Rhetorics of Pollution, Travel, and Environmental Justice*. Tuscaloosa: Univ. of Alabama Press.

Phillips, Susan A. 1999. *Wallbangin': Graffiti and Gangs in L.A.* Chicago: Univ. of Chicago Press.

Piano, Doreen. 2016. "'Boost or Blight?' Graffiti Writing and Street Art in the 'New' New Orleans." In Ross 2016, 234–46.

Pough, Gwendolyn D. 2004. *Check It While I Wreck It: Black Womanhood, Hip-Hop Culture, and the Public Sphere*. Boston: Northeastern Univ. Press.

Powell, Douglas Reichart, and John Paul Tassoni, eds. 2009. *Composing Other Spaces*. New York: Hampton Press.

Powell, Malea. 2012. "2012 CCCC Chair's Address: Stories Take Place: A Performance in One Act." *College Composition and Communication* 64 (2): 383–406.

Powers, Stephen. 1999. *The Art of Getting Over: Graffiti at the Millennium*. New York: St. Martin's Press.

Pritchard, Eric Darnell. 2017. *Fashioning Lives: Black Queers and the Politics of Literacy*. Carbondale: Southern Illinois Univ. Press.

Quinn, Susan. n.d. "History & Mission." Coolidge Corner Theatre. Accessed July 1, 2021. https://coolidge.org/about-us/history-mission.

Rai, Candice. 2016. *Democracy's Lot: Rhetoric, Publics, and the Places of Invention*. Tuscaloosa: Univ. of Alabama Press.

Rai, Candice, and Caroline Gottschalk Druschke, eds. 2018. *Field Rhetoric: Ethnography, Ecology, and Engagement in the Places of Persuasion*. Tuscaloosa: Univ. of Alabama Press.

Ramsey, Alexis E., Wendy B. Sharer, Barbara L'Eplattenier, and Lisa Mastrangelo, eds. 2009. *Working in the Archives: Practical Research Methods for Rhetoric and Composition*. Carbondale: Southern Illinois Univ. Press.

Rawson, K. J. 2018. "The Rhetorical Power of Archival Description: Classifying Images of Gender Transgression." *Rhetoric Society Quarterly* 48 (4): 327–51.

Reddy, Nancy. 2019. "'The Spirit of Our Rural Countryside': Toward an Extracurricular Pedagogy of Place." *Community Literacy Journal* 13 (2): 69–87.

Reid, Alexander. 1994. "Graffiti: New Sign of Times." *Boston Globe*, May 29, 1994.

Reiff, Mary Jo. 2011. "The Spatial Turn in Rhetorical Genre Studies: Intersections of Metaphor and Materiality." *JAC* 31 (1–2): 207–24.

————. 2016. "Geographies of Public Genres: Navigating Rhetoric and Material Relations of the Public Petition." In *Genre and the Performance of Publics*, edited by Mary Jo Reiff and Anis Bawarshi, 100–116. Logan: Utah State Univ. Press.

Reisner, Robert. 1971. *Graffiti: Two Thousand Years of Wall Writing*. New York: Cowles Book Company.

Restaino, Jessica. 2019. *Surrender: Feminist Rhetoric and Ethics in Love and Illness*. Carbondale: Southern Illinois Univ. Press.

Restaino, Jessica, and Laurie JC Cella, eds. 2013. *Unsustainable: Re-imagining Community Literacy, Public Writing, Service-Learning, and the University*. Lanham: Lexington Books.

Reynolds, Nedra. 1998. "Composition's Imagined Geographies: The Politics of Space in the Frontier, City, and Cyberspace." *College Composition and Communication* 50 (1): 12–35.

————. 2004. *Geographies of Writing: Inhabiting Places and Encountering Difference*. Carbondale: Southern Illinois Univ. Press.

Rhizomes. 2013. (25). http://www.rhizomes.net/issue25/.

Rice, Jeff. 2012. *Digital Detroit: Rhetoric and Space in the Age of the Network*. Carbondale: Southern Illinois Univ. Press.

Rickert, Thomas. 2007. "Invention in the Wild: On Locating Kairos in Space-Time." In Keller and Weisser 2007, 71–89.

Rickly, Rebecca J. 2012. "After Words: Postmethodological Musings." In Nickoson and Sheridan 2012, 261–70.

Rivers, Nathaniel A. 2016. "Geocomposition in Public Rhetoric and Writing Pedagogy." *College Composition and Communication* 67 (4): 576–606.

Rivers, Nathaniel A., and Ryan P. Weber. 2011. "Ecological, Pedagogical, Public Rhetoric." *College Composition and Communication* 63 (2): 187–218.

Rohen, Liz. 2012. "Writing of and on the City: Streetwork in Detroit." *Reflections* 11 (2): 39–65.

Rose, Tricia. 1994. *Black Noise: Rap Music and Black Culture in Contemporary America*. Middletown, CT: Wesleyan Univ. Press.

Ross, Jeffrey Ian, ed. 2016. *Routledge Handbook of Graffiti and Street Art*. New York: Routledge.

Ross, Jeffrey Ian, Peter Bengtsen, John F. Lennon, Susan Phillips, and Jacqueline Z. Wilson. 2017. "In Search of Academic Legitimacy: The Current State of Scholarship on Graffiti and Street Art." *Social Science Journal* 54, no. 4: 411–19.

Ross, Jeffrey Ian, and John Lennon. 2018. "Teaching About Graffiti and Street Art to Undergraduate Students at U.S. Universities: Confronting Challenges and Seizing Opportunities." *Journal of Interdisciplinary Studies in Education* 6 (2): 1–18.

Rothenberg, Alex. 1987. "Students Write in Classroom, Not on Walls." *Boston Globe*, June 3, 1987.

Rousculp, Tiffany. 2014. *Rhetoric of Respect: Recognizing Change at a Community Writing Center.* Champaign, IL: NCTE.

Royster, Jacqueline Jones. 2000. *Traces of a Stream: Literacy and Social Change Among African American Women.* Pittsburgh: Univ. of Pittsburgh Press.

Rule, Hannah J. 2018. "Writing's Rooms." *College Composition and Communication* 69 (3): 402–32.

Sackey, Donnie Johnson, Jim Ridolfo, and Dànielle Nicole DeVoss. 2018. "Making Space in Lansing, Michigan: Communities and/in Circulation." In Gries and Brooke 2018, 26–42.

Saltzman, Jonathan. 2003. "For T Rider, Vandalism Raises Question of Security. *Boston Globe*, Aug. 31, 2003.

Sanchez, James Chase, and Kristen R. Moore. 2015. "Reappropriating Public Memory: Racism, Resistance and Erasure of the Confederate Defenders of Charleston Monument." *Present Tense* 5 (2): 1–9.

Sanfeliz, Kimberly. 2008. "Police Take a Shine to Scrub Squad." *Boston Globe*, July 27, 2008.

Schryer, Catherine. 2002. "Genre and Power: A Chronotopic Analysis." In *The Rhetoric and Ideology of Genre: Strategies for Stability and Change*, edited by Richard Coe, Lorelei Lingard, and Tatiana Teslenko, 73–102. Cresskill: Hampton Press.

Shaer, Matthew. 2007. "Pixnit Was Here: Her Urban-Art Spots Adorn Public and Private Property. But Some See Her as a Menace." *Boston Globe*, Jan. 3, 2007.

Sheller, Mimi, and John Urry. 2006. "The New Mobilities Paradigm." *Environment and Planning* A 38: 207–26.

Sheridan, Mary. 2012. "Making Ethnography Our Own: Why and How Writing Studies Must Redefine Core Research Practices." In Nickoson and Sheridan 2012, 73–85.

Silver, Tony, director. 1983. *Style Wars.* New York, Public Art Films.

Snyder, Gregory. 2009. *Graffiti Lives: Beyond the Tag in New York's Urban Underground.* New York: New York Univ. Press.

Soja, Edward W. 1989. *Postmodern Geographies: The Reassertion of Space in Critical Social Theory*. New York: Verso.

———. 1996. *Thirdspace: Journeys to Los Angeles and Other Real-And-Imagined Place*. Malden: Blackwell.

Stewart, Susan. 1991. *Crimes of Writing: Problems in the Containment of Representation*. Durham, NC: Duke Univ. Press, 1994.

Stinnett, Jerry. 2012. "Resituating Expertise: An Activity Theory Perspective on Representation in Critical Ethnography." *College English* 75 (2): 129–49.

Swan, Jon. 1984. "South End Mural of Brotherhood Destroyed." *Boston Globe*, Dec. 28, 1984.

Sweet, Laurel J. 2008. "Graffiti Vandal Suspect Slapped with $10,000 Bail Tag." *Boston Herald*, Oct. 1, 2008.

Sweeten, Mary. 1975. "Boston Graffiti—1975 Edition." *Boston Globe*, June 20, 1975, 35.

Temin, Christine. 1983. "Graffiti Is Her Business." *Boston Globe*, Dec. 24, 1983.

Topinka, Robert J. 2012. "Resisting the Fixity of Suburban Space: The Walker as Rhetorician." *Rhetoric Society Quarterly* 42 (1): 65–84.

Trimbur, John. 2000. "Composition and the Circulation of Writing." *College Composition and Communication* 52 (2): 188–219.

Tuan, Yi-Fu. 1977. *Space and Place: The Perspective of Experience*. Minneapolis: Univ. of Minnesota Press.

Tuck, Eve, and K. Wayne Yang. 2012. "Decolonization Is Not a Metaphor." *Decolonization: Indigeneity, Education, & Society* 1 (1): 1–40.

Union of Minority Neighborhoods. 2021. "Boston Busing/Desegregation Project." Accessed July 1, 2021. https://truthlearningchange.com/about/.

Valencia, Milton, and Mark Shanahan. 2009. "Street Artist Arrested on Way to Event at ICA." *Boston Globe*, Feb. 7, 2009.

"View Reports" *BOS: 311*. City of Boston website. Accessed July 20, 2021. https://311.boston.gov/reports.

Vigue, Doreen Ludica. 1994. "Graffiti Mars Suburban View Peer Pressure a Tactic in Fighting Back." *Boston Globe*, June 5, 1994.

Visual Inquiry: Learning & Teaching Art. 2020. 9, nos. 1–2.

Ward, Irene. 1997. "How Democratic Can We Get?: The Internet, the Public Sphere, and Public Discourse." *JAC* 17 (3): 365–79.

Warner, Michael. 2002. *Publics and Counterpublics*. New York: Zone Books.

Weide, Robert Donald. 2016. "The History of Freight Trains Graffiti in North America." In Ross 2016, 46–47.

Weisser, Christian. 2002. *Moving Beyond Academic Discourse: Composition Studies and the Public Sphere.* Carbondale: Southern Illinois Univ. Press.

Weisser, Christian, and Sidney Dobrin, eds. 2001. *Ecocomposition: Theoretical and Pedagogical Approaches.* Albany: SUNY Press.

Welch, Nancy. 2008. *Living Room: Teaching Public Writing in a Privatized World.* Portsmouth: Boynton/Cook Publishers, 2008.

———. 2012. "Informed, Passionate, and Disorderly: Uncivil Rhetoric in a New Gilded Age." *Community Literacy Journal* 7 (1): 33–51.

Wells, Susan. 1996. "Rogue Cops and Health Care: What Do We Want from Public Writing?" *College Composition and Communication* 47 (3): 325–41.

———. 2002. "Claiming the Archive for Rhetoric and Composition." In *Rhetoric and Composition as Intellectual Work*, edited by Gary A. Olson, 41–54. Carbondale: Southern Illinois Univ. Press.

White, Diane. 1973. "The Curse of Graffiti." *Boston Globe*, Feb. 22, 1973.

Whitehill, Walter Muir. 1968. *Boston: A Topographical History.* 2nd ed., enlarged. Cambridge: Belknap Press of Harvard Univ. Press.

Whyte, Murray. 2019. "For Public Art in the Boston Area, Competing Interests and Big Questions." *Boston Globe*, July 28, 2019.

Wilson, James Q., and George L. Kelling. 1982. "Broken Windows: The Police and Neighborhood Safety." *Atlantic Monthly* 249 (3): 29–38.

Wimsatt, William "Upski." 1994. *Bomb the Suburbs: Graffiti, Race, Freight-Hopping and the Search for Hip-Hop's Moral Center.* New York: Skull Press.

Wood, David E. 1981. "Sullied Monuments." *Boston Globe*, Dec. 21, 1981.

Woolhouse, Megan. 2018. "A Midnight Ride with BU's Graffiti Cop." *BU Today* (Summer). https://www.bu.edu/bostonia/summer18/a-midnight-ride-with-bus -graffiti-cop/.

Yancey, Kathleen Blake. 2014. "Locations of Writing." *College Composition and Communication* 66 (1): 5–11.

Young, Alison. 2005. *Judging the Image: Art, Value, Law.* New York: Routledge.

———. 2012. "Criminal Images: The Affective Judgement of Graffiti and Street Art." *Crime Media Culture* 8 (3): 297–314.

———. 2014. *Street Art, Public City: Law, Crime and the Urban Imagination.* New York: Routledge.

Zieleniec, Andrzej. 2016. "The Right to Write the City: Lefebvre and Graffiti." *Environnement Urbain/Urban Environment* 10: 1–20. https://journals.open edition.org/eue/1421.

Index

ACOMA, 135, 153, 160–61, *172*
Anti-Establishment Artists (AEA), 105
Athens of America narrative, 52–55
Augé, Marc, 102
Austin, Joe, 23, 29, 155, 176
Autrey, Ken, 143

Baca, Damián, 13
BAST, 1, 4, 48–49, 68–73, 96, 100, 131, 135, 156–57, 191, 200
BEAN, 85–87, *86*, 93, 142, 148–50, *149*, *193*, 208, 211–13, *212*, 216, 230
bibles, 131–36, 162–63; blackbooks, 131–36; defining, 129–31; in New York, 132; practice page, 137–44, *138*; public and private spaces, 143; repetition, 139; resonance with notebooks, 143; talismanic archive, 153–62; traveling gallery, 144–53
blackbooks. *See* bibles
Bloch, Stefano, 10–11, 60, 217, 219
bombing, 91–98, 121–27
BONES, 2, 3, 128, 144, 160
Boston, Massachusetts: Athens of America narrative, 52–55; Bostons, 65–67; Cradle of Liberty narrative, 46–52; as "legislated city," 34; Melting Pot narrative, 36–46; New Boston narrative,

55–67; trains in, 173–207; writers in, 21–32; writing spaces in, 6–15, 33–36, 52–55
"Boston by the Numbers 2020," 52–53
Boston Planning and Development Agency: guidelines, 57–58
BOWZ, 28, 82–83, 92, *103*, 104, 110, 146, 182, 195, 216
Boyle, Casey, 181
Bradshaw, Jonathan, 151–52, 182
Brighenti, Andrea Mubi, 11, 92, 96, 238–39
broken windows theory, 58–60
Bruce, Caitlin Frances, 11, 94
Burns, William, 16, 143
busing, 55–56; and trains, 173–76

CADET, 144–45
Cardona, Rebio Diaz, 9–10
Castleman, Craig, 132, 155
Chmielewska, Ella, 24
Cintron, Ralph, 101
circulation, trains, 177–80; framework of mobility, 179–80; movement, 180–86; practice, 197–207; representation, 186–97
circulation studies, 147, 178–79, 185. *See also* trains
citizen critics, 60

263

College Composition and Communication (CCC), 7, 13, 20, 162
Community Interludes, 25, 222–23; blackbooking, 164–72; bombing, 121–27; piecing, 68–80
Conference on College Composition and Communication, 13
Coolidge Corner Theatre, 49–52, *50*
counterpublics, 15–16
Cradle of Liberty, narrative, 46–47; Longfellow Bridge graffiti, 48–49; monuments, 47–48, 228–29
Cresswell, Tim, 7, 11, 35, 40–41, 147, 164, 180–81, 191, 198, 238
Cushman, Ellen, 16, 158, 218, 221

D'Angelo, Frank J., 23–24
dead letter. *See* graffiti writing
de Certeau, Michel, 83
Delmont, Matthew, 174
DeVoss, Dànielle Nicole, 17, 158, 182
Dickens, Charles, 81–82
Dickinson, Maggie, 58, 190
Dobrin, Sidney, 8–9, 239
Doran, Meghan, 55–57
DS7, 136

Edbauer, Jennifer H., 91
el (elevated train), 183–85, 199. *See also* trains
Elbow, Peter, 66
Endres, Danielle, 139

Fairey, Shepard, 44–45
Farmer, Frank, 66, 95, 133

Ferrell, Jeff, 11, 38, 45, 48, 58, 60, 86–87, 94, 96, 109–10, 132, 142, 153, 177, 219–20, 230
Foucault, Michel, 7, 144, 177
Fraser, Nancy, 15
Freed, Justin, 49–52

García, Romeo, 13
Garrison, William Lloyd, 37
Garrity, W. Arthur, Jr., 55, 174
Gastman, Roger, 29, 41, 49, 173–74, 224
Geertz, Clifford, 129
geocomposition, 16
GOFIVE, 114–18, *115*, 122, *122*, 148, 150, *150*, 160, 165, 224
Graffiti Busters, 45
graffiti writing: academic literature, 10–11, 23–24; bibles, 128–63; Boston writing spaces, 33–80; producing space, 6–15; publics, 15–21; spots, 81–120; trains, 173–207; writers, 21–32
Greater Boston Metropolitan Area, 3
Green Line. *See* trains
Gries, Laurie, 16, 44, 178, 180

Hamm, Mark S., 219
handball court. *See* Peters Park
Harcourt, Bernard E., 60
HATE, 98, 109, 134, 139, *169*, 180, 184
highways, 88–102
hip-hop graffiti. *See* graffiti writing
History of American Graffiti, The, 173, 224–25
hooks, bell, 7

Iveson, Kurt, 5, 12, 94, 99, 133

Jenkins, Sacha, 132

kairos, 92, 95
Keith, Michael, 94
Kelling, George L., 59
Kluge, Alexander, 15
Kulturez, 1–4, 2, 33, 95, 128, 137,
 144–47, 148–49, 153, 155, 163, 168,
 193, 195, 230, 233
Kynard, Carmen, 133, 146, 179

Lab, The, 114–18, 122
Lachmann, Richard, 157
LADY PINK, 50, 52
Lefebvre, Henri, 7, 12, 47, 57, 231
LIFE, 1, 28, 108, 121, 128–30, 130,
 134, 143, 145, 166, 187, 195,
 200–201, 222
Longfellow Bridge, 48–49

Macdonald, Nancy, 100, 223
Massachusetts Bay Transportation
 Authority (MBTA), 173
Massey, Doreen, 7, 100
masterpiece. *See* piecing
Mathieu, Paula, 12, 15–17, 133, 178–79,
 214
MBRK, 27, 98, 99
McAuliffe, Cameron, 180
Medway, Peter, 143
melting pot, narrative, 36–38; invok-
 ing spatial boundaries, 42–43;
 mobilizing writers, 43–46; place
 of graffiti in, 40–41; *wheres* of graf-
 fiti, 46; writers racialized out of,
 41–42

methodology: ethnography, 29–30,
 217–27; reciprocity, 221–22; and
 warehouses, 224–27
Micciche, Laura, 143
Mill, The, 104–10
Miller, Ivor L., 161, 178, 190
mobility, trains, 177–80; practice,
 197–207; representation, 186–97
monuments. *See* Cradle of Liberty,
 narrative
Moss, Beverly, 20
movement, trains, 180–86
MYND, 6, 26, 90–91, 99, 104–8, 124,
 137–39, 142, 145, 154–55, 164,
 187–88, 192–96, 194, 216, 222, 229

Neelon, Caleb, 29, 41, 49, 74, 173–74,
 224–26
Negt, Oskar, 15
New Boston, narrative, 4; antigraffiti
 posters, 60–62, 61; and broken win-
 dows theory, 58–60; defining, 56–57;
 Massachusetts Turnpike, 55–56;
 naming space, 58; participation in
 spatial production, 62–65; reliance
 on dispersal of authority, 63–65;
 visual quality emphasis, 57–58
New Boston, 4, 72, 102, 131
New York City, 3, 22, 28, 55, 76, 79, 91,
 133; aesthetic discipline, 58; bench-
 ing, 208–10; broken windows in,
 59; considering graffiti historically
 in, 66–67; train writing in, 176, 185,
 187–90, 192, 199, 201–3
NIRO, 88–90, 90, 92–93, 100, 102, 109,
 145, 150, 153–54, 181
notebooks. *See* bibles
Nunley, Vorris, 20

O'Connor, Thomas, 35–37, 53, 56, 134, 174
Oliver, Veronica, 23
Opelika, Alabama, bench in, 227–35
Orson Welles Theatre, 49–52

Pabón-Colón, Jessica Nydia, 11, 22, 132–33, 151–52, 219, 223
Parks, Steve, 12, 133
Peters Park, 110–14, *111*
Philadelphia, 22, 40, 42, 66, 185
piecing: Community Interlude, 68–80; defining, 108
Powell, Malea, 13
practice, trains, 197–207
practice page, 137–44, *138*
PROBLAK, 28, 74, 98, 108, 116, *123*, 136, 138, *170*, 190, 199
public transportation, 174–75, 189, 200. *See also* busing; trains
publics, 15–21
public turn, 15

Quincy, Massachusetts. *See* warehouse

REACT, 73–75, 140, 145, 171, 184–85
Red Line. *See* trains
Reisner, Robert, 66–67
RELM, 11, 27, 91, 93, 96, 109–10, 138, 152, 173
RENONE, 27, 78–79, 97, 100, 122, 125–27, 152
representation, trains, 186–97
Reynolds, Nedra, 7–9, 141, 197, 233, 236–37
Rickert, Thomas, 92

Rickly, Rebecca, 227
Ridolfo, Jim, 17, 158
Rivers, Nathaniel, 16, 181
rooftops, writing space, 183–84. *See also* movement, trains
Ross, Jeffrey Ian, 23
Rousculp, Tiffany, 12, 178
Rule, Hannah, 8, 162–63
RYZE, 98, 136, 181, 183

Sackey, Donnie Johnson, 17
schools, graffiti and, 53–55
Schryer, Catherine 84, 147
Senda-Cook, Samantha, 139
SENSE, 3, 18–20, *19*, 85, 102, 115, *115*, 155, 236
Sheridan, Mary, 218
slow circulation, 182. *See also* trains
Snyder, Gregory, 22, 41, 60, 132, 218–19
Soja, Edward, 7
space, 6–15; making, 6, 17–18, 20–21, 31, 84, 87; material, 8, 232, 237; pedagogical, 4, 110, 118, 131, 138, 140, 154, 162; politics of, 12–15, 237–38; production of, 6, 30, 33, 112, 139, 223, 233; regulation of, 34; rhetorical, 17, 20, 44, 47, 84, 97, 232, 235; social, 10, 31, 163, 231; theories of, 21, 234; urban, 6, 10–11, 34, 46, 48, 58, 60, 62, 93, 133, 144, 147, 155, 224
SPIN, 28, 90–91, 99, 104–5, *105*, *107*, 121–22, 124–25, *125*, 140, *141*, 154–55, 192
spots: alternative spatial epistemology, 87; bombing, 91–98; chill, 104–10; defining, 84–88; handball court, 110–14, *111*; highways, 88–102; hot,